THE SHOSHONEANS

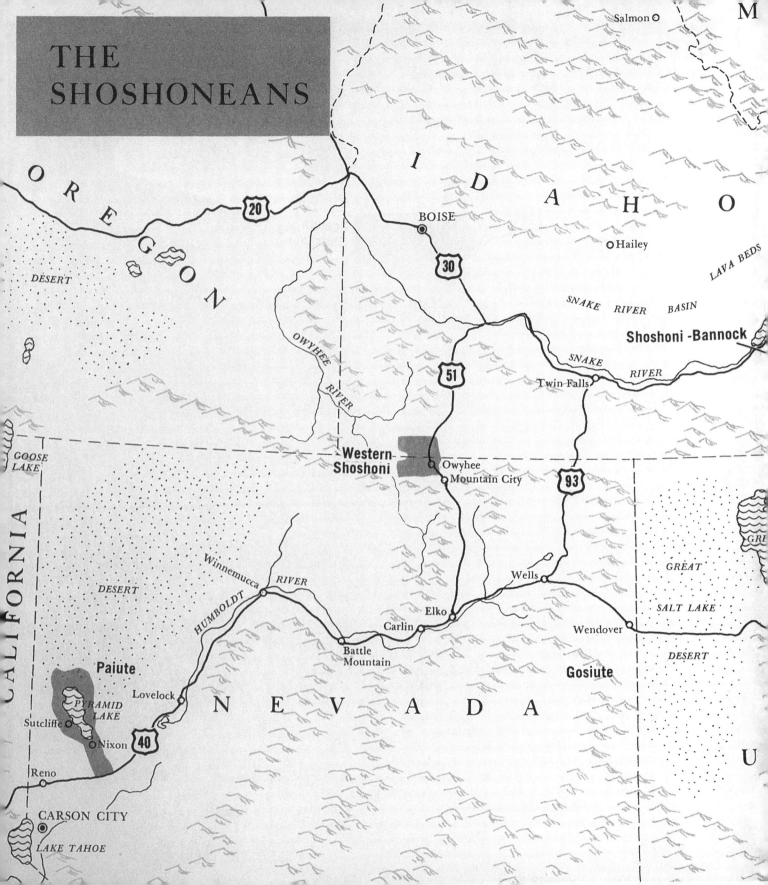

THE SHOSHONEANS

OREGON

M

IDAHO

Salmon

BOISE

Hailey

LAVA BEDS

20

30

SNAKE RIVER BASIN

Shoshoni-Bannock

51

SNAKE RIVER

Twin Falls

DESERT

OWYHEE RIVER

Western Shoshoni

Owyhee
Mountain City

93

GOOSE LAKE

GRE

GREAT

CALIFORNIA

DESERT

Winnemucca RIVER

Wells

SALT LAKE

HUMBOLDT

Elko

Wendover

DESERT

Carlin

Paiute

Battle Mountain

Gosiute

Lovelock

N E V A D A

PYRAMID LAKE

Sutcliffe

40

Nixon

Reno

CARSON CITY

U

LAKE TAHOE

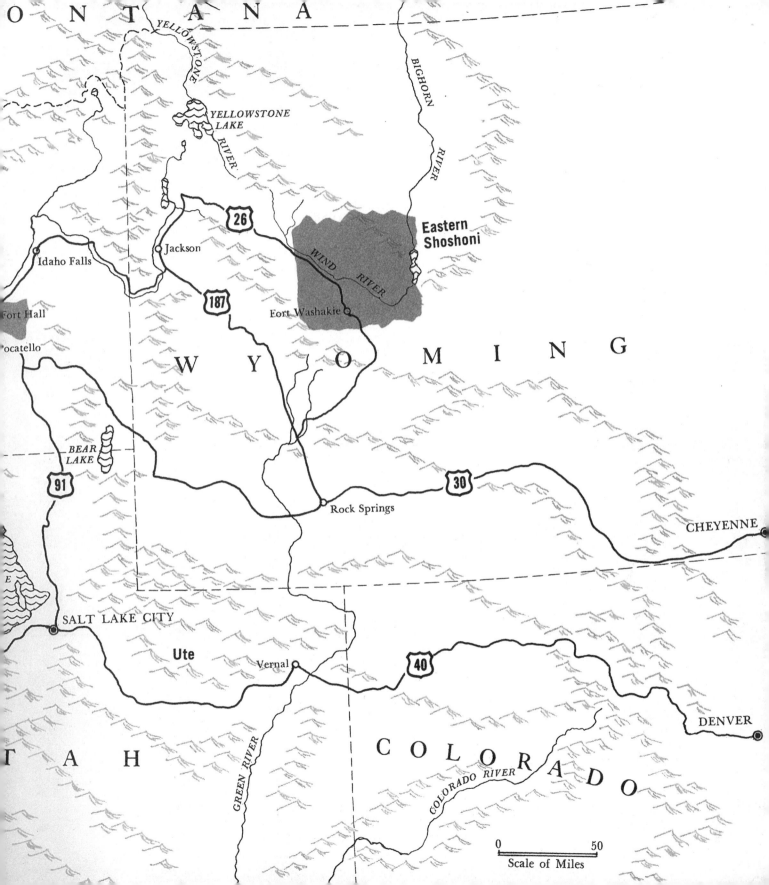

RECENCIES Research and Recovery in Twentieth-Century American Poetics

MATTHEW HOFER, *Series Editor*

This series stands at the intersection of critical investigation, historical documentation, and the preservation of cultural heritage. It exists to illuminate the innovative poetics achievements of the recent past.

Other titles in the Recencies series available from the University of New Mexico Press:

Amiri Baraka and Edward Dorn: The Collected Letters edited by Claudia Moreno Pisano

THE SHOSHONEANS

The People of the Basin-Plateau

EXPANDED EDITION

Text by Edward Dorn
Photographs by Leroy Lucas
Foreword by Simon J. Ortiz
Edited by Matthew Hofer

UNIVERSITY OF NEW MEXICO PRESS • ALBUQUERQUE

Acknowledgments

I want to thank Dr. Sven Liljeblad, the linguist, who pointed out a great deal of monographic material I might otherwise never have come across. He is in no sense, of course, to be held responsible for my interpretations.

To Miss Alice McClain, of the Idaho State University Library, I want to express my thanks for her aid with library materials.

I want to thank my wife for her very patient help with the manuscript.

In various tangible and intangible ways the following people were helpful to both the photographer and writer: Mr. Max Pavesic, Mr. Raymond Obermayr, Professor E. W. Dawson, Mr. Jack Fitzwater, Mr. Jeff Phippeny.

Original text and photographs © 1966 by Edward Dorn and Leroy Lucas

Expanded edition © 2013 by the University of New Mexico Press

Published 2013 by arrangement with the authors.

Printed in the United States of America

18 17 16 15 14 13 1 2 3 4 5 6

Library of Congress Cataloging-in-Publication Data

Dorn, Edward.

 The Shoshoneans : the people of the Basin-Plateau / Edward Dorn, Leroy Lucas, Matthew Hofer ; [foreword by] Simon J. Ortiz. — Expanded edition.

 pages cm

 Originally published: New York ; William Morrow & Company, 1966.

 ISBN 978-0-8263-5381-8 (pbk.) — ISBN 978-0-8263-5382-5 (electronic)

 1. Shoshonean Indians—Pictorial works. I. Title.

 E99.S39D67 2013

 978.004'974574—dc23

 2013026919

SHOSHONEAN FAMILY. The extent of country occupied renders this one of the most important of the linguistic families of the North American Indians. The area held by Shoshonean tribes, exceeded by the territory of only two families—the Algonquian and the Athapascan,—may thus be described: On the N. the S.W. part of Montana, the whole of Idaho S. of about lat. 45° 30', with S.E. Oregon, S. of the Blue mts., W. and central Wyoming, W. and central Colorado, with a strip of N. New Mexico; E. New Mexico and the whole of N.W. Texas were Shoshonean. According to Grinnell, Blackfoot (Siksika) tradition declares that when the Blackfeet entered the plains S. of Belly r. they found that country occupied by the Snakes and the Crows. If this be true, S.W. Alberta and N.W. Montana were also Shoshonean territory. All of Utah, a section of N. Arizona, and the whole of Nevada (except a small area occupied by the Washo) were held by Shoshonean tribes. Of California a small strip in the N.E. part E. of the Sierras, and a wide section along the E. border S. of about lat. 38°, were also Shoshonean. Shoshonean bands also lived along the upper courses of some of the flanks of the Sierras, Shoshonean territory extended across the state in a wide band, reaching N. to Tejon cr., while along the Pacific the Shoshoni occupied the coast between lat. 33° and 34°.

On linguistic grounds, as determined by Kroeber, it is found convenient to classify the Shoshonean family as follows:

I. Hopi.

II. Plateau Shoshoneans: (a) *Ute-Chemehuevi:* Chemehuevi, Kawaiisu, Paiute, Panamint, Ute, and some of the Bannock; (b) *Shoshoni-Comanche: Comanche, Gosiute, Shoshoni; (c) Mono-Paviotso:* Mono, Paviotso, part of the Bannock, and the Shoshoneans of E. Oregon.

III. Kern River Shoshoneans.

IV. Southern California Shoshoneans: (a) *Serrano,* (b) *Gabrieleño,* (c) *Luiseño-Kawia:* Agua Caliente, Juaneño, Kawia, Luiseño.

Frederick Webb Hodge, 1912[1]

1

In 1835, the padres of Mission Santa Barbara transferred the San Nicolas Indians to the mainland. A few minutes after the boat, which was carrying the Indians, had put off from the island, it was found that one baby had been left behind. It is not easy to land a boat on San Nicolas; the captain decided against returning for the baby; the baby's mother jumped overboard, and was last seen swimming toward the island. Half-hearted attempts to find her in subsequent weeks were unsuccessful: it was believed that she had drowned in the rough surf. In 1853, eighteen years later, seal hunters in the Channel waters reported seeing a woman on San Nicolas, and a boatload of men from Santa Barbara went in search of her. They found her, a last survivor of her tribe. Her baby, as well as all her people who had been removed to the Mission, had died. She lived only a few months after her "rescue" and died without anyone having been able to communicate with her, leaving to posterity the skeletal outline of her grim story, and four words which someone remembered from her lost language and recorded as she said them. It so happens that these four words identify her language as having been Shoshonean . . .

Theodora Kroeber[2]

Contents

3

Photographs follow pages 18, 34, and 82

Foreword

I hadn't read *The Shoshoneans* for many years, and I was totally overjoyed when I found myself being asked to write a commentary that would be an introduction to a new publication of *The Shoshoneans*, a powerful and beautifully expressive book by the late Edward Dorn with photographs by Leroy Lucas, originally published in 1966. Vividly remembering the book, I said, "At long last!" since I was excited about the prospect of writing about a book I loved. Of course, obviously and immediately, I agreed to write such a commentary.

I began to reread Dorn's words—I call him Ed, by the way—that I remember first reading in 1968 or 1969. So much was happening during that period of time, including the publication of *The Shoshoneans*. I was a busy summer teaching intern at Rough Rock Demonstration School (RRDS) in Arizona on the Navajo Nation ("reservation" was the operative word back then, not "Nation" as it is now) and was a student during the regular year at the University of New Mexico College of Education. Soon I would begin full-time work as the public relations director at RRDS since the school was asserting and demonstrating local control in Indigenous (the usual operative word in common use then was "Indian") education.

The time period also included those incipient years when anti-war protests against U.S. invasion and occupation of Vietnam in Southeast Asia were beginning. Activism plans, peace projects, and other such actions were being tactically organized, and they would soon be in place in full popular

force. There's a big difference between then in the latter 1960s and now in 2013, isn't there? Basically, popular activism was a cultural, social, and political dynamic movement within the American community.

It was evident that there was an unabashed national political movement underway. Soon, it would be in the mode of open public resistance against the Vietnam War, and these acts of resistance were, in effect, active protests of U.S. international policy. Much of it was within the thematic rubric of "bringing the war home," and a good deal of it was led by Students for a Democratic Society (SDS) and the Weather Underground, an offshoot of SDS. It was also directed by voices from within the American community. I remember one of the RRDS summer interns in particular; he was an energetic, talkative guy named Blackburn, and he was an SDSer from Denver whose rhetoric was fiery and upfront!

When I think about it, I have to consider that *The Shoshoneans* was also part of that voice from within the American community of that time, especially because the U.S. Civil Rights struggle led by Dr. Martin Luther King Jr. had been waged for more than ten years by then. And that struggle had morphed into the Third World Liberation Movement—Black Power, Red Power, Brown Power—and catalyzed the Farm Workers Strikes led by Cesar Chavez. Even the hippies, the Love Generation, and perhaps even "the streakers" were somehow allied within that voice.

For me as an Indigenous tribal community person, when I think more about it, I have to say that personally it was "the community," the *hanoh* as we call it at Acoma Pueblo, that stimulated the voice and movement.

And this is what inspired Ed Dorn to write *The Shoshoneans*, I believe.

The Shoshoneans is unusual in the sense that it is not necessarily a pro-Indian text, although "Indians" are its main narrative topic and Ed uses the word "Indian" since it is the most common term known by the general American English–speaking public when referring to Indigenous Americans. In the 1960s there was very little or no use of "Native American," although once in a while "Aboriginal" was used. And there is no narrative about the generally accepted use of "Indian" nor that the term derives from original coinage used by Christopher Columbus when he encountered Indigenous peoples in the Caribbean, depicting them as "gente en Dios"—people in or of God. Soon "en Dios" morphed into "in Dios" and soon thereafter became Indios. And too soon after, it became a mainstay of historical vocabulary that reflected the diminished role Indigenous peoples were stuck with

6

as a result of the full-scale invasion and occupation by Euro-Americans that comprised the colonization of the Americas.

Ed does forthrightly focus in his narrative text on the fact Indigenous peoples have not fared well historically. For instance, he notes, "over the fiercer part of native-white history . . . affairs were subsumed under the Department of War," meaning that's how the U.S. government conducted itself toward Indigenous peoples. *The Shoshoneans* is not exclusively a paean of or for Shoshonean peoples, since Dorn also depicts their material poverty and the vastly diminished and disempowered role they and other Indigenous peoples have in U.S. society and culture. His narrative scope covers a vast area of the western United States where Shoshonean peoples resided in the past and currently in New Mexico, Arizona, Colorado, Utah, Nevada, northeastern California, southeastern Oregon, southern Idaho, and western Wyoming. Although he briefly mentions their ethnic-cultural reach all the way to southern Canada, he doesn't explicitly locate them in Oklahoma, Texas, and northern Mexico where nomadic Comanches resided. Their traditional homeland habitation covers a vast plateau-intermountain-prairie-desert region that is almost limitless. And he partially journeys this region not only rhetorically but also conducts a physical trek with photographer friend–associate, Leroy Lucas, an African American. Lucas's presence also provokes transcultural interactions with Shoshoni people that Ed mentions but does not address extensively. I find it interesting and intriguing that he doesn't allow a fuller collaborative effect about that to have impact in his narrative.

Nonetheless, I like the fact that Ed Dorn has the innate courage, integrity, and mindset to take himself and his friend Leroy on the journey into the heartland of the Shoshoni homeland. On the way to Mountain City, Nevada, a hybrid cowboy and mining town, they meet and give a ride to Wilbur, a beaten-down Shoshoni cowboy rodeo performer who is more or less inebriated. Driving northward toward Mountain City and Duck Valley, where Wilbur's many relatives live, he regales Ed and Leroy with stories of the Vietnam War, rodeo life, and his relatives, and he vows to show them that he can ride a steer! They end up at Wilbur's "cousin's" home where Ed and Leroy are initiated into a wild carousing time with several Shoshoni, a time that's edged with a hint of unforeseen and unspoken danger and a surreal hypertension. At this point, the narrative of *The Shoshoneans* provides us with a simple yet complex account and visual grasp of the results of almost five hundred years of Euro-American colonialism that has beset the Shoshoni and other Indigenous

peoples of the Americas. Ed offers almost no commentary or interpretation, nuanced or otherwise; his book details only the expository narrative. And I wonder whether—combined with my earlier remark about his courage, integrity, and mindset—that's part of the reason why I like the journey he leads us on: an awesome trek into the Shoshoni heartland.

Yes, I think so. Thank you, Ed.

TEMPE, ARIZONA

I

I BEGIN where it was the highest pitched for me, at Duck Valley, on the Nevada–Idaho border. One hot July afternoon we stopped at Mountain City for a sandwich. It was a particularly western restaurant, varnished pine, fixed in the style of "mountain-outwest"—what the stereotype dictates but which is not really so common. For all that notorious motif, westerners tend to use the same materials people do everywhere else. We had a beer. There were Indians. I looked at them by now almost casually as my special subject, other men seemed part of the blurred background. One Indian in cowboy clothes came over to our booth, from the bar, and asked if he could have a ride on north. Yes.

The road enters the reservation shortly after you leave Mountain City. Then, across several miles of reservation, it comes around the point of a rib of mountains, toward Owyhee, going northwest. There was a tall and slender butte with sides nicely curved out to the base on the first horizon across the valley, the sun lay back of it. The butte rose flat and black against the evening sky. Below, Duck Valley, broad and green, the hay fields scattered in squares over the valley floor.

We arrived at Willie Dorsey's house late the next afternoon, on our way out of the reservation. Willie Dorsey is 102 years old. He was born before the treaty of Fort Bridger. He is a Shoshoni. We had heard earlier in the day from his great-grandson that there was such a man, of such an age. This man's picture had been taken, he had been inter-

viewed by state historians. He was probably the oldest living being in Idaho or Nevada.

The road was along an irrigation canal, six-inch dust, velvet fine, spraying before the wheels of the car and accompanying it as a cocoon in the still air. It was the center of the valley floor—willows along the canals and ditches, clouds of mosquitoes. To the east a high ridge with bands of lava rock, to the west the varying pitch of horizons and the butte, Chinaman's Hat, the Indians call it, not Hat Peak as it is on the map. There was a group of three houses, wooden clapboard structures. An old man, who had the first store in the valley when it was home-steaded by whites, told me the Indians had adopted that style from the settlers. That habit of building was only now being replaced by the modern brick ranch-style houses which a progressive Indian builds, or the government-sponsored community project houses which are less pretentious but do resemble lower-class tract houses at the edge of a small white town. Willie Dorsey lived in one of these three houses among a grove of tall Lombardy poplars. The trees were planted by the whites. They are old, the boles of some of them of great circumference. In the bowl of the valley these groves occur in the distance like flecks and invariably there is a house which one cannot see under the high, cool vaulting of the trees.

There were three gates to be opened, and then closed. Small, crooked aspen poles hung on rusty strands of barbed wire and hooked by a simple (but complicated for the novice) stick and hoop of wire. There were dogs, the skinny, hungry-looking Indian dogs, mongrels of mongrels, and they rushed out barking viciously but were finally friendly, wagging tails. We went through the last gate to a well and short-handled pump set up on a wooden platform. Two of the houses were near the pump and it didn't look as if there were anyone around. The other house, away from the trees, looked abandoned. It didn't occur to us until the last moment Willie Dorsey might live there. It was a hot afternoon and the whole affair had in it the press of lateness, the peculiar quality of last minute attention. In fact, that other house, in the full sun, seemed out of everything and when I did go to the screen door on the other side of it, over a path through high grass and up onto the low platform of the back porch, and looked through the screen and saw the old woman, the very very old woman, the oldest creature I ever

saw, with a faded blue bandana covering her whole head right down to the middle of her eyes, I was somehow calmed, because of her, from the shock of what it was I was doing and what it was I saw, the heat, the vociferous mosquitoes in the building's shade, the slightly moist filth at the back door. Not spectacular filth, most everyone has witnessed that in America, but the grim weight of bad condition, not especially outlined, more heavy with despair than one could possibly arrange with rubble.

Mrs. Dorsey unlatched the screen door as though I were simply an animate object appeared one day, some moment, at her door and when I entered she motioned with no particular meaning to the room beyond, where I could see a small wood-burning stove. I went into that room. Mr. Dorsey sat on the edge of the bed with his feet on the floor, a piece of cotton over his thighs. He looked up at me with clear eyes, the eyes of the ancient, bright, but the shine from behind a milky covering, a tough overlay almost a protection formed by the years. Brightened only by a sudden cognition which in turn seemed a completely self-determined generosity. Very old animals have such coats over the eyes, a privacy impenetrable from the outside. He made a shaking motion with his finger, trembling in space, toward a chair. The room itself was overpowering. I was struck right off and singularly by his beauty, the sense of the power of his presence I later remembered I felt immediately, but I also saw myself as a curious paleface. My attention was suddenly arrested—this man was a great deal more than old. I was looking at the scene, and at myself, in a mirror, seeing the looking. The chair was covered with spilled water and bits of debris from his eating. I sat down on it, and without, I told myself, thinking to prove anything. It was difficult to do it. I felt crossed by an embarrassed confusion: what and who I was compressed all at once into one consideration, again I watched myself as I might think of a god watching, and there was in me at the same moment the hopelessly practical hesitation to soil my seat and the public willingness to do so—followed by a self-censure for having thought of it in either sense. The point in any case for me was moral. I must sit in this man's refuse.

He began by pointing to the areas of his ailment, around his lower back and chest. The volume of his voice, the force of his gesture, were low keyed but so articulate and registered I could hardly make the ad-

11

justment, no matter how I intended to know, to align with his sense. His engagement with the room and all in it was pure. Life for him had turned into full rite, the tone of his existence was self-measuring. The act of his presence was a total rhythmic manifestation from his gesture to the inward mirrors of his eyes. He barely moved, only his lips were the agents of the muscles of his neck and eyes, the ends of a network of force around his head. His English seemed fair, the problem was his hearing, I thought.

The place was intensely neglected, I gradually saw, and not just filthy as it looked to be at first glance. It was simply the remains of a life, and one must not forget a century is a difficult space of time for a man gone to the utter end. There was a safe, or cupboard, in the corner. It had some things in it, back of the glass. The light too dim to tell what. There were two beds. His wife, nearly as old and even frailer than he, went every now and then to his ear and spoke in the whispered endings and stopped throat tones of the Shoshonean speaker. He made low, nodding, assentive replies. She should have died, by the rules of our biology, thirty years ago. But it was evident that she would stay on, the weaker of the two, until he smelled the summary message in his nostrils, then she would be free. Once in a while she went to the edge of her bed and curled up on her side to rest. A discontinuous sound came from her throat. A chant she barely said. Her final spark was deeply internal, wrapped in the unending wrinkles; silent, nearly departed, she lived to administer his last service. And trying the sense of their relationship with my own subjectivity, at that moment it seemed to me here was the contrary of my own Western notion that one goes through the portal of death alone to greet some large blank which hopefully might be an extension of a "personality," whether that be God or oneself as a continued state. Thus wrapped in the service of their ritual antiquity, they formed an effective edge of the real, an area of existence both life and death, neither morbid nor quite quick. A substantial prayer of flesh, plasma, spirit, all one fluid. And so, if this all sounds religion, I hope it does in no orthodox sense, more *religare*—to tie back: the nearly absolute briefness of ceremony, its power an intense spark, renewable as each time it reconstitutes the entirety of creation, the *Every Thing*. I did not for one instant look upon that qualified vitality as mystic. This man and woman were the most profoundly beautiful ancestors I've wit-

nessed go before me. He is the spirit that lies at the bottom, where we have our feet. The feet which step between the domains, the visible sign, the real evidence of the coming event, and which one can see on the Humboldt fragments from Mexico, or on a linguistic map where this man's low, incantatory verbs spill down across the plateau and basin, between the mountains into the final plexus of the great Uto-Aztecan image of the world he sings in his daughter tongue. My point is that one can hardly think to be merely in Idaho, or Nevada, and that his beauty is that simple one would not treat it as anything special, not more Indian than man, still as much the flower as the fruit.

His feet were dirty. In the dry climate they had gone untended until, on the floor of the room at the ends of his legs, wasted to leather covered bone, they rested cracked in the dry air and drifting soil. I was aware of the presumption of my thinking he would be relieved or made happy by having his feet washed. Was he unhappy? There was no reason to suppose so. Would I dare wash his feet?

Occasionally the woman traveled into the kitchen and once, she returned with a small bowl of canned pears and placed it on the stand beside the bed. I almost involuntarily helped set it down, attempting to make a space in the clutter, taking the bowl but not exactly taking it from the extreme fragility of the movement of her hand. I was then preoccupied with what was going on, and coincident was the feeling, quite strong and uncomfortable, that I was thinking about it, again the psychological double mirror. It was very hot in their cabin. Should we be there. There was in me an oppressive thrill over the idea of my own presence. I thought of it as a ruptured cord in the consciousness, a strong confusion of the signals of my culture. I think I failed to see this as a pure event having nothing to do with *me* as such. I felt intrude the foolish insistence of the conception of myself, the content of my own particular conception of history raced past my head and I must say I thought of my government's relationship to this man, I felt I would "realize" him somewhere in the cache of all *my own* sentience. For one thing, I smiled at the man and he smiled back, and this led each time to a new attempt to make him understand me. Did he need anything? Could we bring him something, anything possible, would he tell us what they needed? Shouted into his ear so close my face was nearly touching his, the deep texture of his rich skin an untranslatable brown

13

geography suddenly printed on my own eye, locations I would never have to cross, the hundred years were so laid out they included my own perishing flesh. And I felt some embarrassment over the difference of our two charities. His straight short hair was evenly divided and mixed, black and bright gray.

I took the bucket from the kitchen to fill it at the well. At the back edge of the house my ear at once caught his long, high, enormously full song, it came as a near falsetto flutter of amazing strength from his thin body, the sound departing with the diminished *ach*'s and quavering whispered endings of Northern Shoshone. A volume of *Yaa~Aaa~Aaa*, but a more compacted quickness than that, embellished the ends of his periods. It was not so stunning as it was peculiarly attractive. What was happening? I looked around at the well expecting to see something material.

It is his quickness which remains in me and why I choose to begin this essay on the Shoshoni with him, the highest circumstance I have ever encountered.

The end of the visit was marked in a no less earthly way. When almost as an afterthought we offered him a cigarette his face lit up with pleasure and we all then laughed at the simplicity of the discovery. We finally had our answer. He would like cigarettes. The old woman took one but did not smoke it until it was lit for her. We all sat and smoked and laughed and then the spell was over. Back out through the three gates to the store for a carton of cigarettes and then back in through all the dust, where at one gate an approaching car stopped and a largish Indian woman, perhaps in her thirties, asked us what we were doing and when I explained gave a strange smile to the man in the front seat with her and drove on.

I had a great desire to be off, to not take any more, or give any more, to let the spiritual fact be the function of its instant and not an exposure, not a continuum. A Heathenism, of course, entirely of my own origin. For I will say it, at the risk of blunder: It is impossible for myself and my people to offer themselves in any but the standard senses. The minute there are human implications we back off. It was painful to go back, and at the screen door redo the unlatching, see again the room, take his hand again, reconsider the social and economic configurations that rise inevitably like specters in the eye of an enlightened Western

mentality; not to do all that was then a problem, the cross-telling in the busy circuits of the mind in the oppressive heat for which we are the fuel. None of that. Not why did those pasty doctors at the agency hospital not come and bathe the man at least, of course not to clean him because that was certainly none of their business, his cleanliness was established far beyond what their pop-ritual of medical deodorization could manage, but to cool him? That *seemed* reasonable. But was it? It was I who objected to the heat and stillness of the air. Not him. It was his place, his home, that *was* where he was, his own chamber, own rectification. And I did not wash his feet. That meliorism, strong in me, tinged with the Methodism of my youth, I put down. I left their house. Again, his song as I first heard it, the high Shoshonean vibration and cadence.

II

THE LOCATION of the Basin-Plateau area of the western United States is well known only to a few gamblers, professional criminals, movie stars, divorcees, and, of course, the people who live there. Lay your right hand palm down, fingers spread, on a map of the West scaled approximately one inch to fifty miles, your little finger on Salt Lake City directly under the wall of the Wasatch, the end of your thumb on Reno by Lake Tahoe in the Sierra Nevadas, the tip of your great finger just under the mountains of Idaho, your index finger touching the southeast corner of Oregon, the heel of your hand above Las Vegas, and you will have covered the Basin-Plateau area. Within that area there are three major drainages. On the Plateau to the north the Columbia provides access to the Pacific for the rivers of the inland Northwest. The Snake is its major tributary rising in far western Wyoming and cutting a long arc across southern Idaho. In the Basin the Humboldt and its tributaries flow into the Humboldt Sink almost directly south of Lovelock, Nevada. The great Salt Lake of the Bonneville Basin in Utah collects water from the nearby Wasatch mountains. One can see the flat crusted whiteness of Humboldt Sink from the road between Reno and Lovelock. Pyramid Lake in western Nevada catches the short run of the Truckee River. None of the rivers in the Basin have access to the ocean. They either run into the shallow alkaline lakes to evaporate or disappear in the sand.

In some places the salts run deep into the soil. It is bitter landscape,

scarce country. Where the mountains are high enough to catch precipitation streams are formed and on the gentler sloping sides of some ranges there are springs. The entire Basin is high. The valley floors range in altitude from four thousand to six thousand feet, and the mountains from six to eleven or twelve thousand feet. Some mountain valleys and margins of rivers supported more existence than others; it must be kept in mind, however, that throughout the Basin life was harsh and, for man, unrewarding. Precipitation in the Basin-Plateau area ranges from 4.2 inches at the western edge of the Salt Desert to 15 inches on the upper Snake River plains.[3] On some of the highest ranges the precipitation is greater, and retained. The snow melts and runs off slowly.

The ecology was and remains important. Their contact with the white man has done little to improve the Shoshoni despite the fact that some of them cling, at least in conversation, to the most dubious straws of American technology—the battered automobile, canned beer, artificially produced wine, the thinner and thinner yards of calico their wives and daughters wear, their own faded western jeans. The ecology, in other words, still demands of them that they pay attention to the drought of their still narrow material possibilities while the propositions made to their spiritual futures are banalized beyond comment. Their condition at first contact with the white man, and presumably for some time before that, is said to have been subsistence level—just barely enough during good times, at other times less than that. They seem to have traded piñon nuts for beans. Which is the fairer crop I have no idea.

It seems settled in the minds of authority that a better food supply, which I suppose goes right down to a protein count, leads to a finer and more elaborate cultural apparatus. The people of the Plateau, closer to quantities of fish, and on the eastern Plateau close to bison, became economically distinguished from the Basin people probably in the eighteenth century. Of the whole area the following summary seems reasonable: 1.) The Pre-horse, Pre-Caucasian intermontane Shoshoneans had in common one broad set of cultural and political configurations. The variables were determined by the nature of local ecology, *i.e.,* microclimates, the reach of a spawning stream into their territory, as along the northern rim of the Basin. 2.) There were variations on the periphery—for instance, the partial agricultural practice of the

17

Southern Paiute, or the proximity to salmon of the Western Shoshoni along the Snake River where they met the horse-owning Nez Percés and Kutenai. 3.) Ecology dictated the general population density, and its locations. One to three family units moving across the landscape through the season of food gathering, huddled in larger numbers in the winter villages. 4.) In the shifting demands of a wanderer's economy, the biological family was tight and related but never elaborately structured. In those few areas where the ecology allowed more or less fixed settlements, say at Owens Valley, Nevada, bands formed and were named, and land owned under chiefs of defined authority. This condition contrasts well with the simple family society under the externally enforced weight of their migrations—where the headman was specifically "talker." 5.) Only along the eastern margin of the Basin-Plateau did the acquisition of the horse ring a change in the old economy. The buffalo then became the main food source, and beyond food, a new socio-political base. Given the great mobility of horse travel, the Eastern Shoshoneans moved out onto the plains after the few buffalo west of the mountains were killed. There they were exposed to more elaborate and established ritual than their own, and indeed could now afford recurrent ceremony, which their poor relatives to the west never managed. And as Steward points out, the horse never became important in the life of the Western people because the measure of its own support was too large—it would have consumed the very grasses and seeds the people ate.[4] Since there were no masses of large meat animals, buffalo or otherwise, in his land, the Gosiute, for instance, quite accurately saw the horse as meat itself. And because he had nothing much to carry about in his meager domain, its value as transportation was trivial.

The question comes up then, what are those collections of Indians attached to small towns? In the late nineteenth century the reservations were marked off and Indians settled into that existence. However, during the early shaking down to present situations a good many Basin Indians stayed more or less where they were and by some final gravitation now cling to the edge of a town. Roots, seeds and nuts, grasshoppers, and Mormon beetles (those strange multicolored and thinly armatured insects, an inch and a half long, who move across the ground like a tractor and trailer) have been exchanged for another series of embarrassments.

The People

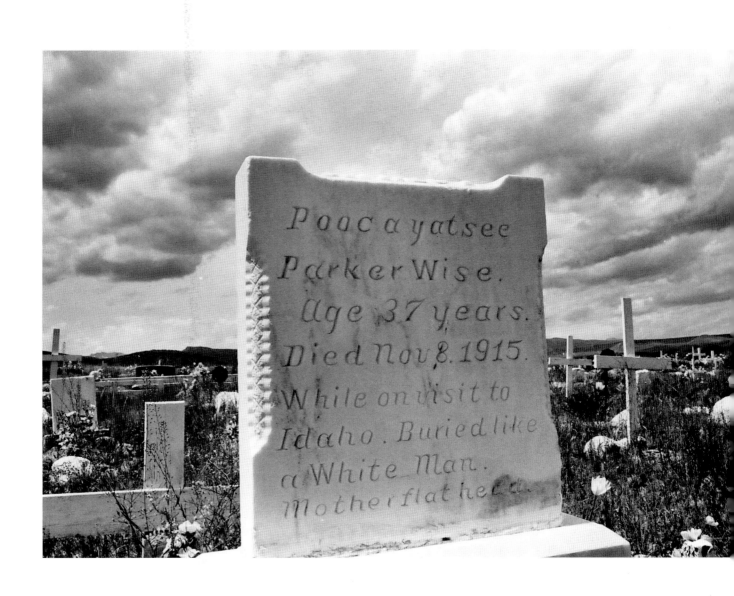

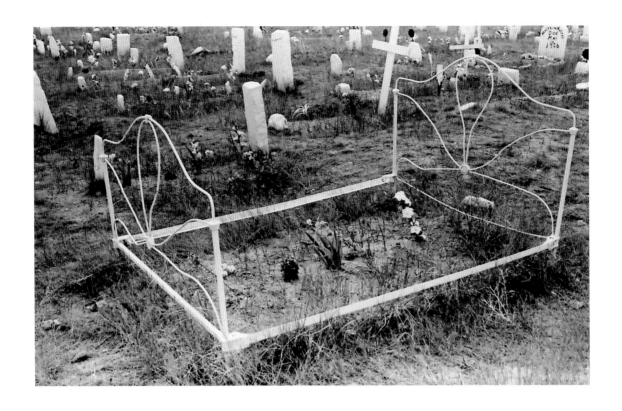

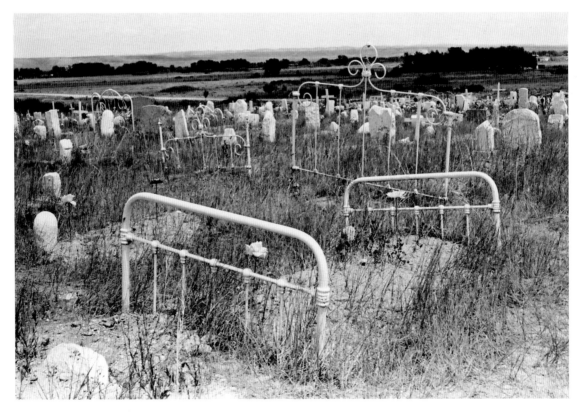

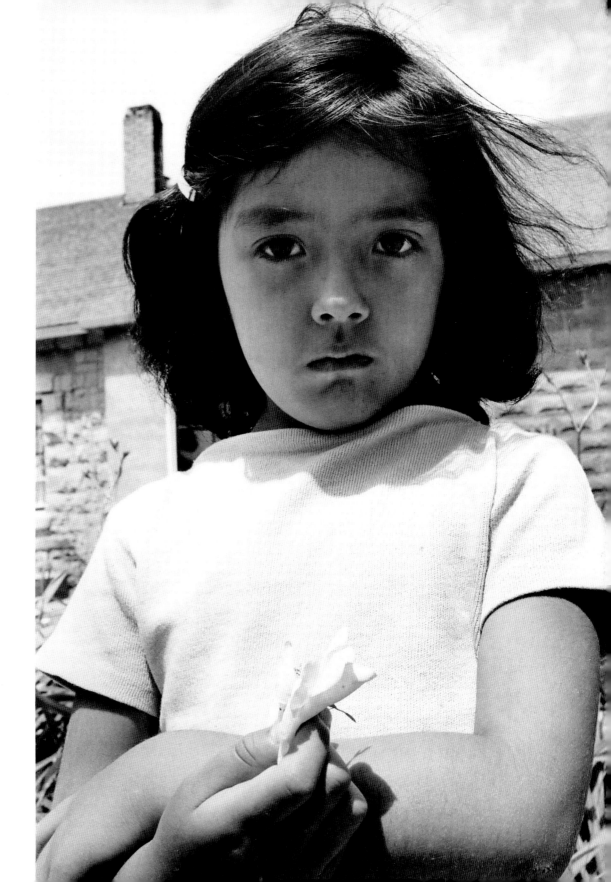

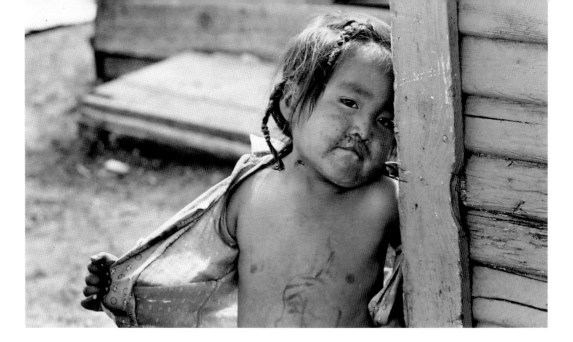
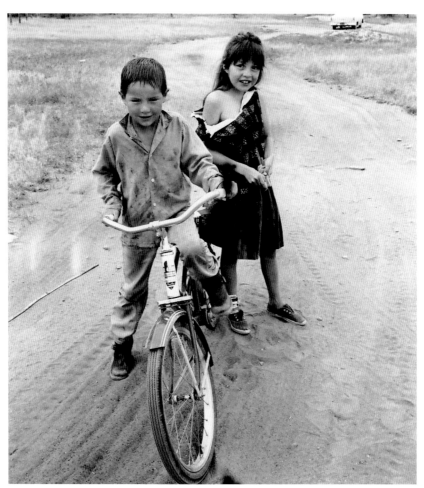

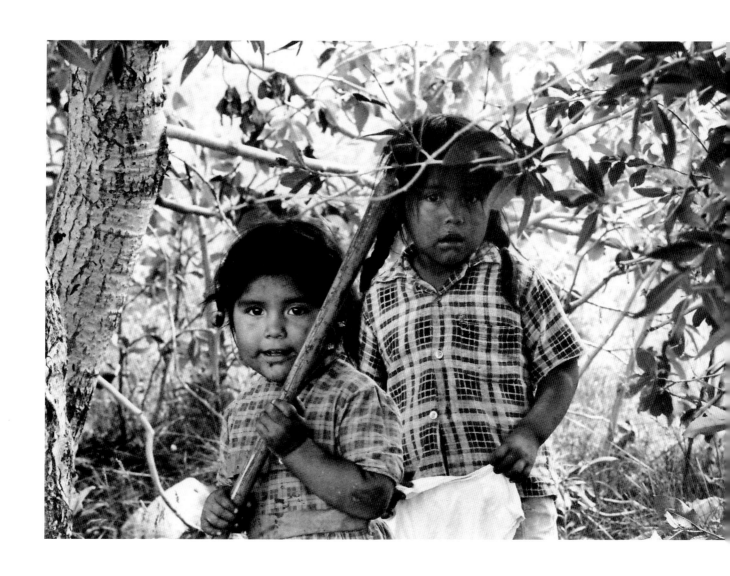

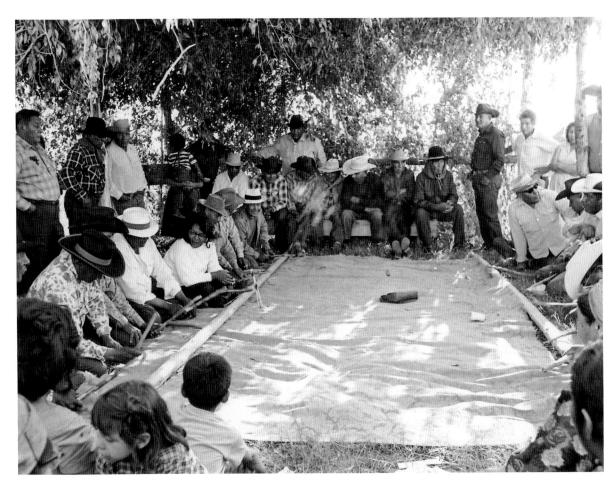

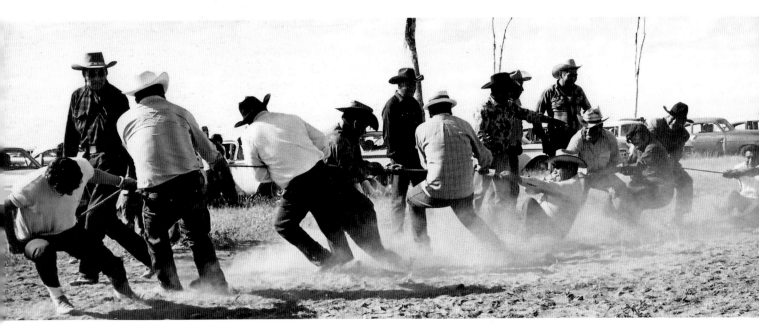

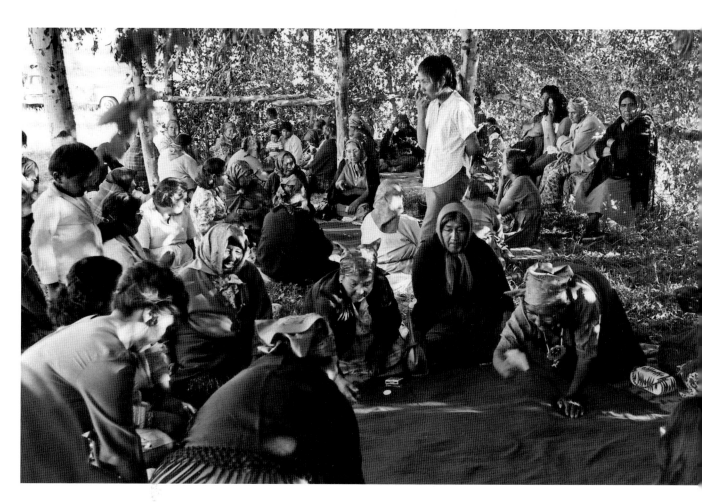

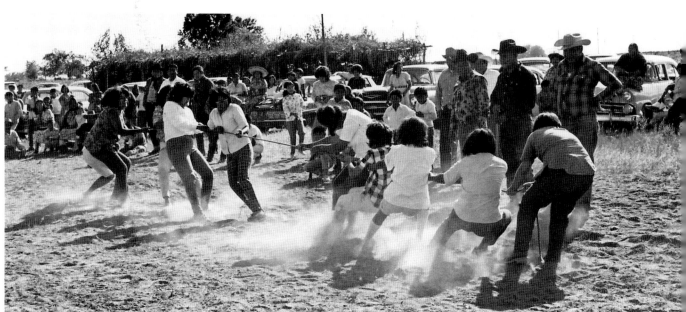

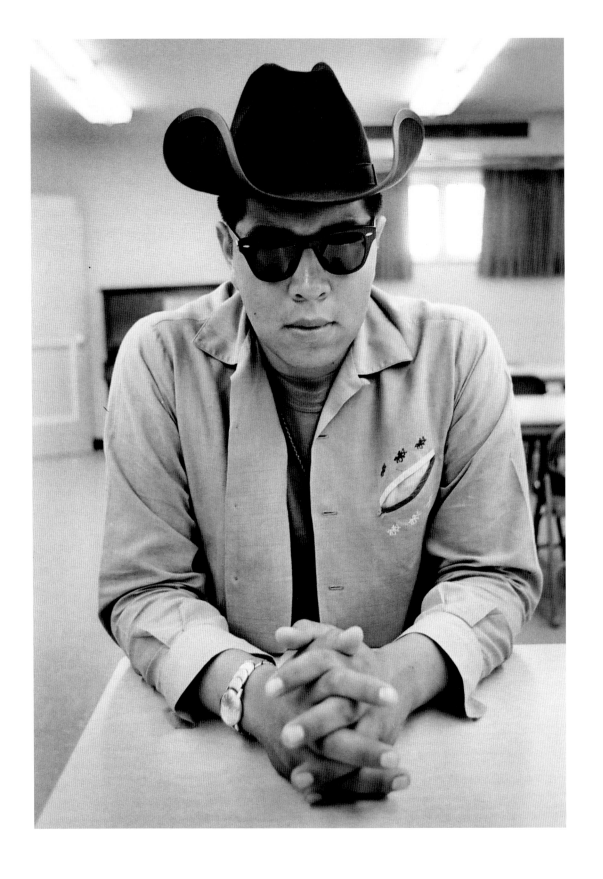

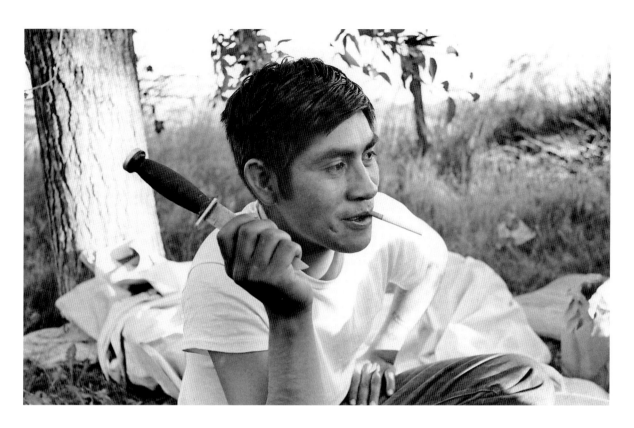

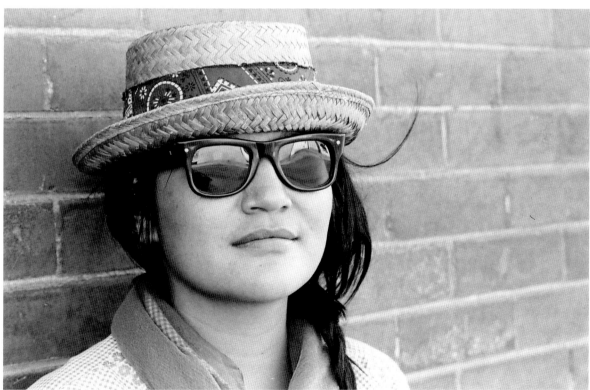

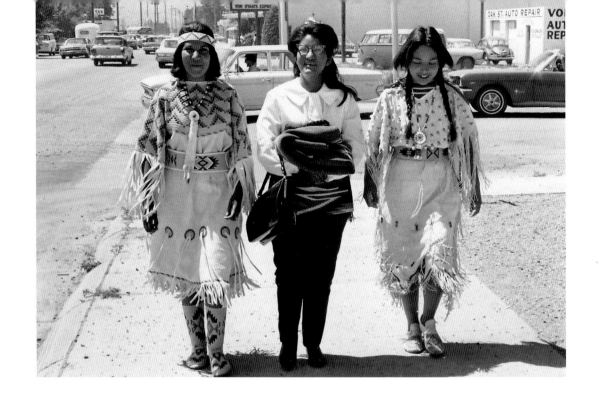

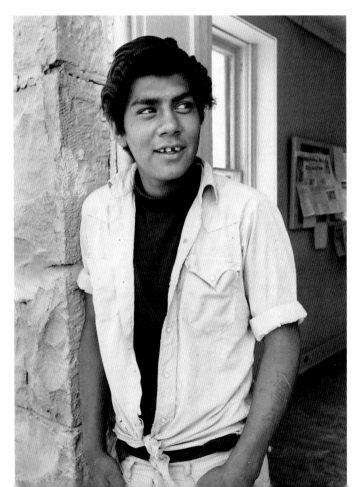

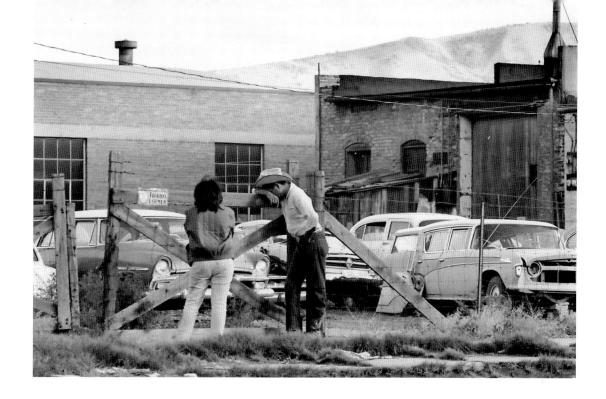

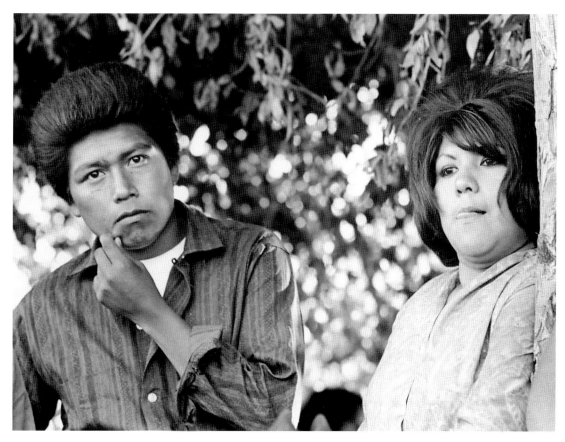

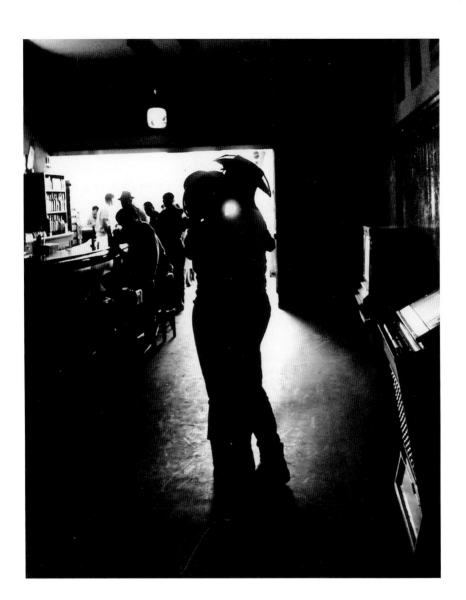

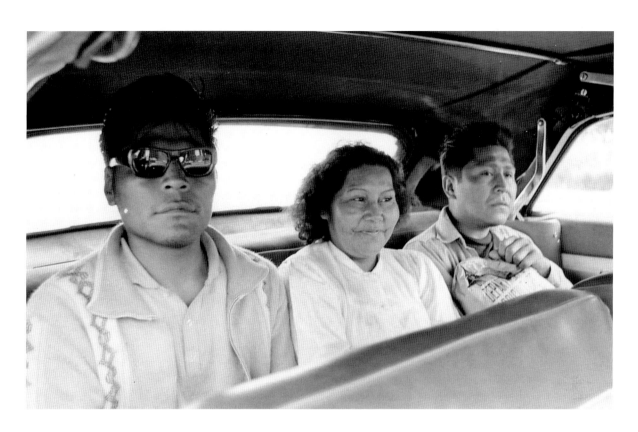

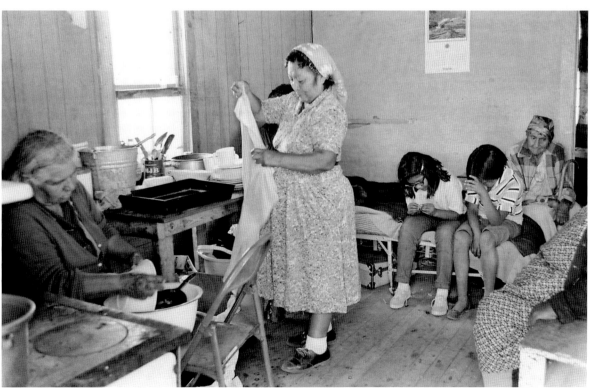

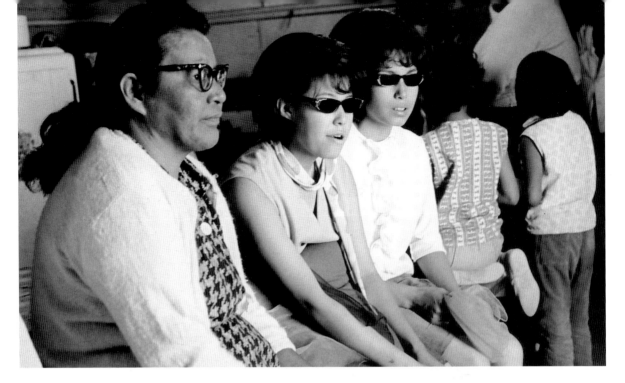

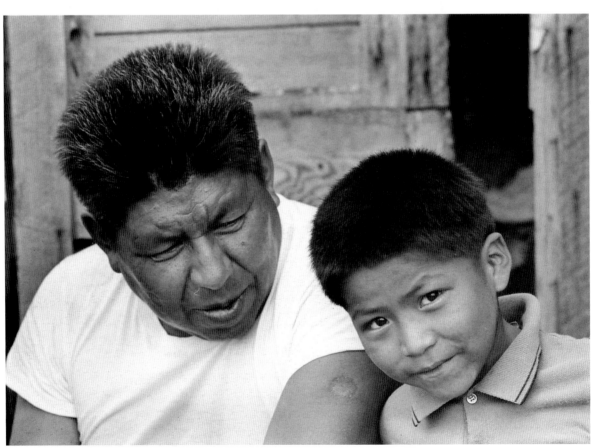

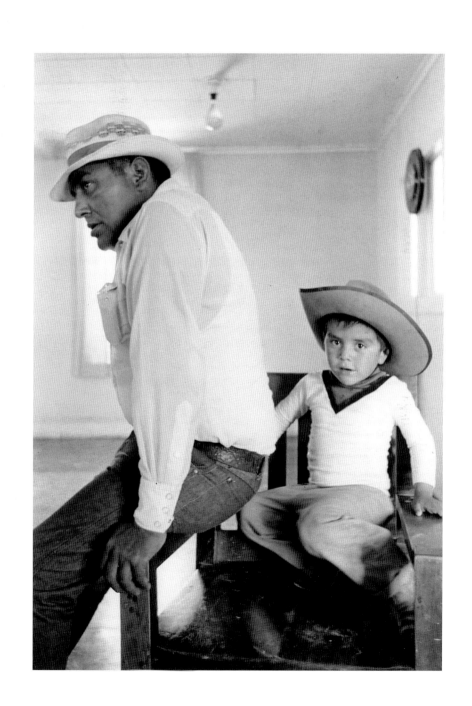

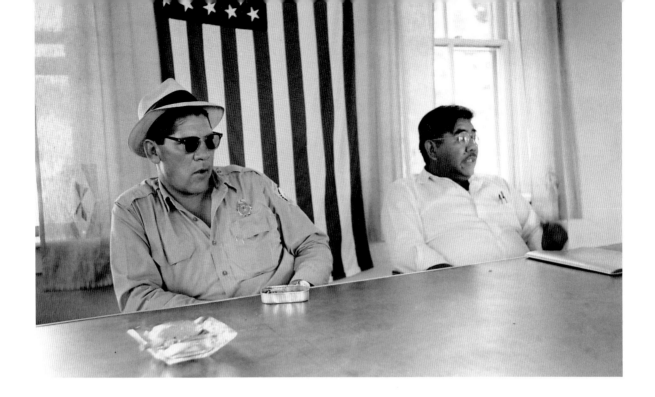

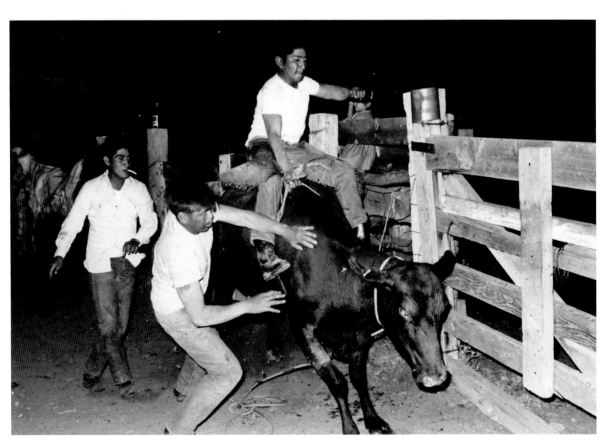

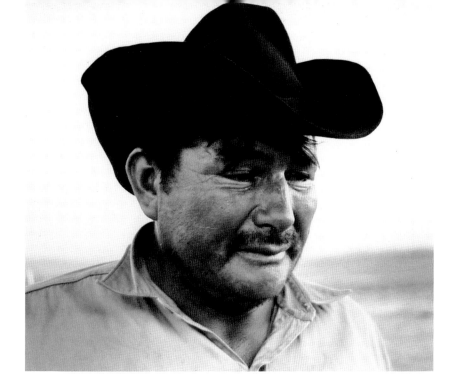
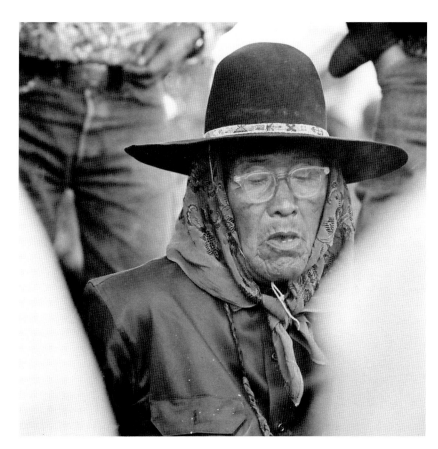

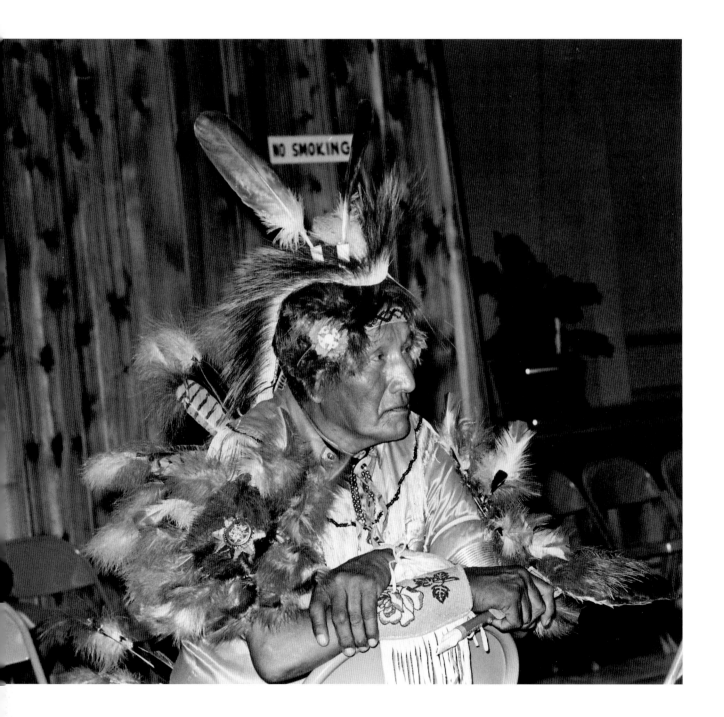

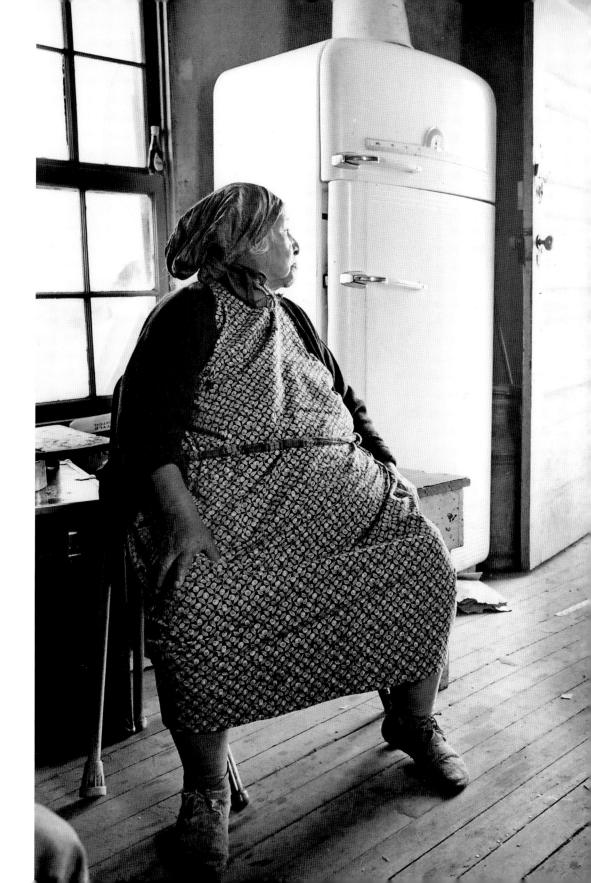

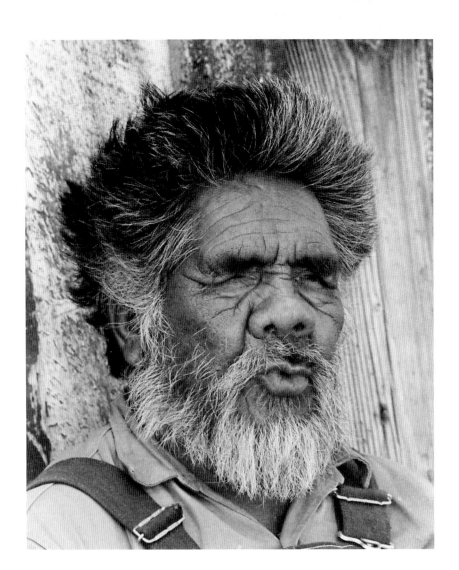

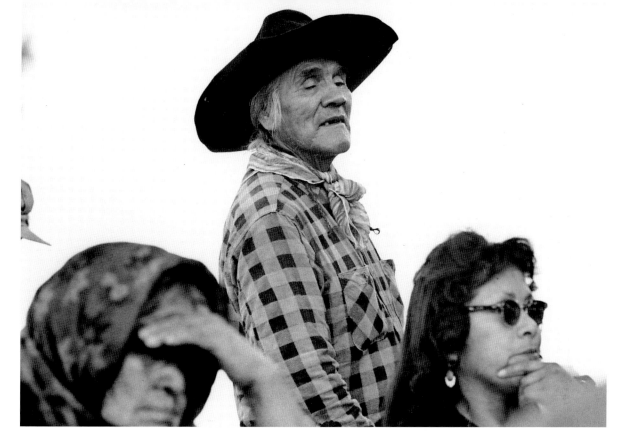

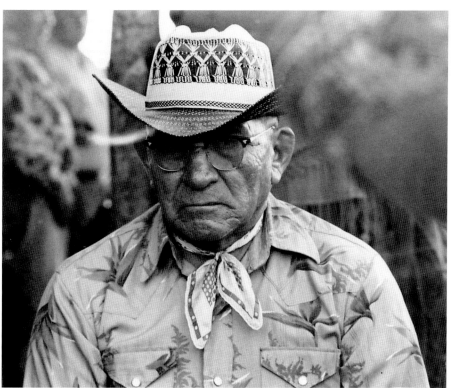

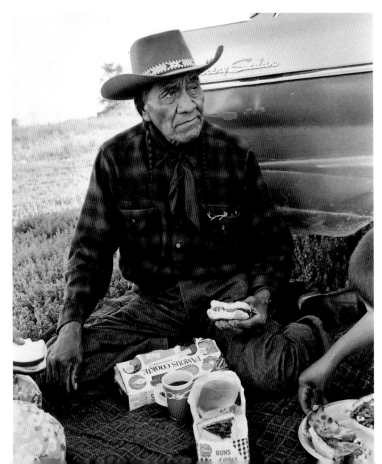

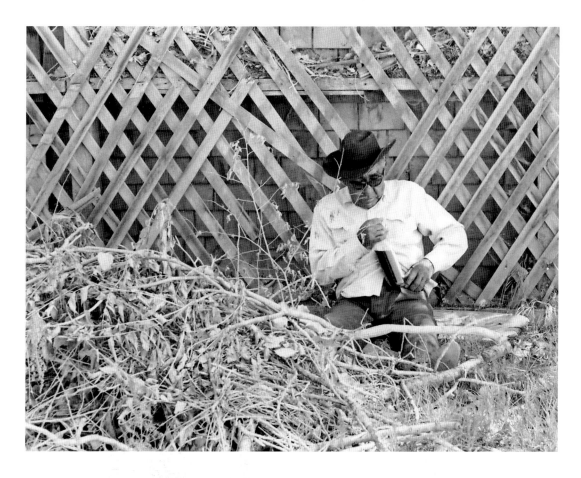

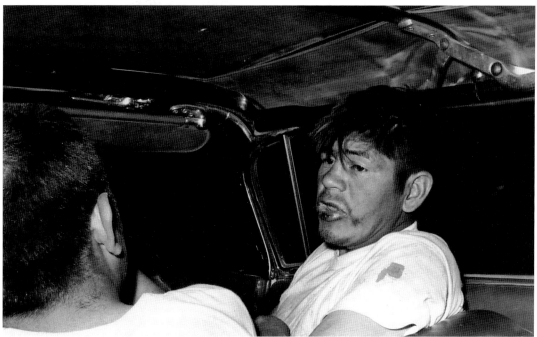

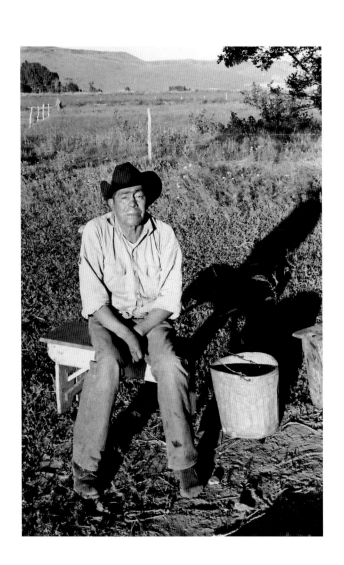
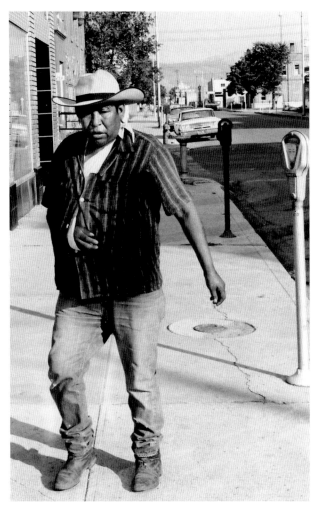

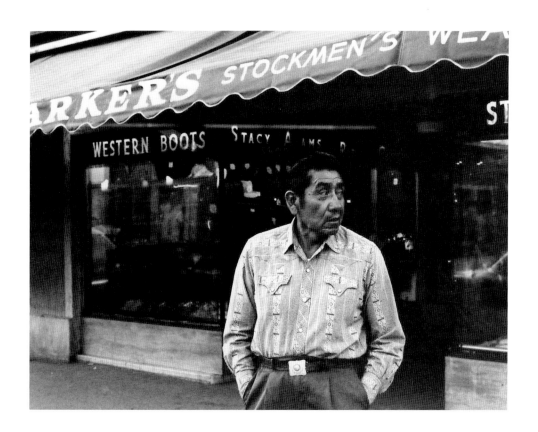

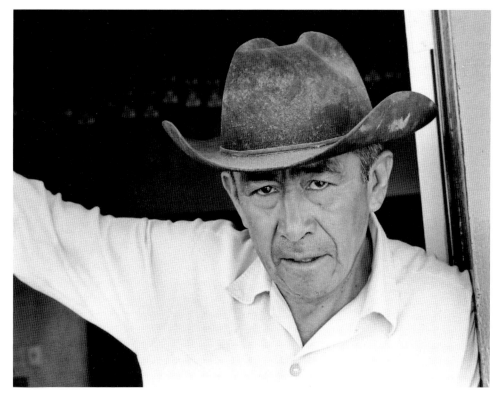

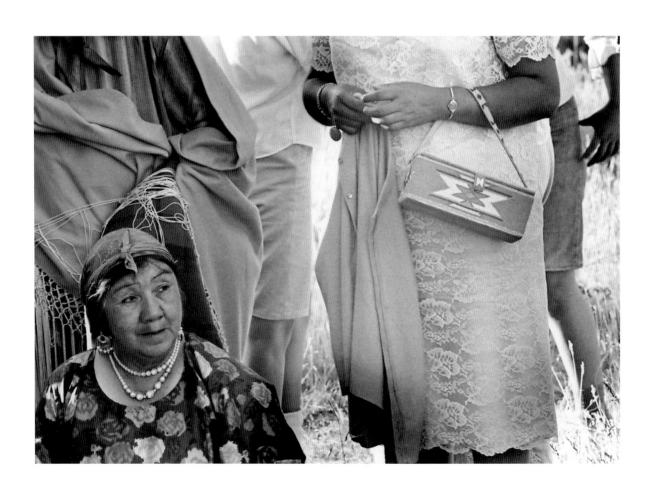

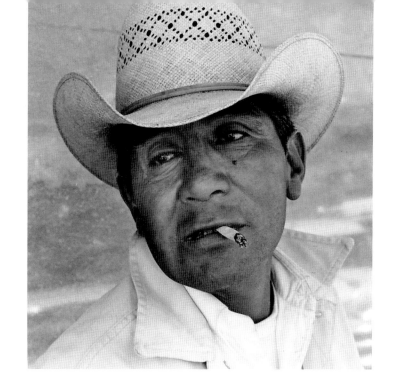

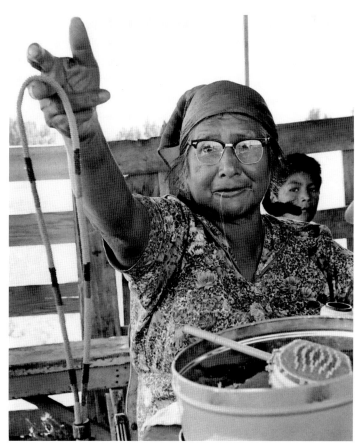

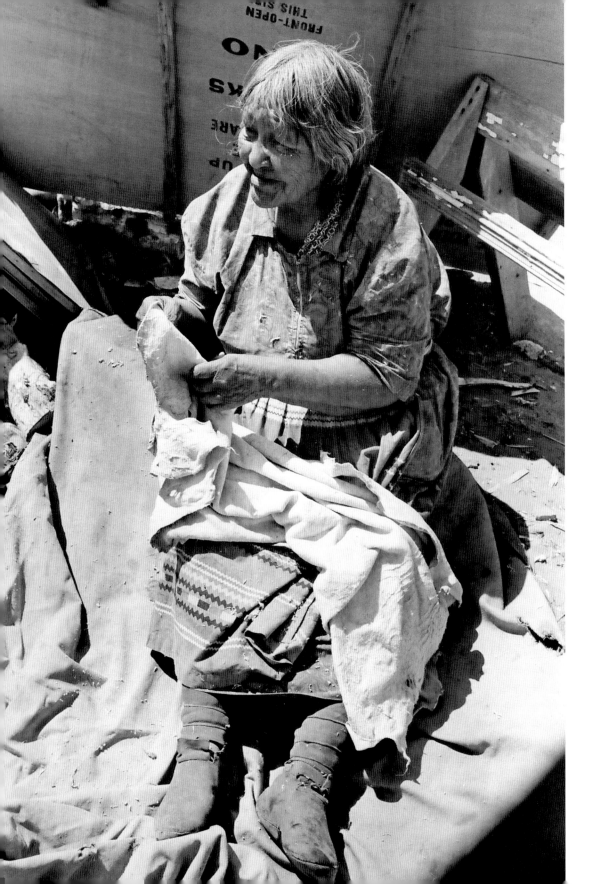

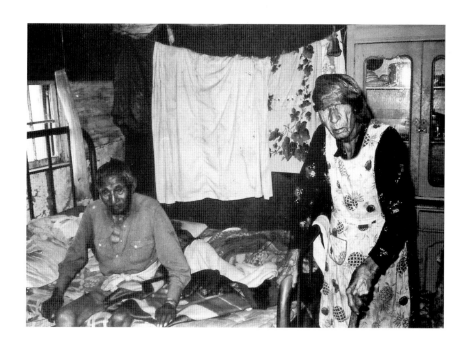

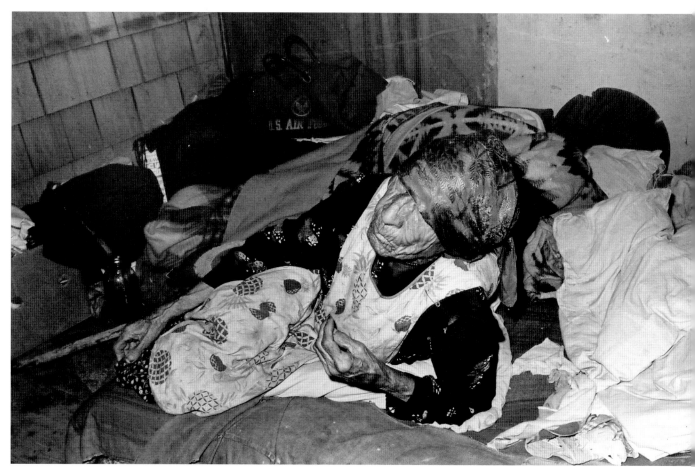

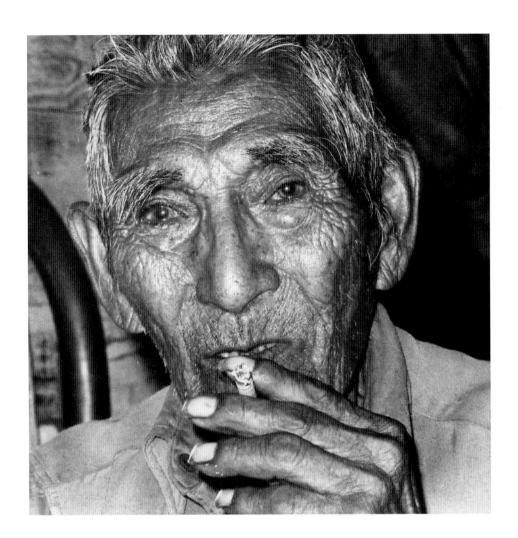

III

IN 1888, a young Paiute medicine man named Wovoka (The Cutter) received a revelation from the Great Spirit. Dead ancestors would soon come back to earth, buffalo would run again, white invaders would be destroyed. It was a Messianic movement. There were new dances and songs for the new religion. A new coming. The Ghost Dance spread rapidly across the plains. Wovoka was not yet thirty-five. He had been raised by a rancher named Wilson, the whites knew him as Jack Wilson. He had his vision while under an attack of fever when he was ill. There was an eclipse at the same time. He was a Paviotso (Northern Paiute-Bannock), a derogatory name now, considered lowly among Indians. His father had been a medicine man before him.

Affairs between the Ute and whites have rarely been good. The Ute-Chemehueve, in the Eastern Basin, had particularly interesting contact with the whites and remain a problem for the now established population of foreigners who presently occupy Utah. The Ute once ranged far and wide around the Uintah Basin and Green River and into western Colorado. Chief Walker, a Northern Ute, was plying the slave trade with the Spanish (Paiute children carried off to be sold on the Sante Fe market) when Brigham Young arrived with his band in 1847. It would be too much to say, perhaps, that all Intermontane Shoshoneans suffered by their eventual juxtaposition with Mormonism, but there is,

certainly, a long history of mutual dislike between the Mormons and the Ute. In the Eastern Basin the Ute were the most unfortunate. It does not seem strange then that only a few Indians, who were mixbloods born into Mormon families, were converted by a doctrine so zealously missionary as Mormonism. A religion of such ponderous self-assurance was bound to erode the spiritual terrain of the Indians as its practitioners' cattle and sheep eroded the hills, sweeping away the grass and seeds, the base of nutrition. One of the most unfortunate aspects of the arrival of the Saints was that, unlike the California travelers, they decided to stay. Brigham Young came around the bend and said, This is it! The Promised Land.* Exactly which deity it was so peremptorily gave away the ancient lands of the Ute is hardly clear. It was probably no Christian god. The Ute makes a careful distinction between the tenets of Mormonism and those of Christianity.[6] Escalante was in the Basin long before Young. His business, however, besides collecting souls for his god, was to see about a route to Monterrey. He did bestow a few names (The Valley of Our Lady of Mercy of Timpanogos), but they have not endured. By the end of the eighteenth century the Spanish energy had dwindled. The Spaniards were not farmers in any case and the Ute had no gold. But they were eager for conversion, it is said, and Escalante promised to return. There was a Christian mission established at Whiterocks in 1897. It was the first, and remains today the only, Christian mission among the Ute.

The Sun Dance came to the Ute probably by way of the Wind River Shoshoni, around 1890. It had been practiced by the Wind River people since about 1800. One authoritative suggestion (Shimkin) is that it was introduced by a Comanche chief, Ohamagwaya, or Yellow Hand, who may have seen it while visiting the Kiowas. The Comanche are a group of Shoshoneans who split off and drifted to the southern plain in

* "His [Smith's] successor was Brigham Young, a man of commanding ability, energetic, vigorous, shrewd, and as ruthless as a professional strikebreaker. His administrative talents were of the highest order. It is customary, in writing conventional histories, to minimize his commanding qualities and to depict him as a fanatical leader of a half-crazy people. Such a description is a thousand miles from the truth. He was nothing of the kind. In mental and moral make-up he was a sort of combination of the outstanding qualities of Jay Gould, Andrew Carnegie and Al Capone, with more than a dash of the oily sanctity of a camp-meeting revivalist. He was too shrewd to be a religious fanatic, and was probably a lifelong hypocrite without any belief whatever in Joseph Smith's fantastic revelations. But he knew the value of a collective fervor in controlling and directing masses of people."

W.E. Woodward.[5]

the eighteenth century. Toward the end of the nineteenth century the Sun Dance was vigorously suppressed and by the beginning of the twentieth had nearly died as an active form over most of the Great Plains. In our own time it has seen a revival, beginning along the eastern slope of the Rockies and spreading, with varying success into the Intermountain region. In 1870, the government interpreter for the Uintah reported bands of the Northern Ute, Northern Shoshoni and Bannock assembled near Bear Lake to hold religious rites. This was something unusual. Rumor had it that messengers to all the surrounding Indians had gone out. This was the 1870 Ghost Dance. Wovoka's 1890 revival was widespread and crossed geographic and linguistic barriers. It is believed that the Ute knew of the 1870 Ghost Dance, and perhaps even participated in it, in spite of their real fear of the dead. They were open to new ideas of group action for religious purpose, and, of course, especially to one which was hostile to the white man. But the Ghost Dance, with its function of raising the dead, recalling of ancestors, probably did not appeal to the Ute nature and so in 1870 didn't catch on. By 1890, the revival of the Ghost Dance found the Ute in an extremely debilitated condition: there had been a dramatic alteration of their naturally lean economic environment wrought by the Mormon expansion (from the original settlement into all the most fertile valleys), as well as a general decline in their life balance worked by the thousands of California emigrants. For a while the horse had enabled them to manage a wider hunting area and set them ahead of their relatives in the Western Basin, but with the reduction of large game by the passing civilized hordes, that animal of transport made little difference. The same thing was generally true in the north with those Shoshoni who acquired the horse, but by 1880, the Northern Shoshoni of the Snake River Plain had ceased to be nomads. They were settled on a relatively provident reservation and most of them were on friendly terms with the whites. The Ute and the Western Shoshoni were in grimmer country, with no well-watered Snake Plain. The Gosiute reservation on the Utah–Nevada border is on difficult land. The Ute were understandably sullen. The Sun Dance the agency so wanted to suppress was held in secret places from 1896 to 1898. The curative aspects of the Sun Dance were very attractive to the Ute, and it is said besides that the traditionalists among them were so sick of the whites and the breeds,

who were also hostile to the dance, they would have maintained it for this reason alone. So it makes sense that they adopted the Ghost Dance in 1890. How wretched the lives of those people must have been made—land grabbing (called "redistribution and resettlement"), winter famine when the game had been usurped from the mountains, federal rations held up by bureaucratic delays or diverted altogether by a greedy agent. The land itself disappears finally under a cloak of agriculture. At that moment of history the Ute perhaps thought their gods were away on other business—perhaps not. No matter how local it may have seemed, their desperation was not singular.

"But that is nonsense," you will say, "a sick man's ravings, nerves, exaggeration. No one would stop at that, and no one would take it for his ideal. Moreover, hunger and slavery are not easy to bear, and they prompt negation and breed scepticism better than anything else. Wellfed dilettantes, taking a walk for their own pleasure, of course, can create spectacles out of the Apocalypse and thereby soothe their nerves, exaggerating and distorting every phenomenon in order to arouse strong feelings in themselves."

"All right," I answer. "Let us suppose that I was carried away by the setting, I will agree to that. But if you had seen how proud the powerful spirit that created that colossal setting was, and how proudly that spirit was convinced of his victory and triumph, then you would have trembled for his pride, persistence and blindness, you would have trembled for that over which this spirit hovers and rules. In the presence of such colossal things, in the presence of such gigantic pride in the ruling spirit, even a hungry soul frequently is benumbed, makes peace, submits, seeks salvation in gin and vice and begins to believe that everything should be so for everyone. The fact overwhelms, the mass becomes ossified and grabs at any escape, and even if scepticism were to rise, it would gloomily and with a curse seek salvation in something like Mormonism . . ."

Dostoevsky [7]

Some time around 1916, Peyoteism was brought to the Ute by a Sioux medicine man and was secret until 1937, when it was legalized. But the agency and those Indians with white blood, the police, and the official citizenry in general have been anxious to eradicate it. Peyoteism is known, whatever its religious properties may be, to impede acculturation. I have myself heard an argument of a different sort from a literate Indian in Pocatello. His point was that peyote may very well be useful

22

to the Shoshoni, but only because of the distance that now separates them from their former state, which was of an accord entirely its own. That the peyote practice is artificial, only a liaison with the cosmic entity, and that there are today Indians he knows well who do not need to rely on such an intermediate to achieve union with the spirit.

My question to him was, Isn't its usefulness enough that it does allow a shield toward a world proven to be impossible, not only for an Indian but any one of the countless people who have found it impossible, or more, undesirable to accept? And then I cited the general fact of the spreading use of drugs of every kind. He allowed that, but on behalf of his own people he pointed out that they were not natively Western and had, until white contact, a cosmological sense of a different order, and while drug-taking may be a useful desperateness on the part of a troubled person in white society, it was at least possible for an Indian to regain his oneness, because the history of the split was quite short and probably not yet complete and was besides actuated by mere suppression in all its forms, true, but was not an internalized psychological shifting of spiritual power, as was the case in Western civilization. He said it is very important then for his people to work for their cosmic identities within the unaltered material of their being, without the agency of an hallucinogene. As for the use of it he had no other objection. He had taken it. His point, I thought, was that a man has as much potential as a plant and should grow by virtue of his own roots. He claimed to know one old man who had embraced all existence and could lift a house off the ground merely by his glance.

My Indian friend is unpopular in local academic circles. He is not the sort of Indian an anthropologist (and by implication some archaeologists) likes to work with. He is too insistently sophisticated about his "Indianness," which they most likely consider an infringement on their domain. The Indian the professional non-Indian likes to deal with is the "natural" one. Those Indians who are old enough to be informants of the Old Way, or those who quite willingly demonstrate, with as little fuss as possible, culture change. An articulate Indian is somehow unuseful if he has informed himself about white culture devices.

IV

A CULTURE is worth no more than the most articulate, or persistent, man in it—no matter how much hay is grown. The question as to whether an Indian society should perpetuate its ancient ways or acculturate and hence progress as rapidly as possible seems to me wholly pointless both for the Indian *and* the national convenience (which can too often be read "conivance," unfortunately).

Some anthropologists seem impressed by the cultural and political split between fullbloods and Indians of mixed white and Indian blood. And there is a general temptation to equate value, as person, with the degree of assimilation. One hardly needs reminding that this logarithmic thinking is characteristic of all American political and social thought. What you possess is what you are. It is computed from the base of what you have. *To be* is nothing. Then, of course, you can be told *who* you are. This goes for all Americans, the entire hemisphere. There are many instances in which radical Indian traditionalists have accepted into their number not only mixbloods but non-Indians. The qualification and quantity of blood seems less determinant, finally, than the conceptual alignment of human activity. This is true even on the most superficial social meeting ground.

The Paiute boy I met in Maggie's Bar in Reno knew I was a white man who wanted to talk to Indians, and I recognized him as a hip Indian, possibly a little of what they speak of as a Professional. He lived

in the Reno enclave. I am no more acculturated than he is, although we are of course quite differently deculturized. He spoke, with my obvious encouragement, of the differences, the allegiances, some old, some modern, of the Indians who come and go through Reno. There is an ancient and enduring enmity between the Paiute and the Washo, according to him, and when Washo come into town there are fights between them and the Paiute. The Paiute will often side with Shoshoni, whose language he said his people could understand with no great difficulty. He said that quite often Navaho came through Reno. He admitted that he disliked them because of what he described as their egotism, an unjustified arrogance. But he was at pains to say he felt all divisions—lingual, tribal, racial—were bad work, and one of the first problems among the Indians themselves and between the Indians and the larger world. He said he thought all those divisions were arbitrarily imposed and willfully maintained by "that shit out there," pointing along a wide arc, in the dark tavern. He wore dark glasses which he never removed, a common habit among young city Indians.

My sense of him was that he was not a progressive. Integration into American society was for him not so much not worth the effort as a silly and pointless way to spend one's life. He had the few articles technology, without much involvement, would provide him: dark glasses, a clean white shirt, hair dressing, and comb, a nice pair of shoes. Nor could I hear that he was a culturist. At least in terms you might expect of an old, reservation man. He told me he had been married when very young, and had gone from the alarm clock to work and then home to shower, eat, and then watch TV. It had been all right, as a life, nothing much either way, and since he was newly wed, the form of it made as much sense as not. Go to work, go home, shower, eat, watch TV, go to bed, etc. He seemed to me possessed of a very uncluttered and unembittered futility—nothing found, and no complicated sociological conclusions. He sat there, being an Indian behind his dark glasses, neat and fairly well-groomed without making it a point. The point he didn't have to make was clear: he was the particular Indian *he* was in Reno. No allegiances beyond what that might be. The city had forced a species of singularity on him he simply accepted. The ingredients of an afternoon. He noticed that the local economy had turned to plastic chips which were redeemable only by the casino issuing them, a transaction

interruptable at the casino's whim. Reno was once a *silver* town. That exchange was primary by definition. He saw the national currency turning into plastic, a sandwich of novel metals. Nor was he a nativist. He remarked that the Chinese-run casino down the street had successfully put the Negro community in its pocket. And who could figure out what those Chinamen were anyway? I asked him what he thought of the Chinese and if he knew what the Chinese, so present in town, thought of Indians. There was no more answer than his smile and shaking head.

Later on in the New China Club I saw at the crap table one of the owners become infuriated with a man who spoke to the dice as he threw them—Come on baby! Get me to New China, I wanta go to CHINA baby. Come on now, take me to FORMOSA! Sweetheart! I'll settle for Formosa, I's so low! The Chinaman running the table said, OK buddy, a joke is a joke, and made him give up the dice. A number of moody, small-eyed men appeared around the table to see the man out.

To return to my point: "Progress" affects the ritual of men. Who, precisely, holds the lever when acculturation is the proposition? One thing is clear. There is no such division as minority, or minority pressure. Except as a handy divisiveness. It is altogether natural that certain collections of persons, some Berkeley students, some Indians, some poets, some Negroes, etc., move according to an image outside the United States. To speak of Indian acculturation is to speak without sound. There has never been in this national soil even the seed to put into the ground. There has been movement, a scourge most often manipulated, back and forth across it, and that is all. Likewise it is natural that the right-winger dreams of Spain (although the Catholicism would choke him, he digs the tyranny) as the ideal state. That the southerner thinks of South Africa as heaven. One gravitates to the center of despair. There are Africans there too.

All contrary persuasions grow out of a superimposed division, an impediment to the real. The force is down, inward, with no return. Nativism only rarely takes a grasp on the full man as against his "individuality," what he fancies is within himself. An interesting exception came the summer of 1965 at Wind River when a Sun Dance was performed for peace in Viet Nam, whatever that means. Various minority persuasions and institutions are faked into believing there is a majority. And there is. A majority produced specifically to believe it has not been

infected by the minority—meaning the rest of the existing world. Most Americans, as well as Indians, are minority in a double sense—in the world as well as within the nation. They wait around to be told what the majority thinks. But that infamous majority is as abstract as it is inert. What they hear they often assume to be what they knew. The headlines rarely let them down. They could reasonably assume they live in the world and not in the United States. The arcane and specifically adamant policies, both domestic and foreign, of the U.S. Government are entirely irrelevant to them. But it is the *same* official force and policy that deals with Wounded Knee (1890), the Vietnamese village (1955–), and the Watts ghetto (summer, 1965).

The utmost good faith shall always be observed toward the Indians; their land and property shall never be taken from them without their consent; and in their property, rights and liberty, they shall never be invaded or disturbed, unless in just and lawful wars authorized by Congress; but laws founded on justice and humanity shall from time to time be made, for preventing wrongs done to them, and for preserving peace and Friendship with them.

<div align="right">Northwest Ordinance, 1787.</div>

V

Now we move at night out across the neo-wild West. Out of the stone-faced belligerence of Salt Lake City across the Salt toward the Bonneville Flats, over the territory of the wretched Gosiute, flee from the tightly gloved fist the people, the Negro people, tell us hangs over them in the well-planned city of the Saints, and we decide to drive all the way to Reno against the high and heavy Sierra Nevadas, then work ourselves back through the reservations and the dotted line of huddled enclaves along Route 40, the general line of Frémont–Talbotin in 1845, the Donners in 1846, and the flooded emigrant trail into the Gold Rush. The Indians of the Basin, except for taking advantage of the opportunity to steal a few trifles, watched all that go by. The Comstock Lode of 1857 brought some of the travelers back to stay.

There is an open pit copper mine west of Salt Lake City. The biggest on earth? Probably. Every operation is the biggest on earth in somebody's mind. Once I saw the Kennicott thing from the ridgepole of the Wasatch fifteen thousand feet over the Ute country, over Huntsville, across the Colorado plateau, past Ship Rock, floating to Albuquerque. Now in the blackest of night the thousand lights hover off the ground a vibration of insects, anonymous busyness has come into the desert and possessed it. The contract is a superlatively soundless hum exchanging men and materials for men and material, leveling mass to one interchangeable, the Chilean copper night is the Utah copper night, come

and go, see nothing, be nothing, on call. The valley, the flats, the Basin have come into other hands.

From the minute you cross the border into Nevada the difference is clear. The texture of the land stays and apparent differences move by every hundred miles or so. But what Idaho is, or Utah, they make clear, bitterly clear. Nevada is nothing. Suddenly you are No Where. There are travelers, it makes no difference, going either way across the border, gas, trailers, campers, Lincoln Continentals, all the varieties of new Chevies, EAT HERE, GAS HERE, THE MOST LIBERAL SLOTS IN NEVADA—and the sexual connection is certainly conscious, *everything* is conscious in Nevada. The consciousness of No Where. A corny, flashing interzone where the no man's land has been contrived to satisfy all specialty—you name it—clutched surplus expense-account dollars thrown on the table solely for the pleasure of having them snatched away—the secretary's superb bottom ascending the motel staircase ahead of you—or, if we haven't got it, we'll get it. There is no grip whatever. Not the grip Utah has on one, sticky and tenacious and above all, dreary and boring. Just no grip. Everything slides on, and on, through it, exactly as the slot machine works, the coin into the slot, the lever pulled and down through the metal bulk of the innard's casement to the BOTTOM, clink, perhaps a nickel or two, dime or two, to keep you on. Along Route 40 the dry heat is terrific. The two-directional tourists are hot and sticky in their vinyl seats packaged in colored metal. Gorgeous women crumpled by travel. Middle-aged women collapsed from a stark incognizance step out of air-conditioned Cadillacs to find themselves actually and critically in the heat of sudden sun. Into restaurants for sandwiches or more likely some dependable hamburger, which to eat is to ruminate on all of life. The total injection of a cradle-worn blandness of "reaction" leading right to the door of the next life. It is doubtful anything can die in Nevada, one crosses the border and is immediately soldierized.

The ecological balance looks to have maintained itself—hard land to endure. A storage dam here and there turning the crotch of land below it green. But the land is a sink. It turns a negative face to the sky, unwilling. And that delicate, if fine, balance the heathen had, seeds, oh where are they now? Into the gullet or crop of some hopefully industrial species. And yes, the white population more present along the roads than even their numbers would indicate, they are part of that species

too. Women driving pickup trucks, numberless, at every crossroad, a weird sexiness about them, all in tight jeans and cowboy hats, think of it, something *strong* about it, in pickup trucks—as a man I know might say, you could become a woman-pickup-driver freak, in Nevada. A very distinctive breed. They are so attractive, you stop seeing the women in cars.

And the landscape at first is hard. Cruel with bold fingers of shadows reaching out in the violent slant of the morning sun and then diminishing toward noon as the high glaze of the horizons shatters the eye. It is not like withdrawal. Then out of the noon the mass is transformed under the vast radial sun into monumental hands searching east again from where the spell came, as the reddening gloves settle on the western rim of the Great Basin. And quietly one feels in the rapidly cooling air the grave beauty of its purples, the possibilities of its fresh mesas and the rich expanse of the desert floors, the cool mat substance of the playas. An aesthetic change, you know as you drive along. The playas are still intensely hot. The mountains just as barren as they were in the morning.

It isn't that so *much* difference is made. It takes only a *little* difference in some places. I've seen women driving pickup trucks in Idaho and they didn't strike me much either way. Not so sexy as all that. Simply another harassing phenomenon of a commodity-induced behavior. And finally, after the thrill of hoping that perhaps here is every man's Amazon brought right into the machine age with four gears forward and a lovely long arm and leg, you dig this is just that tired thing in pants the more articulate traditionalists have always talked about. The frenzy of gambling, and the desert, and the stops for gas set up a pulse through it all, through what, as the day wears on, you think a more and more grimly magnificent land, and land only, to be had with the eyes only, the people are slowly revealed as something else: people. Who are not *the* people, alas. They all get around in the end to arranging themselves as some instantly recognizable thing.

The three present states of the Basin-Plateau, Idaho, Utah and Nevada, are endowed with a feel as cloth between the fingers. Nevada is singular. Southern Idaho (the plateau) differs from Utah only as it may not be said to be so *utah* as Utah. Northern Idaho people are loggers and miners: they were never very utah. I said earlier I felt Nevada

was *No* Where specifically. Since I am thinking of Indians and their present ecology, I meant: where and what is it. Leaving Shoshoneans momentarily aside, thinking of Nevada as everything else, I played with the term *neo-wild West* awhile before using it because the mentality of the West is strange and any place could mistake what gratuity the term might conjure. Given the peculiarly dramatic picture the "westerner" has of himself, one must be constantly aware of the perverse use he will make of the very terms that were proposed as pejorative, if not derogatory. Far from a resurgence, I mean it as an increasing ossification of what were originally thought to be prime virtues: 1. wide open spaces, 2. independence, 3. a special freedom from corruption (usually the imagined corruption of the "city"). Ranchland-derived concepts can be sharply distinguished from farm-. The farm boy or girl traditionally fears the city but is inexorably attracted to it and *then* follows the classic Fall into the industrial pit.* Children of the ranch mentality have been completely conditioned to see a city but have absolutely nothing to do with it, *i.e.,* the people in it. The farm is near the city and within its gravitational field, so to speak. The ranch is, at nearest, in a distant orbit. There is a firm belief in violence as manly, but more important, self-interested collective reaction. One must remember a lynching was almost always reported as the shouting of an incipient idea by one man, "the stirring up of the crowd," and the fast draw, whatever it once was, possibly defensive, is now via TV as much an assertion of manhood and singularity as one's own penis, *i.e.,* the literal extension of an extant cowboy-grown ethic of copulation and economy. The cowboy in the movie *Bus Stop* (Logan, 1956) was inaccurate. He possessed none of the innate, dynamic fascism you will find in the nineteenth- and twentieth-century cowboy character. In one respect the characterization was true: an extension of pure ego uninhibited by any hint of a reflective or indecisive moment except as a bewilderment at the possible uncooperativeness of the girl. His one great line—Make them hamburgers RAW!—was a startling dare if one remembers a typical highway restaurant. Politically the cowboy West is more interesting, of course: Wyoming has a congressman who is a direct descendant of James Garfield, or William Henry Harrison, or is it Chester Arthur? And a former presidential candidate from Arizona

* See *Intolerance*, D. W. Griffith, 1916.

31

is a member of an indian tribe which excludes from membership all Indians.

Everything in Nevada, we notice, as we go through it, is nonexistent. Attempts at agriculture are eccentric, one can see without driving off the highway. The cattle, if they are really there, hidden in ravines and depressions, God bless them, must be few; and no more satisfied with the salt grass than were the antelope. The mines, and there must still be those, are surely saving their metals for as yet unforseen wars against the guerrillas of underdeveloped areas. Perhaps that is it: Nevada is the underdeveloped ace in the hole America has to play against the under-developed world. You won't believe this—there are towns in Nevada which have no dime stores! I mean towns of considerable size, towns with a population of four to five thousand people. No Woolworth's. That's exotic. When I first learned this I was shocked, it seemed as unAmerican a thing as I'd ever encountered. I've forgotten what it was I wanted to buy there—one of those trifles you take for granted but hardly think of.

Of course one knows what Nevada is, and what's there. It is still the Basin and that is exactly what no civilization will get past. You *can* live in it, I imagine. People did once, even if they don't quite, now. That is not their fault, even if it was their choice. If the Basin will not yield to the westerner much more than it did to the Indian, neither will it yield to whoever comes next. God made some parts of the earth His own. Even the Uto-Aztecans wandered into the Basin by accident. It has nothing to do with what *kind* of people they were or are. Long before the white man came there was what is now described as a Puebloan culture, which penetrated the Eastern Basin and then died out or passed on. Once, the archaeology suggests, some Athapascans may have dwelt like a shadow at promontory Utah and then passed on to where they now reside: Arizona, New Mexico, Chihuahua, Texas.[8] Moved their language down from the north, drifting through what to us is a band of silence. Once Salt Lake Valley was nearly pristine. Early men and the fresh call of migratory birds. An entire language and the tumult it registers—a differentiation of the scoring of the earth was made there, a fluttering of the spirit we have no notion of. Not the high Uto-Aztecan configurations of Willie Dorsey, another stock—Athapascan. I don't think I've ever heard it. How do I know? I wouldn't recognize Uto-

Aztecan for sure if I heard it again. What *do* I know? Simply that men are lovely when they sing, I suppose. True enough, and whatever it can mean to me I'll have to settle on as my limitation. Each utterance is particular, that's what saves us all. We must have that. Still, the whole language calls, calls to us through the caverns and finally into where we are.

Morris Swadesh, the linguist, by attention to the glottis, the space between the vocal folds, has estimated the time between the cleavage of languages. The languages of this continent seem reduced to three. It might in the end be one art. It may already be one articulation.

I have in front of me, propped against the lamp, an old picture, cut I can hardly recall from what, an *Arts and Archaeology* of the twenties I would say. She is a Moapa Paiute girl. She's breaking up. I can't stop laughing myself. The field is from her breast up to a foot or so above her head. On her head is a basket hat one thinks of immediately as a Piman design. Crossing around in front of her shoulders comes a strap that looks like hide, and holds, sticking up on her back, a woven jug. Her hair comes abundantly and straight out from under the hat, cloche, in effect. On her unabashed dark face white swatches of clay rise where she laughs, the same strokes on her chin. Everything in the background is out of focus. Her eyes themselves are almost shut with laughing and her teeth are frankly exposed not quite hard and white enough for even such a willing onlooker as I, who can't help noticing. She has completely exposed herself. Much more than if she had inadvertently taken off her clothes. And I shall laugh with her as long as the paper holds her and long after. Oh yes, her throat is covered with white clay. She is very casually ceremonial, it seems to me. Beautiful. Fully beautiful. One day, facing the sun, she stood just at that moment to laugh. At something. Or nothing. Some part of Nevada, we call it.

You can recognize Reno even if you have never been there. It is not a language. Not even a sophisticated trick you may think yourself prepared for. We enter just as the sun's glow hangs back of the city, a luminous California beyond. Reno is a set. It comes on fresh. The lights are myriad of course but this isn't the thing—they are fresh—an electrical sparkle so wholly immediate one is pulled into it, into the turgid meatus with the cars and people. Turn left on the main street and under the arched simultaneous coat of arms and slogan, "The

Biggest Little City in the World." The photographer says, Stop here, jumps out to take a picture of a man hanging from rope so long it looks like a thread in the middle of an acre plot of sign—a blue-white immensity of lumination upon which he is fixing letters the size of himself. And I go on in the packed traffic with my right eye catching a dummy broad whose tits are each the dimension of double beds. Legs spread, she moves slowly facing down the street toward the Truckee River and then back up toward Route 40. She was intended for a colossus, and would be by herself, but the denseness of the lit action blends her effect, all effects, into one irritating sparkle. Around and around the block—guiding the car, which now seems a delicate breathing animal, into the contours of people dressed in showy hot-weather clothes. A rich blue atmosphere. Rich, not precisely white. Reno is a contraption. A contraption of energy arbitrarily set down at the westward extremity of the Basin.

One of the first tests the stranger in a small western American town has to pass is to get himself straight, if possible, with the local police. This chore is formalized somewhat for the true alien since he can register his name and business if he plans to be around for any length of time. The way past the barrier is a more subtle difficulty for the suspicious-looking citizen. It hardly needs saying that *any* irregularity one possesses is cause for suspicion, not simply the obvious signals— untrimmed hair, a beard, poor shoes, an old coat. The eye of the constabulary has been carefully trained, and besides, nearly all policemen are chosen for their essential difference from other men as well as their prime physique. And of course, the affair between the stranger and the police will be changed by the size and nature of the town. If it is an unimportant little town with shady streets, the cop leans with classical nonchalance against the barber pole and minutely surveys all transient movement through his little domain. He looks quite directly out from under the pocket flap of the richest man in town. The larger or more specialized the town, the more difficult that pocket is to locate—the connection nonetheless remains essentially the same. The famous police corruption of the very large city, the exploitation of all the points of the triangle, won't apply to the small western town—the smallness of the force governs the range and variety of possible corruption, and in turn defines the limit of police ambition. This is not to speak of what is

The Basin-Plateau

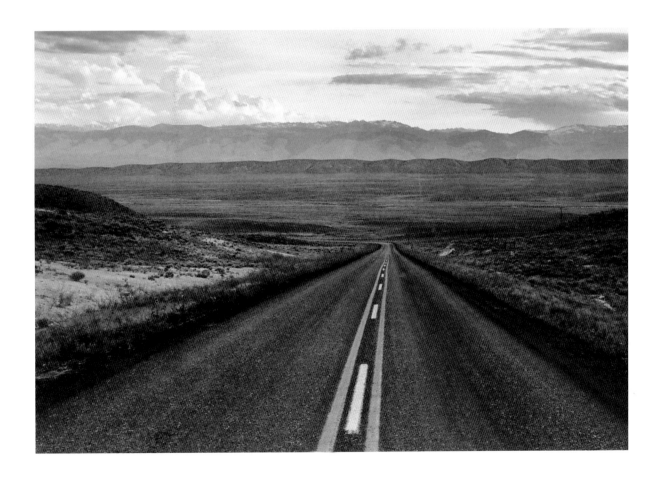

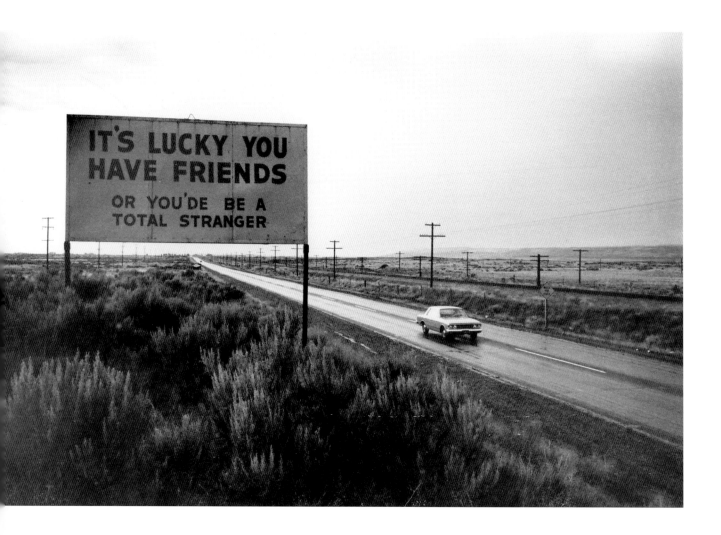

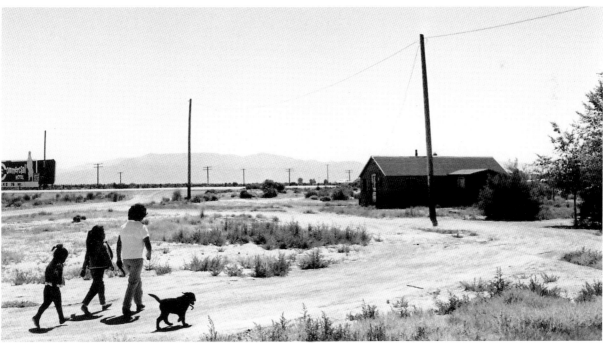

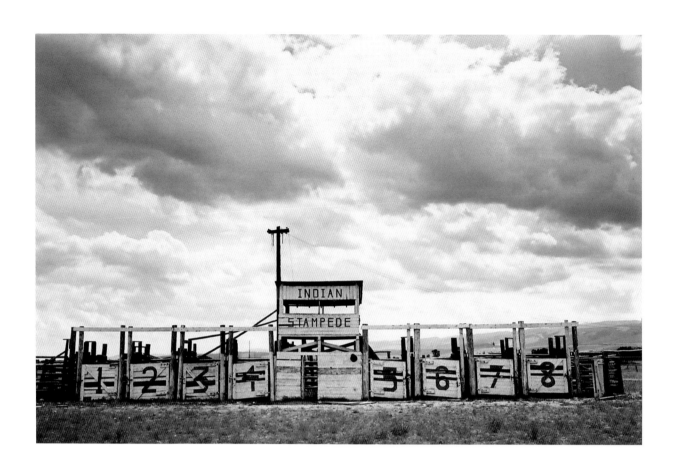

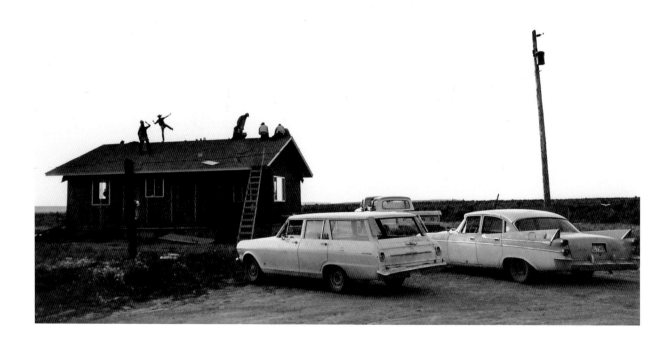

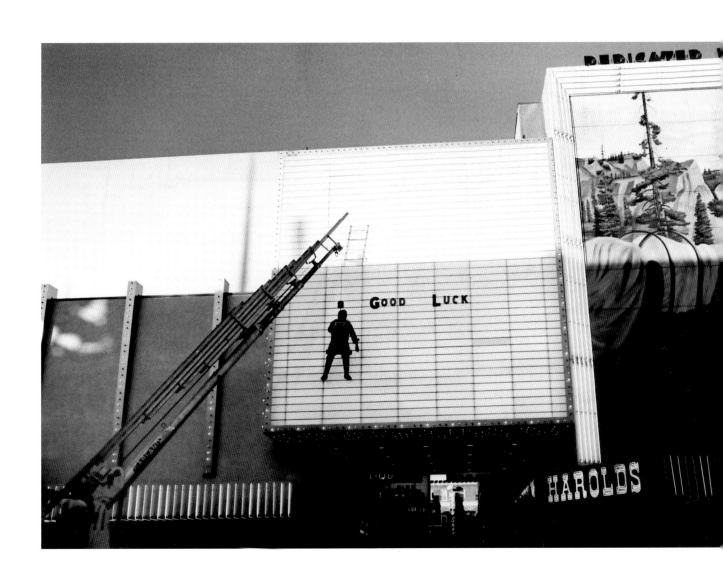

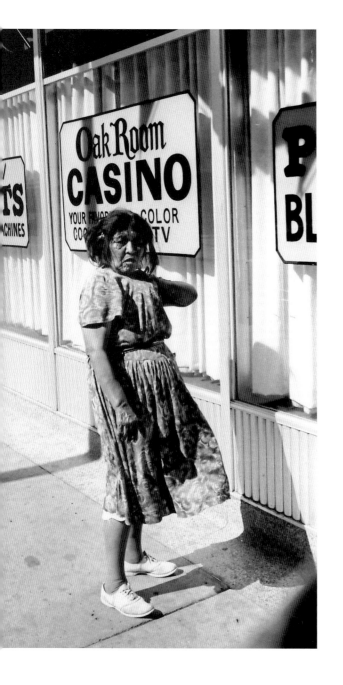
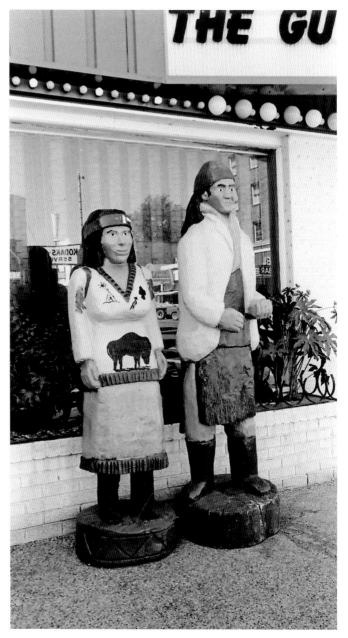

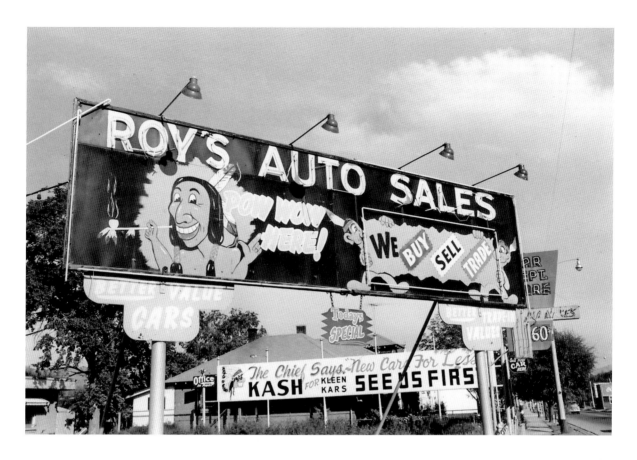

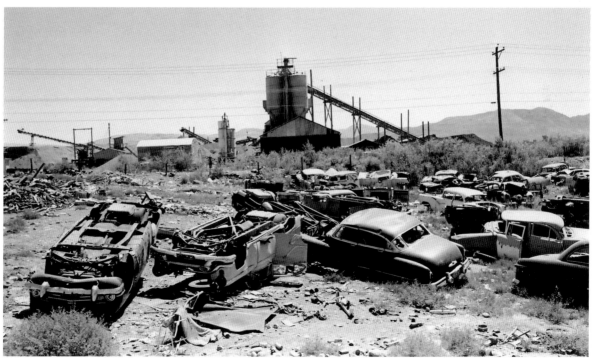

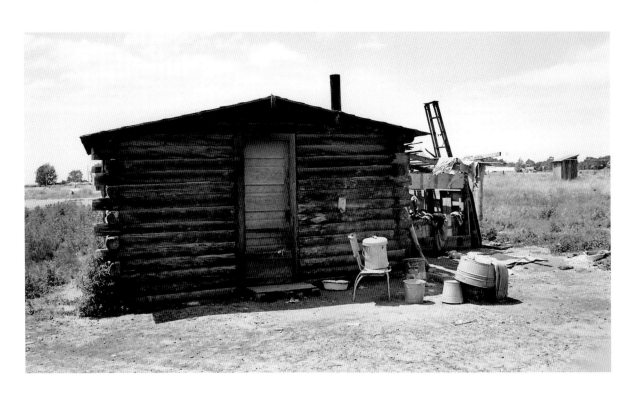

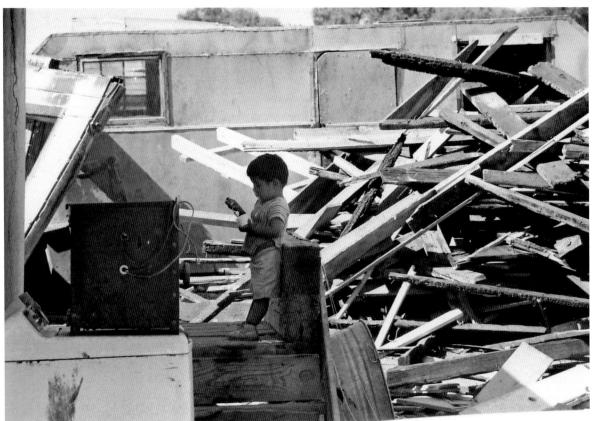

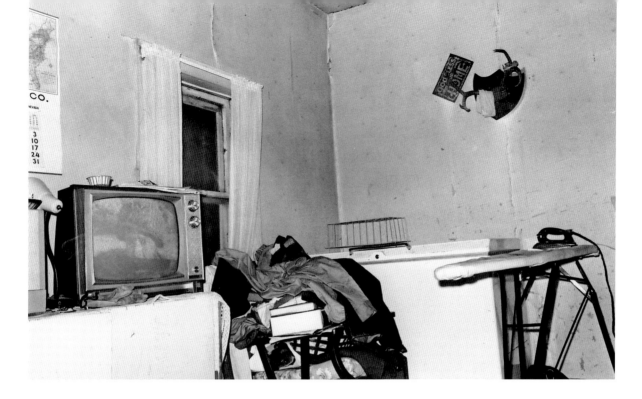

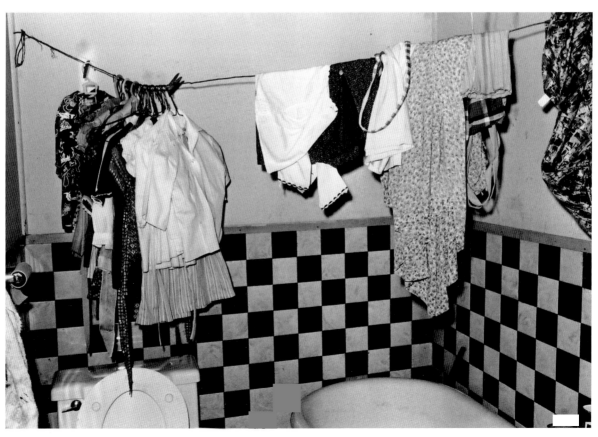

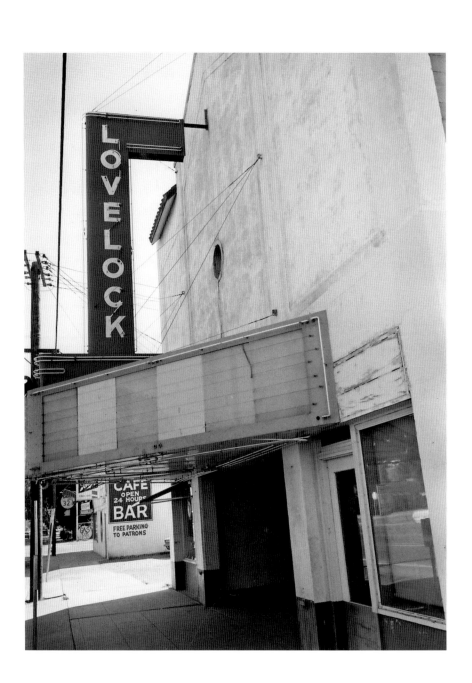

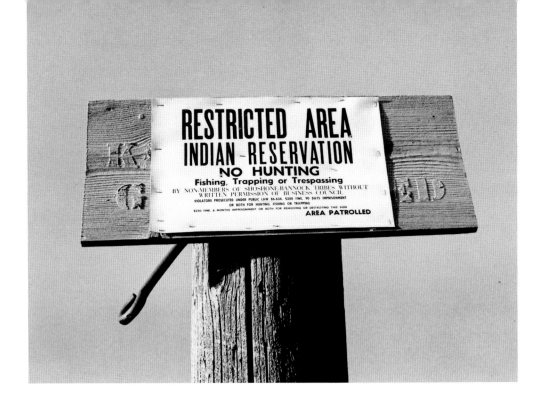

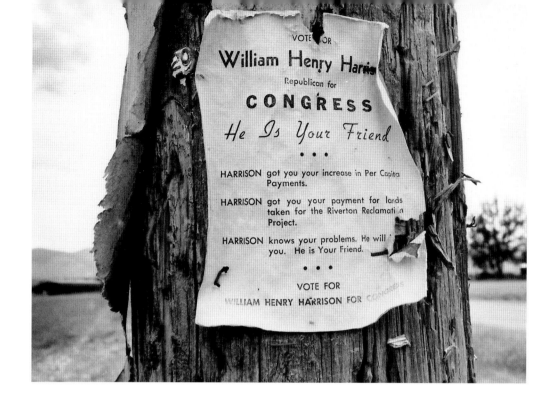

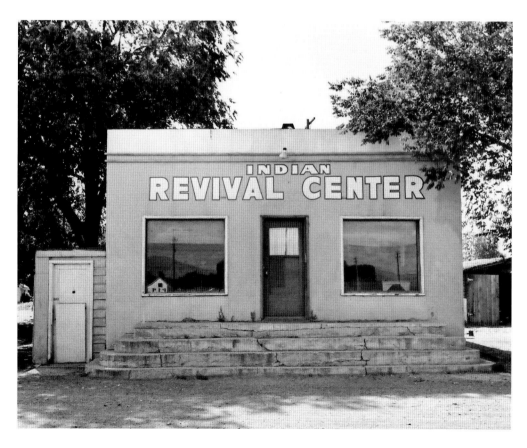

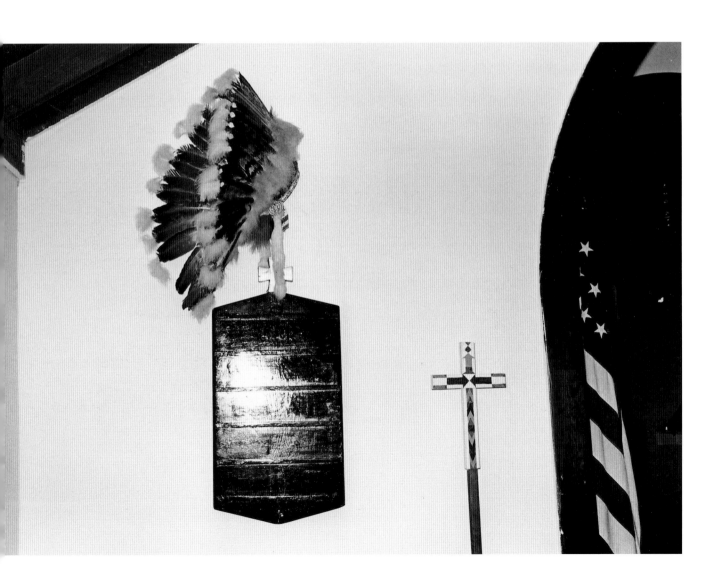

commonly meant by "crime"—murder, rape, robbery, etc. I mean the arbitrary and casual surveillance of men on the street, the estimation of the delinquency of image—the plausibility of presence, the manner of walking, the degree of assurance, the nature of any hesitation. Experienced transients know they must look like they purposely came from some place and are passing through in order to get to an equally definite further place. Even if they have nothing more on their minds than a derisive curiosity. The constable of the small town is *hired* in every sense. He hasn't much to do—the small town is called small because it is small.

"The Biggest Little City in the World," then, is both small and special, and it has a police force to suit its needs. There are of course much larger quantities of money to be guarded than in any ordinary town—every casino is, in terms of money on hand, a small bank. When we walked down the street toward the New China Club we knew we had entered what skid row Reno had to offer. We didn't know those chattering exiles had been robbed twice in the past month and how sharp that made the normally tight patrol of that area. A moment before we saw the six cops they saw us. By the time we did see them they had, I presume, stopped talking and like a reflex formed themselves into a kind of half-ring, a moving striped-trousered cul-de-sac which quietly and dangerously closed. We moved almost gently into it, until we stopped, our backs against the wall.

We had been cool. At the first tightening apprehension we warned each other. Without a flicker we had considered the alternatives to a run-in with them. We knew there was nothing to do but continue. We came to a stop, inside them, near the door of a small bar. Inside were Indians. We had almost made it.

The Police Face assumed a kind of deadly watching—open, methodic, scrupulously indifferent, paid. They wore pearl-handled revolvers, unstrapped in open holsters; and that one piece of western phenomenology was rendered largely academic because we were not similarly armed—thus, deprived of the theatrics of The Draw, and since the sun had already set, the routine question came forth with drab predictability: *Where you boys from? Oh—new in town eh—Uhhuh—Well, let's see your identification—How long do you figure you'll be stayin' around here?* One cop who seemed the largest of them, and slightly older,

looked at our cards and papers with ostentatious deliberation. *You have a driver's license Leroy—you say you don't drive. Well, which one— oh yes this is your driver's license Ed.* At each answer to each question there was a sort of implied, involuntary jerk from the rest of the semi-circle of cops. It was a sort of exaggerated dream, half funny to see them ready, any second, to draw. A synthetic sobriety in the air and in my own intestines there was a painful hilarity. All the while one knows that to laugh, or even to suggest a smile, could be to die. Naturally one's face must assume an idiotic mask. *So you are a professor, that right Ed.* He separated papers and handed them to us. *That your camera Leroy— Looks like a pretty good one—you two travelin' together eh—Well, I want you boys to know we run a clean town here and we keep the streets in good shape—if you're gonna be here overnight get yourself a room, no sleepin' in the car—and I think it'll be a good idea if you stay away from the casinos.* The arc of stony faces pulled slowly to the side and we moved slowly, but not too slowly, on. It had to be just right, not an inch this way or that, only the exact amount of relaxation was permissible, none but the precise degree of relief and insinuated thanks would do. As we walked away our backs burned with the expected entry of some foreign object. Either one of us alone would probably not have attracted attention. But two men, one dark, one light, new in town and road-weary as we were, could hardly have got by for less inspection.

It was something special in the look of the place, something special in the eye of the clogged transience of the street. Everyone in Reno, no matter what his apparent business, looks intently at everyone else. If your business does not come under the several categories they've provided, then you'd better have a disguise which may be no more than the correct dress. You can play the slots, which are all advertised as "the most liberal," you can be at the crap table, or you can be at the roulette table. Outside that, if at the exact moment a seat at the bar is vacated and you can get to it, then you have a place to be. If you walk in off the street, you have to calculate where you can be if you stand still. If you want to pass through, you can do that but each hesitation is re-corded somewhere, beyond the thousand-deep throng, the step is the measure. It is dangerous to look like an observer. Persons with expen-sive cameras and lenses are asked to keep them holstered. There's always the chance that the man in the gray flannel suit might get caught

off base, next to some well-stacked infielder, by a free-lance photographer or blackmailer. A slow dance into ruin.

Unquestionably, some men and women go away truly broke. But the majority must be there to satisfy their curiosity about what they think is glamorous. They're not gamblers. For them Reno is an amusement, no matter how perverse that may seem. The rich probably gamble more seriously because they have a more sophisticated appetite for money, but unless they become hysterical, which must be rare, they can afford their losses. If you ask you can hear the standard legends within minutes after arrival. Some fabulous owner descending from his Danish modern office, passes directly through the crowd in the flair of his business suit and power. He implores the college boys who have a system and have won ninety thousand dollars at the roulette table to quit while they are still ahead, and they, rather than taking the advice of this obviously knowledgeable benevolent, don't. They keep it up until they are down to eight thousand dollars and in a sobered gesture of defeat, quit. Alas. They were warned. One can't win at gambling, the odds belong to the house. Everyone admits that. The management is the first to warn of it. Somehow everything is clean. And if you are hopelessly co-operative enough to bring up the business of cheating, that, in one breathlessly waited-for moment, is waved away as too Bat Masterson, too Frank Leslie-like. This is a business like any other. Not to have understood that from the beginning makes you a nuisance.

The atmosphere is distracting enough to keep you from the Indians, momentarily. But they are there. Up on the main drag they stand around on the corners, singly, or you see an occasional couple walking along. Until you catch yourself with Why shouldn't they be here?, you might wonder why. What do they think of it? Perhaps they see it as simply a more intense multiplication of what they always knew. After all, their problem is gone in that sense. They are singular. Once in a while though, on the street, I remember it was a problem separating them from the effluvia they moved through. And I remember thinking, Why should they be separated? They are here as much as anyone else. It was hardly a problem of *them* maintaining *their* recognizability.

Along the few streets devoted exclusively to casinos (and it is interesting how the high, gaunt, black altar of the Bank of Nevada stands astride the two main thoroughfares) pass the transient tourists in short-

sleeved shirts, the women in slacks, the too-young people nondescript altogether. No children. They come, some of them, with their hands in their pockets, thinking they may be outsmarted in such a smooth-looking town, some of them possessed of a slick self-confidence got from having been there before, maybe once, and most all of them dig right off they must pretend *something*. They needn't bother. Reno is sharper than that. Those people's necks have all been exposed to the sun in their simple-minded endeavors back home and Reno knows that. All Reno knows that. Reno knows all.

From the merest dishwasher who dreams of that money to the coolest investor who has been careful enough to hide behind the lights which spell with blinking regularity, HAROLD, HURRAH, etc., up, and down, across the plaster tits of forty-foot-high monetary angels. The thing you do not want to do, unless you are a hick and it is tolerantly understood by the locals as natural for you, is look. Because you will be looked back at, and the next question is price, which is high I was made to understand and varies upward according to what sort of gig you have in mind—what's your particular perversion. And at first, as you walk along the street it seems any rate might be fair. But it all has the dull ring of business and those chicks one might dig anyway, because who isn't a rube, turn out to have work to do and don't want to be just looked at—they mistake that for a signal and are understandably chagrined at any waste of time. They are so got up they draw your eye. I stopped looking altogether. But that leads directly to boredom.

The alternative is the muscular business of the slot machines which were there all along. Batteries of them fill the gaping mouths of each casino. Try to ignore them. A distant hum and then a roar, once you hear it always in your ear. Thirty or forty deep. The crap tables and roulette wheels are beyond, and deep inside is the entertainment—some incredible jerky song and dance act most often (the big names are on the floors above where it is more difficult to just walk through). Along the sidewalk in the meantime the people pour out of their just-parked cars, or stream into the main streets from parking lots one is surprised to discover charge only twenty-five cents for twenty-four hours. The easy preliminaries are almost obvious.

As the drones of oblivion the slot addicts stand pulling the levers in a rhythm imposed by the machine. It can be done swiftly, there would

be no point to it otherwise. But not too swiftly. Lulled, they fall into it. The most masterful device of the machine is the timing. It is careful to be prompt so the patient's eyes do not open but it also knows that unwarranted speed or an irregular span are irritants. So the three wheels go, the second following the first and the third the second, under the glass, the smooth control of sequence, fruit appears, cherries most often, then a few coins fall out of the vent below. Bars and bells are what they want. There is a town on the Nevada–Idaho state line, just south of Twin Falls, called Jackpot. People from Idaho understand this special enclave is designed to receive their money. They take it there. When the jackpot occurs, so to speak, the coins do not fall out the bottom, as you might think, to be scooped up and put proudly into your pocket, the weight of it all very tangible. No no. *If* you get a jackpot, and it seems to take a long time and a lot of work, *i.e.,* pulling, a stem of plastic on top of the machine lights up and a bell rings. An attendant comes promptly and gives you paper money, seven dollars, or more if the jackpot you won is more. And there are variations. You may play a machine with four spinning wheels. It may show spinning watermelon slices. Or playing cards. Dice. There aren't too many devices that can be used.

The din from the machines is always in the air. It spills into the street. It gets back of your head, a tumor the X-ray didn't locate, they thought the trouble was in your feet, nobody seems to know what you're talking about, sometimes you can't hear it yourself, and then suddenly it was always there, an obnoxious hum, all the time. Within the general buzz it is never loud. Reno the organ functions, the balance of alimentary intake and discharge is maintained. Julian Steward says the one word that most describes the Basin Indian culture is "gastric." That's a simple necessity to understand. Perhaps this "Biggest Little Town" is "gastric" in another way. The people dine on the seven courses of human debasement starting with furtive concentration and ending with retouched images in a stemmed glass. Shortly thereafter they evacuate nickels. The bulk of the diet is nickels.

At some distraction, a professional woman usually, one turns from the din, only to realize it follows, carried in your ear. It is on the intensely obsessed faces of the California women, sometimes working three machine at once, that you settle. They never tire. Long after all

39

reasonable workers, prostitutes and dishwashers, have gone to bed, at five o'clock in the morning they are swaying before the machines, pulling, pulling. Some slot machine types have a controlled cast of facial muscle altogether unlike the laughing picture of my Moapa girl.

The reservation is profoundly attractive suddenly. Along the banks of the Snake at Fort Hall the birds fly up, the Indian ponies stand with turned heads, the old Indian woman governs her circle of bright-eyed children and sleeping dogs under the shelter of cut aspen boughs. It is another time altogether. It is not so simple a difference as place, or the easy excuse that cities are bad, the country is good—men once built and lived in beautiful cities. Maybe it is only because you can hear their songs, and you can't in the noise of other places. But I don't think so. Why not admit that a people infuse the ground with their own particularity, affect equally with other animals the outward style of landscape.

Paiute Reno is a daydream. The settlement is along one clay street with several score propped-up wooden houses. To find it, just look for the most hard-pressed neighborhood and that's it. The other side of the tracks? Isn't that where you instinctively look? And if there aren't any tracks? Then the town is too small to need them. But nobody needs track. That's old-fashioned. That's the depression and the pairing-off of debilities, foreman of the W.P.A. (down at the mouth boozoise) here, the shovel leaner (the perennial poor) there. That's a very out-of-date key. Now you tell by the automobiles. You understand, the most hopeless man you can conceive has been awarded an automobile. In this period automobiles are the dead bodies of industrialization. We have automobile graveyards. I'm not talking about the man who can get a car and pay for it, wash it, polish it, push it, fix it, screw it, etc. I'm talking about a class of men, of several ethnic conditions, who simply and naturally enough feel safer in a car than on the street, exposed. So they have a car. That's not why they are allowed to have one, however. They aren't "allowed" to have a car at all. There are simply so many cars they can have one if they want. Old uninsured ones, nearly worn out. The very last legs the machine has. The signs of a really rich technological society. The last man in it can have a car. Even if it will barely creep. It seems useful for everybody. An old, dirty, rattling car. It can be heard for miles, heard differently, of course, than the hot rod of the dentist's

son. The hard, tight muscles have long ago relaxed their grip when the Indian gets the car. Everything is loose and bangs about. Bam. Everybody has to walk now. Or Blam! a tire. Oh the balding tires! It's a real menace. Once when I went to get insurance for my own car in Pocatello, part of the insurance salesman's routine was to assure me that the rates would be lower if the area were not so overrun by drunken Indians in "unreliable" cars, who "cause" accidents and because they are "wards" cannot be sued and therefore, etc. My smile was hardly sympathetic.

Indians in cars look. Have some special look, on their faces, part of the whole aspect, the car bearing its occupants along the road, down the street, uneasily shifting into a filling station. Round Indian-child faces at the side windows, their full brown eyes moving past the earth. Held on a lap, perhaps standing on the floor of the back seat. The young girls most often under an amazing quantity of bouffanted black hair. And the manner is passive, straight ahead. They don't drive fast. Their speed on the road almost the same, relatively, as on the sidewalk. And the impression is rather the same every time, the short trip must equal the long trip. I mean to say it could be the form of migration, transferred from the horse and travois or from the community moving on its legs over the terrain. And that it is passive, as the difference, the fact and nature of the automobile—you sit. It is difficult to keep from yawning. The enclosed ride, the nodding mechanics of the springs' affair with cracks and tar strips.

This is not the scrupulously white Indian. He looks like the counterfeit he is, in Texas or Oklahoma or Nevada. I mean the dark Indian, inwardly dark, resting behind the wheel, a profile of expert dishevelment. Long hair from under the felt hat, impassive eyes on the road, just *going*. The engine is out of tune maybe, at the stop sign you can hear it, near expiration. The inside packed with people. An old woman, head wrapped in a blue bandana, in the back seat silently, slowly, drawing on a cigarette. Sometimes a very old culturalist sits in the front beside the driver, his tight braids caught on the ends with narrow strips of cloth.

No standard look, though. The old ones all have their difference inside their routine. In Blackfoot, Idaho, I once saw an old Continental of great singularity. He was in the back seat. The shaky conveyance moved down the street. His dreaming eyes straight ahead, a mood of

uncorruptible fixity. From under his black unblocked hat which had a beaded band with a silver buckle, a black cloth came down around his beaked face and under his chin. His eyes were in residence behind dark glasses. His arm, in the sleeve of a suit coat, lay on the ledge of the open window, there was a brilliant ring on his finger. Such innate style. My God, I said, he's beautiful. Awesome, his inflexible person born along in the acrid traffic smoke of this absurd valley town. Every second-rate vice of it so pitifully exposed at the elbow by this old man's presence. That town, those people, the hammering uniformity of its renown inelegance. Magic. The first rule of magic is style.

The point is, you now look for a collection of unusable cars. By the location of those corpses you can find the people who used to be across the tracks. And if there are tracks, they may be still there, but in the West the edge of town is more likely. The unusual thing about the Reno ghetto is that they have gone all the way. They have dug out a burial pit for their cars. I didn't see such consideration anywhere else. I don't at all mean to imply they were forced into it. I have no idea why. But that is where they toss the bodies of their discarded cars. Down into the pit. Or, wild thought, maybe they get those cars they know to possess one last breath pointed in the direction of the yawning chasm, start the motor and jump out. Over she goes. Most of the cars look as if they had been merely shoved in. In any case, the sign of where the poverty is located is the dead car. If you see a man working on the car, head under the upswung hood, *i.e.*, trying to fix it, the man is "white," it's a "white" ghetto, whatever color that man's skin. He has bought the package. When an Indian's automobile fails him he settles for that generally. It stopped.

To get back to an earlier question, What *is* Nevada now that it has become a state: where and with whom does the Basin Indian live? It seems perfectly clear that the California emigrant, as he moved across Nevada, was so anxious to make the last awful leg of that journey he dragged the place with him into California. Across Donner Pass. Few of them made it all the way to California—they left the most vivid effort of themselves in Nevada, mumbling like idiots as they stumbled across the salt expanse.

The present ecological reality is surely rooted in metal, the influx back into the state that meant—Virginia City, Bonanza, etc. There is no

evidence the television Cartwrights (cartwheels) by their high-bonded and self-righteous dealing with the transients who cross their land are not the ideal moral picture of the quality "native." Looming over it all is the mass of the Bank of Nevada in Reno. It is fifteen or twenty stories high, out of sheer spite. It's black. You think that evil? It is, of course. But the color doesn't make it so. They chose a predictably fashionable flat charcoal, something you could wear. Could a structure be more clear? You can see it from anywhere in town. Any time you look up. Isn't that where it is? Don't some of those Black men down at the Chinese casino think of that building as groovy? Aren't there some progressive Red men around with some of their *money* in that bank? Aren't we just kidding ourselves when we speak of Indians, or Civil Rights, Justice via the courts, like due process? What do we think we mean? And when culture is brought forward, like a pizza on the tray, whatever combination you want, that's *really* loading it! You know what—I'll bet you money there are people in Reno who are "interested" in Indians, dig their folklore and so on.

As to the look of it, the Reno Paiute enclave is neither here nor there. Of course it is a slum. The two- or three-room wooden settler houses moved from the reservation into a city context. An increase in the quantity, and maybe some difference in the quality, of dirt. Poor, certainly, and life from birth to death a needless cramping of the spirit, a needless cutting at the vision. But after all that, theirs is finally, as the world goes, not the worst lot. It would be a tedious, difficult task determining the worst lot in Reno.

It is the ghastly dullness of Reno that is harmful as a severe injury for a people primitive differently from the sleek Californian who comes, another horde out of Asia, across the border to test his pent-up apparatus. It must be for the First People some ultimate wear and tear on the soul. Those injuries are hard to calculate. One cannot say, really, what it is even if one can say for sure *where* it is. Something choking. The obsessed and cruel dreaminess of California women pulling, pulling off the machine well into the vacant hours of the morning just before sunrise, waiting. Pulling, pulling.

And as you leave this "Biggest Little City in the World" (or is it some other place, America perhaps?), you may think of the townspeople, all of them, those who have to rise in this Baal to cook a meal, wash

dishes, or tend a baby, see a man off to work. A dirtying of what were reasonably true domestic habits. Everything made service to that streaming, horrifying dead-faced thing. Think of the townspeople, if they may be called that. The Chinaman, worried, and well he might be, about where he came from, the Negro, holding on in that little desert rathole at any cost, the Indian trying to remain obscure in his birthland so he may avoid the heavy shoes of the Reno police. The saturation of the atmosphere with money, or only the inclination it proposes, sets up a tension. One goes down the alley (some of which, by the way, between the casinos, are carpeted) as the safest route. The innermost bulb of the onion.

VI

And now, "back east." An important cultural direction for a white American. The westerner looks on the eastern United States with a derisive suspicion. At the same time he expects it to save him from what he fears: the dark, unAmerican forces of the outer world. Pop-sociology tells him his "history" is in the East—the arrival of those dauntless wretches in the Mayflower, Ethan Allen's simple-minded lament that he had only *one* life to give for his country, and the Constitution, which, in spite of the First and Fifth Amendments, he understands will protect him from rotting teeth and smelly armpits.

To Pyramid Lake. It is thirty or forty miles from Reno. East then north. Some old maps show a Lake Winnemucca (named for the Paiute chief) alongside of it, but that was drained in the forties and is now dry. A stark moonscape—vast vertical stacks of tufa rise away from the floor of the dry bed.

Pyramid Lake is immediately west of the dry lake, over a low range of mountains. The road north is a black ribbon going into the desolate stretches of southeast Oregon. Toward the southern end of the lake, more on the eastern shore, three pyramidal earth masses stand on a single base. Pyramid is a natural lake, nearly thirty miles long. The waters of the Truckee run through a green slash of valley into the shallow mud flats at the south end. Since it has no outlet, the water in Pyramid Lake is slightly salty. The Paiute woman at the trading post

at Nixon told me that the water contained borax and was no good for irrigation. The main Indian settlement is strung along the Truckee River from the lake to Wadsworth on Route 40, about eighteen miles south.

We arrived at the lake in the afternoon. It was hot but there was a coolish breeze by the water. There was an Indian family downshore, the children playing. Lucas went to photograph them. I decided to go swimming—the water was fine, not at all cold. Upshore from me a white boy and girl had a blanket spread, transistor radio, towels, oil, they rubbed each other and so on. All the portable complement and paraphernalia of the pop culture, an instant fold-out microcosm. But there were hardly any people at all, an occasional car passed up on the road to Sutcliffe. It was quiet and restful and great relief. A sandy shore. A sort of tall, soft water grass blew in the breeze. All around, rising high, the barren hills bore the accumulating shadows away from the descending sun. Far across on the eastern shore some breasts and points of land dull orange. Back to the south on a high bluff stood a large building which, I had noticed when we passed it on the road, was abandoned and had suffered some systematic wrecking. I supposed it was the ruin of an unsuccessful business. It contributed to the loneliness of the landscape. Nothing could endure here, unless along a river, or as a nomadic fact moving across the hills. And it was even more a stark relief to see that obviously unsuccessful endeavor. The breeze, the magnified serenity of the mountains in the setting sun, the presence of the Paiute, unseen along the river under the dark cottonwood groves, the imagined softness of the leaves' rattle in that same wind far across the lake. And, lingering faintly, in my other ear, the tortured acoustics of Reno. The air felt cold when I came out of the water to dry myself.

Not quite half way up the western shore of the lake is the place called Sutcliffe. It is difficult to say from the impression that night, but it looked a collection of a dozen or so houses. Perhaps there were twice that. It was nice and cool. You could hear the water below. The place felt "resorty." The bar seemed to confirm that. All the manner of a lodge, log construction, large fireplace which that night, however, had garbage in it. It seemed an isolate place and the people already there, at the bar, and a few beyond at tables up the steps, on a raised area, seemed surprised at our arrival. They were shocked by the sudden

presence of a Negro in their midst. This was probably much farther off Route 40 than Negroes care to go. After the initial shock they seemed intimidated, as the police did in Reno, to see us together. A large place, pleasant enough. We had a drink. There was an old woman by the fireplace, a suspicious look on her face, doing something with her hands, sewing or knitting, she rather hid it. The jukebox was a collector's item. The records not only corny but in some weird and disturbing way, dated. The bartender spoke with a distinct accent. Scandinavian, I thought at first, but then from what was said I decided he was some scary German. He had the complexion and look of a skier, a sort of international confidence and carelessness. The types at the bar were not immediately clear. As a matter of fact I found it strange because all through northern Nevada there are the obvious wheeler and dealer types, dressed cowboy fashion. Here suddenly were a pocket of utterly civilianized drinkers. One weak-mouthed young man left his stool and took what looked to be a prematurely sagging stomach to the restroom. When he returned he had his mouth to the ear of an ordinary blonde on the stool beside his. Earlier I'd heard him ask her, Why can't they stay in their place! But it was cool. I sat at the table making a few notes.

On the wall above our table there was a sort of department-store painting of an "Indian." Most indefinite. I suppose if anything a vague plains dress. That sort of headdress and get-up most Indians themselves are willing to allow as the indiscriminate public idea of Every Indian. A noble chief. That's it too. No other Indian existed. War chief at that. The only time the white damn well had to admit the men were there. But there were no Indians in that bar drinking. Ah this town. What is this town? Then I remembered Pyramid Lake lies entirely within the reservation boundaries. Even the western shore, where it comes closest to the boundary, looks on the map separated by a margin of ten miles. The line seems to go along the crest of the mountains. I thought perhaps they had somehow wrested some Red man's allotment away from him when he was drunk. But the place looked to be on reservation land, land held in trust by the government. All conjecture. Then, abruptly, from the end of the bar, a man broke into the velvety flatulence of the Irish tenor. He sang to a woman sitting next to him, one of those banal Irish songs about his father and mother.

The next day in the store at Nixon, I asked an Indian man about

Sutcliffe, what it was, if it was indeed on reservation land, and if so how it got there. Oh, Sutcliffe, he said, yeah. I waited, and thinking he hadn't understood me, tried to put the question another way. He had gotten it the first time. Sometimes I noticed the Indians I met didn't register at all when the first thing I said to them was in the form of a question. They reacted differently if I opened the conversation with Hi, here's a cigarette, or It's pretty hot! In any case the answer was affirmative. I think it gives them more time to look you over, make a few silent guesses about what *you* are, what you're going to do next and perhaps what you've got on your mind, *i.e.*, what you probably *want* from them. And even if it turns out to be a harmless question about Sutcliffe, whether or not, reasonably, to answer either way lest it lead to some complication with you.

Yeah, Sutcliffe, he said. They're squatters. Squatters? Well, how can they do that? He threw his hands apart. They just came in there a long time ago and . . . squatted. We laughed at that but I still didn't know how. Well, he says, if you can stay seven years in a place you can't throw 'em off. Even on a reservation? I thought that land was held in trust by the Federal Government. I said, further, that something ought to be done about it (cringing a little, I'll confess, at that typical indignation). Well, I don't know, he said. A lot of Indian people used to go over there to ask them to leave but it didn't make any difference. They're still there, ain't they? Then we talked generally about the problem the Pyramid Lake people have with the tourists (and I did notice the scattering of their tinned corruption when I took that swim), the promoters and ceaseless general pressure. The promoters from Reno would build hotels, resort complexes, and of course the inevitable casinos, along the west shore of Pyramid Lake. They say it would mean income to the Indians and he said there were some of the Indian people, some of the leaders, who were in favor of it. What do you think of it? I ask him. Oh I don't know. He had a slight frown around his mouth. There would be a lot of newcomers out here. I just don't know. It was too much for him. And why not? All life was a series of compromising effects for him, and that probably accounts for the innate hesitation of his reply. Although he didn't say it, I could read it on his face: Whatever goes down, I won't have any control over it and I (and my people) will have to get through it the best we can. For "get through" you

might as well read "stay out of the way of it." And I was thinking too, good God, how hopeless, it really *doesn't* concern this man, he just lives his life along with it. Manifest Destiny, whether he's heard of that or not, turns back in on him anyway, as much a domestic force as it is foreign, and the more it becomes frustrated and resisted abroad the more it turns back in, turns back into America. Those progressives will go ahead with it, buying the luminous hope of incorporation into civilization, always so close to the apple in their intensity to bite it they never see the worm. The Indian leader and the Reno businessman are in effect the same man.

Finally I had a funny irrelevant question spinning in my mind. Will Pyramid Lake developments be lower-middle-class? After all, the landscape is beautiful only if you can look at it—the skeletal earth revealed, sunset and moonrise. Not the thing clothed neatly in ponderosa those machine-masturbating fools from California think is "beautiful." And they will have to get the salt and borax out of that water. But of course that can all be done. Some investor will come out and say get the borax out of that water and some engineer will hop to it. Six hundred and fifty thousand 150-foot trees of pure epoxy can be stuck on the mountains. Paint the pyramids decorator colors. Rout the injuns out every morning with "The Star-Spangled Banner" so the whole thing will look REAL for the kids—who have been to Disneyland and aren't going to settle for any sleepy valley.

On the several occasions I heard Indian officials use the word *progress* they had no idea on earth what the word was or what complex use traditionally rides behind it. Any sophisticated American of course catches all the signals of falsity and propaganda of intention that word gives off. But I take it any Indian is always thinking in some latitude of translation and so may take the word at its face value. Without even the root—to walk, or at grade, to step. It is too bad. No Indian's condition will be improved by a "forwarding" of him into (with all the concomitant loss of his language and land, given up to a rapacious people) the world that so persistently surrounds him.

In front of the store I talked to a man named Pancho. We sat on a wooden bench out of the sun. Pancho had a nice face. He had a nice hat on too, weathered, showing the wear of the climate, where he had been, back and forth over the land. He said his place was just down the road

49

from the store, pointing west to a line of cottonwoods. He told me a story, just as a story, about some men and women who had come once in a car and run out of gas near his place. They were from the outer world and apparently on some tense business because they were arguing among themselves and in a hurry, unable, though, finally to do anything. They were this way and that way. He would never forget them. It later turned out the men had escaped from prison and were on the run, right past his place. His telling of the story was absolutely without a tinge of conclusion.

An old car came up and stopped by the edge of the building, short of blocking the way to the gas pumps. Several Indians got out and went in several directions. A little boy about eleven years old came up and sat down on the bench by Pancho. An old woman stayed in the car. Five mongrel dogs appeared around the corner, white, brown, spotted black, long tails, short. They all came to the boy. The sun was high and brazen against the pavement and on the buildings across the road, the church and government buildings. Pancho was talking to the boy. Those are all your dogs. No, I don't know these dogs. Well, they're always following you around, ha, they must be your dogs. Every time I see you those dogs are with you. Those dogs always follow you. No NO NO! the boy shouted, looking over at me. Hey, somebody's here, Pancho! Oh no! HaHaHa, no no no. They pushed each other, gently rocking the bench. Say, where's your mother? Oh, she went to Reno. The dogs drifted away to lie in the dust. Pancho was smiling, eyes out over the landscape. The boy left and the dogs shook themselves and trotted after.

A newish but beat-up car came around by the pumps and to an abrupt stop. A very young boy got out and slammed the door behind him. He greeted Pancho who asked him where his mother was. The boy said she was going into Reno as soon as he got back with the car. He asked Pancho if he wanted to go along. Pancho asked why they were going into Reno. The boy said they were going to pick up his brother who was getting out of jail. Tell your mom to stop when you come back and I'll ride in with you, eh? The boy nodded. He was so small he had to look through the steering wheel to the windshield. He drove away with a professional swerve in the dust and flying gravel.

We sat talking on the bench in front of the store. The hot dust

50

churned up as cars pulled abruptly around the pumps for gas. Several times young girls came to get some article or other from the store. They were quickly in and out. Some of them very pretty—modern-looking, with that Indian difference. Their young women were slender and lively and the older women heavy and slow-moving. Not heavy exactly, more a careful weight, unhurried over the ground. The phone rang in the booth by the door. No one bothered to answer it. A truck with a back as well as a front seat pulled in from the road and backed to the door. The driver jumped out and came around to open the rear doors. He smiled at me and took mail bags inside—I followed him in to get a bottle of soda. The Indian woman told him he should stop bringing a certain kind of sweet roll. I couldn't tell what she meant and apparently he couldn't either because it took him some time to get it. It seemed what they wanted was a greater variety of rolls. I was outside again with Pancho when the man came out, banged the rear doors shut and said good-by. There were passengers. Mail, groceries, and passengers. Three Indians sat in the rear seat. Black cowboy hats on. Ironed khaki shirts. They stared straight ahead at whatever part of Nevada presented itself, waiting to get where they were going.

Pancho took a cloth from his back pocket and unwrapped it. Inside was a magnificent medal, large and heavy, about four inches in diameter, several ribbons connected at the top. He handed it to me carefully. It said *1846—Buena Vista*. There was another date, *1876*. He told me the medal had been given to his grandfather Old Pancho, who had guided Frémont past the Pyramid Lake country. I couldn't understand if the medal had been given his grandfather by Frémont. I thought not. Given later, by someone else. I said Frémont must have come down by the place we were sitting since the maps show the route down the east side of the lake. Pancho said, no, he didn't think so. He said he never agreed with that route. He thought they came over through those hills there, pointing east to the low, rolling mountains. I asked him what his grandfather's name was. Pancho. I know. I mean, what was his Indian name? What was his real name? Oh! Uh. Ya ya. Um. He was shaking his head, smiling. He said it before I knew it. Or it was such a new sound to my ear I didn't catch it. I asked him if he would repeat it. He did, and I tried to say it, several times. Finally he nodded and told me that was about it. It was a lovely name, but hard for me to say.

There were two words. The first I would try to spell, *R, A, M, A, A—* both end vowels spoken with a soft dwindling *k*. The second was *D, U, A* (same sort of uvular softness to the sound of the end vowels). A beautiful name. I kept on saying it as Pancho was laughing. I handed the medal back to him. You know, not many people ask me that, he said.

Everybody calls him Old Pancho. He mentioned offhand that he had once been in Arkansas. I said, Oh?, thinking he was about to tell me a story. When he didn't, I asked him how he'd got there, to Arkansas. How'd you get here? he asked me. We both laughed. Shortly after that the car with the mother and the boy drove up. Pancho walked over to it and slowly got into the back seat.

It was midmorning. I walked across the road to the church. It was an Episcopal mission. Stuccoed, painted wood frame. By the door a small burial yard, five or six graves. On one of the markers was:

Joanne Wooten
Born in Laurel,
Delaware
Feb. 3, 1891
Died May 2, 1894

Died at Pyramid Lake? Among the Paiute? It didn't say. That small person was made to suffer a geographic sloppiness alongside whatever it was killed her. Is it really asking too much to include all the information if *part* of it was assumed significant? Something about that marker offended me deeply. And then, on the wall of the church above the graveyard was a plaster crucifix. Christ wearing an Indian headdress very much suggesting a war bonnet. Too much. With such simple-mindedness directed at him, no wonder the Indian has remained in this hemisphere, top to bottom, either hostile or apostate.

Inside it was cool. Tasteful almost, quiet certainly, parts of the wood painted a nice blue, faded ultramarine. The windows painted as stained glass, lots of blue. Very nice little wooden relief carvings of the stations of the cross. Primitive, but not corny. In the dim interior out of the sun the objects came on clear at last. There looked to have been a spiritual fight here. Some good soul had the taste to insist that simple, provocative wood be the dominant material. But over a small stall

back of the pulpit, which was to the left facing the choir, there was an attendance plaque with a war bonnet and an American flag stuck on. I don't know how many small U.S. flags I'd seen on the radio aerials of Indians' cars. Here it was in the church. Somebody must have given the Indian a big dose of the flag. Maybe that famous separation of church and state was never their concern. In any case, the place felt spiritually dead. Some artifacts stuck on the back wall. Some cone-gathering baskets, a bow and arrows, a cradle board with a ceramic Nativity scene fixed inside. I noticed on a roll that the owner of the store, for instance, belonged to the church. It seemed depressingly clear the kind of Indian who would join this church would be the Indian who would abandon his own religion, not that his own religion can be much these days. But the load of insinuation, development, progress, and that term the old ones have for it, "White Indian," does seem no different than any swindle you can find flourishing on Main Street.

Three miles outside Nixon we picked up a man walking toward the highway, another fifteen or so miles away. He was smiling and happy to have the ride. The sun burns in that treeless land. He was more responsive than he would otherwise have needed to be, I supposed. We all talked. He said he was half Shoshoni and half Paiute. Was going to Reno to sell a pint of blood. I asked him how much blood brought in Reno and he replied, Five dollars—five dollars. I told him I used to sell my blood in San Francisco about once a week and that I got twenty-five dollars a pint. He thought that was very good. Yes, you had to say you'd never had jaundice and hadn't been to a foreign country. There were certain countries they feared but it was best just to say you had never been to *any* foreign country, just in case. In Reno, he said laughing, leaning forward against the front seat, if you got no money they'll take blood, you know? They just mix it all up. Nobody knows where it comes from. He said he had nine kids and at that time worked mostly in the hay harvest when he could. He said if he could ever get a car it would be better for him, then he could go long distances from home, he'd get more work and everything would be better. Things were spread out. It made sense to me. The horse, earlier, was the same advantage in that same country. An old story. We came to a rise and ahead was Route 40. Our route lay back to the east so he asked to be let off in Wadsworth.

53

VII

To Lovelock. Northeast. This time the Humboldt Sink is out the left window. And beyond, southeast of Route 40, scattered over the land are Danger Areas, a red pocking on the map. Bombing and gunnery ranges. Finally, one would come to the vastest pustule of all, the Las Vegas Bombing and Gunnery Range, an odd-shaped exclusion of land approximately forty thousand square miles.

Lovelock is difficult to place. It is ninety-five miles northeast of Reno and one accepts that figure for it. This time, the simple strategy—crossing the railroad tracks with an eye out for the standard signs of broken cars and falling-apart shacks—didn't work. The enclave was north of the tracks, north of the highway on a single clay street.

There was a city cop standing by his squad car, its red light oscillating on top, waiting for two bums to climb down out of a boxcar. It was quiet otherwise. A sort of deadly hot stillness. A dog crossed the dusty street to get to another spot of shade. A filling station attendant came out of a grimy garage interior to fill a tank. Then quiet again. We passed the bus station, and a block later, a single person sitting pointlessly on a bench in front of the courthouse. A pair of girls giggled along the street. The movie house was shut down, boarded up, as if done a long time ago. The town now fed completely by TV and that not so easy to receive judging by the height of the antennas. The air was heavy with a Texas meanness: pickup trucks with men in cowboy hats,

cowboy shirts, fresh-shaven. The smell of lotion, filtered cigarettes, long-range rifles, a bale of hay in the back of a truck, an empty gas can, the mechanical assurance to fix a motor, affirmative reflexes, 410, over and out, roger, get that satellite up there, you betcha, just passing over Australia, kill the President, water rights, the wheat referendum and subsidies, the grim-jawed insistence that girl you married was a virgin, cops checking out toilets.

The one-armed shoeshine man earlier had said, Look out for Love-lock, they're mean in Lovelock. Try to stay out of sight in Lovelock, man. Just pass right on through, if you can. Of course most people would do nothing else. But if you did have to linger there, you noticed this thing about it, a deadly threatening stillness. Not even too many cars, once off Route 40. But always passing the corner of the eye, an official sort of vehicle, sheriffs, deputies, and again those dangerously capable women in pickup trucks. Literally everybody a part of the constabulary. Once, when we were sitting in the car a water department truck came around the corner, and even the water man shot us a long, suspicious look. I thought he might stop. One had the brooding feeling it would be unwise to talk to anyone in this town, and if you went so far as to stop an Indian the town would rush at you, suddenly animate—get away from our goddam Indians there! Hey you What you doin' talkin' to my Indian! The mirage of kidnaping and murder hung in the air. Banged heads, cut-up bodies lying scattered at the edge of town. At lunch in the bus-stop cafe we were looking at the mural on the wall back of the counter. It was done in some vaguely crude amateur style—never quite primitive, yet short of even a standard professional vulgarity. A golf-course scene! My friend pointed—Check that caddy, Jack! I looked at the old man with the bag over his shoulder, he was as black as the color they'd used would permit. Man, that's *realism*, they know what's happening. You know who he is! Oh yeah. That's straight! And it was. Even though there surely wasn't a resident Black man in town. At least for his sake, one hopes not.

Along the back of the Lovelock enclave, however, there is a grove of immensely old cottonwoods—dense grass and brush. A thousand birds. And then the land fades back toward Reno, motels, and filling stations, into the thin thrown-up fronts that make the edge of a western town.

Seventy-two miles later, Winnemucca is a different story. You enter

a bustling town. The people are preoccupied with the gambling. It gives the place an action Lovelock lacks. They are at least busy with it and therefore indifferent. Indifference is a relief. Here again one sees the vagrant-minded Californian pulling the levers, throwing the spotted bones in the green boxed tables. A greater number of tourists have stopped, stayed on a few hours. There are the obvious tourists, all sexes, all sizes, in shorts. It seems at a glance, that of the Californians, mostly the elderly with time and money, those famous Siamese twins, are here. Riding, a couple in the front seat, a couple in the back, in those higher-priced cars. The women gray-haired (dyed to silver) with spotty tanned skin, the men like they had been put together with enriched flour in the backroom of some Bank of America branch. They park their cars and get out. Unending attention—hiking up the belt, swatting the imagined wrinkles from the backside. Wash-and-wear, wrinkle-free clothes are very difficult for the old to get used to, they remember winning this country sitting on their wrinkle-making bottoms. Then all the rolling-up of windows, checking the keys, locking the car. Double checking the locking. Looking up, at last, and then all four moving off to see what particular fountain of youth Winnemucca is.

Outside one of the casinos at the main intersection of Route 40, there are a half dozen or more ponderous wooden Indians. They are carved from six-foot sections of log. Painted on vague human shapes are Indian clothes and faces. Black eyes, brown semigloss skin. They are all startling, a naïve sort of dream-being in their solid presence. They have no bearing on Indians, of course. I should think they stand in the same relationship to Indians as those little cast-iron liveried Negro boys with rings do to Negroes.

To get to the Indians, they told us, you cross the tracks and then take the dump road. The enclave was small, a collection of a dozen shacks. Rather hidden away in some trees, by itself. In Winnemucca there is also a small mixed section of Negroes and poor whites.

The Battle Mountain Indians live apart, in a circular camp, south of town. Battle Mountain got its name from a battle there in 1857 between Paiute and emigrants. The road brought us in across twenty flat miles of sand and bush. Ahead a flat illuminated edge of the moon appeared and rose to a full disc. It sat for an instant on the sharp ridge of the

Tuscaroras. Below Elko, the Humboldt winds through a gorge and just above Battle Mountain it emerges onto a wide valley floor which is about four thousand feet elevation. Shoshoni held this territory, according to Steward, up to Iron Point. They were somewhat cut off from their relatives upstream. The Northern Paiute, or Paviotso, occupied the territory on west. The Shoshoni of this area and the Paiute intermarried. Sometimes they organized antelope hunts together. The population was numerous, but it still distributed itself much the same way as elsewhere in the scarce parts of the Basin, three to five families gathering and traveling together in spite of a food abundance that would have allowed larger concentrations in villages. Between the Paiute and Shoshoni in this valley, Steward conjectures, there may have been some antagonism because of woman-stealing.

Sometimes the Shoshoni from around here made the trip down to Austin to gather pine nuts in the mountains near there, carrying them then the ninety miles back home. They made equal trips north to the Owyhee River, a tributary to the Snake, for salmon. Since there was no antelope shaman among these Shoshoni, they went west to hunt under Musuwitsium, a Paiute shaman. They drove the antelope into corrals made of brush and killed them there. The kill was shared equally by all. The shaman took no more than anyone else. The directorship of lesser group endeavors, for instance rabbit drives (into nets), was assumed by any good hunter. Or a good talker.

The present community, or colony, as it is called, is arranged in a circle around a council house. An unofficial-looking sign on the road says it is a test colony of the Health, Education, and Welfare Department. I talked to a man, standing in his front yard, who told me the colony had been established in 1936. I asked him what he did for a living, since the land there was not reservation in the ordinary sense but a plot for a house for each of them. He said he worked around on ranches and sometimes in the beryllium processing plant across the road. A big dusty complex of corrugated aluminum sheds, pipes and hoppers. I asked him what it meant when the sign said there was modern plumbing here. He pointed to a tap on a pipe sticking up near our feet. He turned it on. Water ran. He said, when I asked him, there weren't many toilets in the houses. Later, at Duck Valley Reservation, when I asked an Indian official of the Public Health Service about the

Battle Mountain people, he said he indeed had put up the sign and that the Indian people there thought an inside toilet, a toilet in your own home, was an unclean thing. It was repulsive to them to have such a thing *inside* their house.

The colony looked to me more and more a product of 1936. The depression mentality that made it is still visible in the weathered exteriors of the shacks. It is as if a not particularly sophisticated Okie engineer had been hired to design a camp. The "conditions" were as built-in as the legendary sanitation. The man said the country had not been, at best, good grazing. After the inevitable overgrazing, the grass never came back and what was common now was salt grass, a tough prickly native to alkaline country. Hardly edible for even starving animals. There were some bunches of it in his yard.

Along the road into Battle Mountain we met an Indian man walking home. He was friendly. When he saw the camera he asked for fifty cents and removed his hat as if to pose. That price was interesting. Most Indians expect a dollar or five dollars, when they want money. This man's sense of money was probably adjusted not to what he might have conceived as a possible gain, but to the price of wine. There was something attractive about his openness. At least one half the going price. In the Southwest, where they are perhaps more exposed to the traffic of U.S. currency, they are much hipper. When they sell something or ask for money the sums are more ambitious. Even the naïve realism of the children in the Basin is more accurate. They often shout to you as you pass by—Hey! give me a million dollars! Quick, I need a million dollars! I heard an American poet once shout at a mansion high up on one of Santa Fe's hills, I want your food! Give me your food!

There isn't much special to say about Elko. The enclave there is large, as they go on Route 40, and the people look a little better off. The arrangement of their houses, the rather conscious effort to make a neat front yard with flowers, an attempt to keep wood painted, the paraphernalia of the lower middle class. In other words, they have made a mocking approximation of the surrounding neighborhood. Elko has more apparent life than the other small towns along Route 40. Except Reno. Someone has invested in Elko. There are three or four sprawling, crashing, driftwood horse-and-saddle motel casinos. And a few shops

have made a gesture toward the expensive. In back of the main hotel there was a rodeo Indian in out-West clothes who wanted a dollar, then he *wanted* his picture taken—Hey, man, take it again (this time hat off). Hey, take another one (now hat off, arms out wide). Hey, you wanta take another one? Smiles, crazy smiles.

Elko is a curiously nondescript town. But there is an aspect to it you've seen somewhere . . . behind the standard gambling façade is a retired rural peace and quiet. Similarly, parts of Las Vegas, New Mexico, an old railroad town, have a midwestern character. If you shut the backdrop of western landscape out of your eyes, and ignore the stetsons, you recall the insensate hum of a prairie village.

I was informed by an old Ute chief that requests were forwarded by mail for a dance leader to be sent to the Fish Lake Valley Paiute to direct a dance in 1950. Not all such efforts to transplant the dance have been successful, however. Steward mentions that the Sun Dance was introduced to the Shoshone at Elko, Nevada, in 1935, but the people there did not accept it; it was too hard (Steward, 1941, p. 226). One wonders what conditions at Elko are like now, and whether the dance would be acceptable under the present conditions or not.[9]

How could a ceremony of such visceral and spiritual necessity be vital among a blatantly captive enclave people. The religio-political cohesion a Sun Dance demands must have at least the sense of place and integrity a reservation can provide. Of course "it was too hard." But why was it too hard, any harder, say, than the old life had been?

"In a valley a little south of Elko (?) Beckwith met about 50 Indian men. They had been shooting gophers with blunt arrows, digging them by hand, or catching them in figure-4 traps, each man getting 40 to 50. These men had hidden their 'treasures,' one bringing out a piece of an old buckskin, a couple of feet square, smoked, greasy, and torn; another a half dozen rabbit skins in an equally filthy condition, sewed together, which he would swing over his shoulders by a string—his only blanket or clothing; while a third brought out a blue string, which he girded about him and walked away in full dress—one of the lords of the soil." [10]

"Thus, for vegetable foods Elko people foraged an area some 20 to 30 miles in diameter. They preferred to winter at the mouth of South Fork, where they cached seeds and dried roots. When special circumstances arose, such as an unusual abundance of pine nuts in some locality or a

general dearth of food, families governed themselves by the circumstances and wintered where most practicable.

"Hunting was carried on along the Humboldt River but game was none too plentiful. A man was lucky to kill enough large game to make a complete outfit of skin clothing. Early accounts indicate that such small game as ground hogs, gophers, and rats were perhaps economically more important than such large game as deer, antelope, and sheep. But there were no communal rabbit hunts in which nets were used."[11]

When and how does ceremony get to be too hard? Perhaps when it is brought back, having been discarded, as first, entertainment, and second, in the Reno instance, as a neat means of creating FOLK. This insures an interest in the Indian beyond the dull use of them as ranch hands or minor service personnel; in other words, it creates an interest in the Indian which is spurious because it is only interest. Probably the Reno Shoshoni never had an elaborate strenuous ceremony and didn't, like their Ute cousins to the south, require one. The theoretical virtues of industrialization have penetrated, at least in some sense, to the smallest crossroads. The only way you will get any one of the millions of ordinary Christians to fast is by starving him—another proposition altogether. The Sun Dance is rejuvenative and curative; a people have to want to be rejuvenated and cured to support it. Once you've been given a little house by the side of the road, ten pounds of flour and beans, a contraption to convey you back and forth to day labor, then you can laugh with everyone else when the flabby Hollywood Indians burn the ranch house and carry off the anemic wife and kids. It is hardly a cure.

In another sense, all that is beside the point. Who can summon the exactitude to care in an environment which is truly mean—even if caring becomes then all the more crucial? The day before, in the Lovelock restaurant with the golf course mural, my companion told me he had been followed into the toilet by the city cop and "checked out," *i.e.,* Where are you going, where (and how) did you come from, how long do you plan to stay, what is your means of support, do you have any money right now, etc.? All this barrage was leveled, presumably while my friend was peeing. I was asked no questions. Again, if I had looked less presentable I would have been. *White* won't get you off entirely.

Coming back through Elko, we stopped in a bar by the railroad, thinking that a safe location. We had our drink and went through the usual tense initiation. We talked to the bartender; it was a boring business. The weather or some equally diversionary tactic. The bartender was friendly and seemed interested in us in no cautious way. He asked us where we were headed and we told him. He had been north, said it was nice country along the Owyhee. Earlier we had speculated on what kind of bar it was. Lucas thought Italian. That seemed possible: massive dark wood bar, mirrors, tables with cloths; the bartender looked Italian. I took the risk. You're Italian, huh? He did what looked a double take he'd been saving just for us. No no, he laughed. What makes you think *that!* OK, so the burden was still on us. It turned out it was a Spanish bar. I had sensed there would be no easy way to satisfy our mild curiosity short of a total setup. Why either one of us hadn't recognized the language I can't say. The man was quite anxious to assure us he was not Italian, and to make sure we were aware of his disdainful amusement. Later it struck me that, from evidence in the neighborhood, it was a Basque bar anyway. In the right context that bartender would insist on America's greatness—but he wanted to play as much as possible, in her latitude, with his Old World animosities. The immigrant to the American West has transferred his greed for "nationality" to a land he can both play and hate in, the cake of mutual disgust, eaten inside these generous boundaries.

For some reason, when the tensions became unbearable in our travels, we ate in Chinese restaurants. The food was a dependably vague and enjoyable glue and a Chinese restaurant itself was usually neutral ground. Not in Elko. At the Liberty Cafe the patriarch stood, blank-faced, by the cash register and watched us closely the whole time. The sons worked in the kitchen and put the plates of food on a chest-high shelf for the waiter. Much banging of pots and busy talk. The man who served us was outrageously inquisitive when he brought the dessert: Where you come from? How arrive? And true to the Chinese particularity—Come bus? Staying Commercial Hotel? No coy setting-up, none of that, all of it behind that lightning complex of smiles while the hands invisibly and silently engage in service. The patriarch brought the check along with further questions, the ultimate deputy, more smiles and deferential gestures. Why don't you just ask it straight

out? Oh yes, the Oriental manner is circumstantial inside all that alleged concretion. I wanted to scream, Listen, you miserable beady-eyed rodent! So there's a Black man with me, are you trying to put that on me too, because if you are, let's go into how *you* managed to stick here along the route of the Union Pacific, the last weakening gene of several generations of cooks—at least your ancestors took their risks getting scalped, etc. But I paid the check with a smile. It's no good. All men get twisted here. Let's go north to Duck Valley where they did not send for the Sun Dance, where they have started a ritual business not yet defined.

VIII

O<small>F ALL</small> North America the plateau of the Basin-Plateau is the brightest extremity—high and cold in winter, high and cool in summer; it has not suffered the ripening touch of serious history. The air sparkles with a dazzling grain; the place is crystal. The Southwest is dry. The Basin-Plateau is superbly dry—it dwells on itself, isolated between the great mountain ranges of the Rockies and the Sierra Nevadas. Mountain City is a mining town of one hybrid (cowboy and mining) street high in the hills, isolated, the old storefronts of the past. An occasional car, slowed down, through to Boise, or somewhere beyond—from nowhere to nowhere.

We stop to give a man a ride. His name is Wilbur P.: I'm going to take you to Duck Valley, see. Look, I've got a lot of relations there, come on we'll go see my cousins! OK? He staggered, grasping for the door handle, and then fell into the back seat. You're gonna meet my cousins, see? We own . . . look . . . uh . . . the valley is, oh you gotta see how wide it is, hey! We goin'? Oh this is . . . the way to go—yeah! Just up the road. We move slowly past the three blocks of Mountain City's filling station garage, general store, cafe-bar on the west side of the road, and then on north. Wilbur P. is a small man, he has a rolling gait, he is a rodeo performer. He walks on sea legs feeling for the firm ground under him, never assuming it will be there. On the way north he asks for cigarettes, has me stop the car so he can pee, and talks endlessly of the Vietnam War and rodeo life and his cousins.

He was dressed in jeans and cowboy boots, white tee shirt—the attire topped by a black felt hat, upturned brim. His face was brown, round, drunk and intensely insistent. From the back seat he spoke, his hand on our shoulders, waiting for an answer, and then the next question was ready and asked six inches away from our heads, whether we turned to look at him or not. He turned to look out the back window to the car following us. That's my sister back there in that car they're goin' to Duck Valley! Hey, you know! I ride horses. I bust horses. . . . Look, I got my arm skinned up last week in Carlin. There was a line of healing scabs from his elbow to his wrist. Shit I can ride . . . There was a faltering in his speech, and then in a lapse of attention he would gaze out the window at the passing foliage as we quickly cut across the rivers and the ends of small high lakes, in a rising, winding road across subalpine meadows and past winter wheat fields. The descent accelerated at last and we were winding sharply along the gorge of the Owyhee to come out finally into the wide light of the sun, the curious flat butte standing black, miles across the spread greenness of Duck Valley.

Wilbur told us where to turn. We ran smoothly along the wide gravel reservation road past irrigation ditches and came to a crossroad. He told us then to turn left—he wanted to see his grandfather. I turned the car around under a row of immensely tall poplars and parked by the fence. There was a wild growth of lawn, several dogs crossing nervously back and forth staring at us. Wilbur P. got out and went to the back of the house. He talked to a man leading two horses, then went into the house. Mosquitoes rose in endless squadrons from the *acequia madre* across the road. We rolled up the car windows and wondered if he would return. I felt tired and faintly oppressed. Wilbur left the house at last, spoke to the man with the horses again, and then came to the car. He decided he wanted to go see his cousins—just over there, go down here and turn, I'll tell you where. Hey, see that spotted horse, that's my horse. . . . I wonder what she's doin' out on the road. . . . Oh, yeah, there's one of my cousins. Hey, you old . . . The three Indians on horseback smiled as we slowed down but showed no inclination to chat. He stuck his head out the window and waved. The horses reared. They were laughing, waving their hats.

We turned into the cousin's place. The lane had such a high center I had to creep along the edge to keep from going down into the ruts.

There was a great mud hole the width of the road. I gunned it and we made it across. The house was under a grand collection of ancient Lombardies. It was a shack of three or four rooms. Wilbur went to the house and returned with three men, one old man, a young man, and a man who looked in his early thirties.

Across the floor of the valley a strong breeze blew, bending the tops of the poplars. We met them all. Names exchanged. The young man had a knife in his hand, the size of a bowie knife. He was smiling, saying, indiscriminately, it did not matter who was talking, How are you guys, hey! You want some wine! The old man smiled and uttered sounds, he was not speaking his own tongue, rather he mumbled and shouted incoherently and then sat down on a chair which had the back broken off. He had a half-gallon of wine in his hand. Every now and then, as we talked about the knife, and the young man threw it wildly, at a tree, or up in the air, the old man would shout his mumble into the wind toward us. No one paid attention. Hey, bastard! Don't throw that knife—Wilbur was managing some concern.

The old man hung to the edge of the chair by the most delicate balance, his black cowboy hat tipped, the jug of wine on its side by his feet. The other two cousins talked constantly and Wilbur, refreshed by the wine, wove back and forth, laboring to focus his eyes. The young man's name was Cally. He stood on the fender of the car and threw his great knife at the tree. It never stuck. In between frantic throws he made disconnected remarks like, See them horses, they're going to get loose. Hey, why don't we eat something, you guys, want something to eat? Then threw his knife.

We left the old man mumbling to himself on the edge of the chair and went to the base of three great poplars where some mattresses were spread. We all sat down and passed the jug of white port. Cally and John, the older man, fought over it, some argument that had started before we got there—between times they both teased Wilbur, rolling him on the ground, all piling on, spilling the wine, and then all at once the whole scene would come to rest as silent and still as a frieze.

Hey! Get some music! Cally tried to grab the radio while John banged on it. The radio blurted painfully like a mistreated ventriloquist: The weather—cl—dy, the hit—to—me baby. Cally asked everyone if they didn't want something to eat and it seemed we did. We got as

far as the back door to the house and suddenly Wilbur said, Hey, you guys! Let's go see old oh whaddeya come on—what do ya say? So we got into the car and went back over the incredible ruts past the horses whose names were all shouted and who stopped grazing momentarily to look up at the waving Indians.

We drove fast along the straight gravel roads. The sun was red in the west and the high shooting brilliance of the afterglow was already beginning to fan toward the zenith. The pitched voices of the frogs in the irrigation ditches along the road filled in the silences in the conversation. They were talking in the naïvely brutal English they spoke, of the Vietnam War. My little brother, he's there now, I was in the Korean Conflict, say do you think we'll go? I'll go! I was in the Marines—Cally, you're gonna go, they're gonna take you to Vietnam. Hey turn here! No no, he has to go up there, oh Wilbur you're crazy—hey, don't listen to him, Wilbur's nuts. Let's go down there, he's our cousin you know. They pounded on Wilbur, hit him on the neck and head with their fists, you're crazy as hell, Wilbur. IDAHO! straight ahead across that field—we turn here, though.

We arrived at a house being built. Fifteen men on the roof, women inside putting up walls. Cally went into a house nearby and came back with a youngish and responsible-looking Indian who stood by the car. They all talked to and about Wilbur, who evidently had not been on the reservation for a long time. He told them his adventures on the rodeo circuit. The responsible Indian was a fire warden. Another cousin. They asked him if he wanted to ride a steer and he merely laughed. They talked of fire fighting. The man said the fire crew had taken along some teen-agers and they had not been much help—every time the men turned their backs to dig a fire trail the boys had rolled huge boulders on them from above, one man was nearly killed, and then they threw rocks at them. The sun had gone down behind an indelible broken horizon line, dense brown below, sharp pink above.

We arrived at a small white house set a quarter-mile off the road after a fast drive north along a large irrigation ditch. A man in the house was called out and we met him. He said nothing distinct. He smiled, took our hand, gestured irrelevantly here and there. The woman of the house was away; she had gone to Boise early that morning. A girl of sixteen or seventeen appeared at the door, the harsh light of

the interior outlined her. She wore tight-fitting jeans and a quilted jacket. Wilbur called her Marsha. She was pretty, a round open face, constant and unwaveringly clear eyes. Marsha was very offhand and ignored us. It was to this place we had started before being diverted to the scene of the house-building. It was here the steers were to be ridden. Wilbur wanted to prove his rodeo experience.

They were all deadly drunk. The man of the house could perform nothing beyond a kind of overpoweringly idiotic smile which he directed more toward the expected question than the question itself. The girl was calm and straight. Inside the house there were two little girls who were happy to see Wilbur. There was a little boy, bright-eyed, very short hair, perhaps eleven years old. *He* was the man of the house, he had been left to look after the little girls. Disapproving but interested, he passed through, occasionally peered around the corner of the door jam. A partial bottle of wine was brought out and passed around. The little girls climbed on Wilbur, he was perhaps their uncle.

In a corner was a double bed. John fell onto it, the gallon wine bottle fell from his hand to the floor. It was saved. On the walls were tacked calendars with nude women, a sign embellished with white glowing flowers on which was printed *FROM THE HALLS OF MONTEZUMA*. The TV picture was on, the sound turned off—an impeccably young American couple were going through the changes of the Pepsi Generation. I thought of Joan Crawford.

Wilbur was holding the gallon bottle of wine, haranguing Cally and John. Come on! Let's ride a steer, whada ya wanta do? Ride a steer? Come on. Let's go now. That's what we came over here for, wasn't it? I wanta show these guys here . . . come on whadda ya say! We all told Wilbur he was too drunk. Cally told him he was too drunk and then asked him if he really wanted to ride a steer—No Wilbur, I don't know, I think you're too drunk. How about it Wilbur, are you gonna ride that steer? John was passed out on the bed. It was getting late now—things seemed to be coming apart. The TV signed off, long picture of the flag waving in the breeze, soldiers marching down Pennsylvania Avenue.

Wilbur shouted to the boy, Hey, will you let me wear your chaps? John came alive—Hey Wilbur, you gonna ride a steer, let me have a drink. The boy told Wilbur the chaps were too small for him, Wilbur insisted he could get into them. The hunt started for the chaps. They

were found in the kitchen under a pile of clothes and pastel plastic containers. Marsha handed them to Wilbur. He told her to get some rope. She smiled—this was something she wanted to see.

Wilbur was too drunk. He could barely stand up. It seemed safe enough in that respect as long as he didn't get literally run over by a cow. The boy was upset. He was half amused, but he had been left with the little girls; he had that moral sobriety common to eleven-year-olds. The older girl in the tight pants was useless to him, she wanted to see the action, or to see if there would be action. Wilbur looked ridiculous in the boy's chaps. They fit like an undersized shirt does, the cuffs up to the elbows. But it was of the utmost importance that he wear chaps. The ritualism called for them. The boy, in his nervous tug of war with himself, hurried around the house. He cast reproving glances at the preparation to go to the corral. Finally his curiosity was too great, he allowed the girls to go and he came along too, at the side of the group, head down, looking at the ground. It was past midnight. The scene was arbitrary now. There had never been a necessity to ride the steer, but the urgency of proof had been real, and now seemed confused and misplaced.

The moon rose late that night. When we reached the corral it was sitting immensely yellow on the top rail. Marsha set a flashlight on the ground. In the shaft of light were three bony, tough-looking cows. Not steers after all. John and Cally got into the corral and started grappling with them, first one and then the next. Wilbur sat on the top rail telling them in bleary rhetoric how to arrange the animals. The excited cows ran around the edge of the circular enclosure. Earlier in the afternoon riding steers had been proposed as something to photograph, now it seemed another thing altogether.

Wilbur fell to the ground every time he tried to mount the running animal. The flashlight jiggled and went spinning—the heavy inhalation of the animals came through the cold, dust-filled air. Always the flash of the bulbs in Lucas's camera exposed a crazy plane of surfaces. An impossible scene to be drawn into. The moon lifted high off the rail. In that increasing light the faint rim of the distant hills appeared. Wilbur got up from the ground each time more battered—tee shirt hanging from his shoulders, a blood-swollen bruise on his forearm, his nose mashed. Hat lost. And all at once it was clear what was happening—

the little girls watched in a trance from the top rail, all light was gone except the rising moon, the churned dust, all animation was focused, relationship was fixed, on a single area: the breathing of the animals, the man and the "steer." Suddenly from the house, the boy made his complaint absolute—we had all been there too long, his mother would return, find everyone there and he would get the blame. Slowly we moved back toward the house. Marsha stayed behind, moving around in between the animals.

They wanted to go to Mountain City. From the start they were fighting, John and Wilbur in the front seat beside me, down the twisty mountain road. They shouted to each other how they would kill if they were in Vietnam, then worked the door open, fell out of the car and rolled along the shoulder their arms beating each other. They said it was natural for cousins to fight. It sounded like a tribal arrangement they had heard of and gotten confused with something else. We arrived in Mountain City shortly before the tavern closed. As we drove in, a police car was parked by the side of the road. I bought them a beer.

At this point there was a total collapse of sense. John and Wilbur were tired and looked battle-worn, blood and dust from their jeans up. Wilbur still wore the little boy's chaps. My tactic was to pretend nothing was unusual. I could have saved my concern. The lady tending bar asked me cool as anything if I'd pay their long-standing bar bill, assuming, it turned out, they *worked* for me. She seemed patient enough when I explained that they didn't and I wouldn't . . . and it obviously was out of the question that she speak to them. They were banging the juke box and pulling at random on the slots, into which they had put *no* money: Come on pay off you godamn . . . They were saying to each other, Hey! remember that time? Yeah, come on, you remember that time! John said, Oh yeah, hey man, I remember that time, oh yeah, oh man, come on, *you* remember that time! Hey bartender, let's have a drink, Jesus, what kind of . . . uh. Oh you can't beat those bastards . . .

We woke up the next morning alongside the road a mile north of Owyhee. The sun was high. It was July 14, Bastille Day. We ate some packaged sandwiches and went on into the filling station. We just happened to arrive as a young Indian in neatly pressed khaki got out of a gray government car. He looked us over and we talked. He worked at

the hospital for the Health Service. He invited us to take a look at the hospital and then to go home with him for lunch. He was Shoshoni, and no mixblood, but undoubtedly what any traditionalist would consider a "White Indian." He had a pleasant manner, and was articulate with English. We had an hour to pass before meeting Willie Dorsey's great-grandson at the hospital.

There was a soft drink and hamburger place across from the high school just up the road from the filling station. Inside two Indian boys sat on stools at a low counter. A man took orders and his wife prepared the food in a small kitchen. There was a magazine rack with the shiny faces of fresh America staring with bared teeth into this obscure cafe. The Supremes purred softly from the juke box. On the wall was a sign: *SMOKING WILL BE REPORTED TO THE HIGH SCHOOL SUPERINTENDENT*. We had an Orange Crush. One of the boys smiled, and so we asked them some inconsequential questions. When they got up to return to work, they said they wouldn't mind if we went with them. We went out to a field where they were baling hay. The hay looked nicely cured. The two boys were very good-natured. They drove a car, had gone into the cafe for a Coke and then back to work. One drove the tractor, the other rode the sled behind and stacked the bales. They were happy and laughing, enjoying their work, which they did with ease in the lofty July sun. They seemed nicely wrapped up in themselves, their world was complete.

At noon we went to the hospital. We chatted and took turns explaining ourselves. There were two doctors on duty. They were rather military, that creased khaki again. When I asked would an Indian from another reservation, *any Indian,* be given treatment, they said yes, but seemed anxious to dispel any fear I might have that this was indeed socialized medicine.

For lunch we had chili and hot dogs. We sat in the front room in overstuffed chairs and when the Indian official's wife had everything ready we went into the kitchen and sat at the table with the entire family. It was a pleasant relief from the road and the pattern of haphazard encounters we'd had up to that point. The man's wife was Caucasian. A thin, nice-looking woman, good with the children. The talk was rather formal—question and answer. He had attended for a while Brigham Young University and we discussed the implausibilities of

that instruction for an Indian. He was a progressive. When we mentioned certain old culturalists at Fort Hall he spoke warmly of them, admitted a very deep admiration for the elegance and real authority of their Shoshoni. He said that the articulation of the language and practically all the formal rite was losing ground fast at Duck Valley. The Shoshoni-Bannocks at Fort Hall were much more traditional. He said that although Duck Valley was not as large a reservation in total area as Fort Hall, much more of it was accessible to water. Much of the Fort Hall land is high, above the Snake River. He seemed to imply that the Duck Valley people had other things to do. Willie Dorsey is this man's great-grandfather.

Duck Valley, the Western Shoshoni Reservation, I thought of as an inherently excellent place. A broad, flat, well-watered plain. Its area is rectangular, the northern part stretches into Idaho. There is a natural, magnificent vista from nearly anywhere you choose to stand. I suppose statistics could be summoned to show those people need this or that to bring themselves alongside whatever standard. The main crop is hay and, I understand, of good quality. The change over to an agriculturist economy can't be easy, even for a gathering people. There is nomadism in gathering as in hunting, no matter the difference in levels of culture suggested by the distinction. It is a habit of considerable millennia to break in either case. And there is hardly any question that it is actually better to have the Korean veteran enact his hostility to the surrounding culture in his own back yard, he can think harmlessly and bitterly of Vietnam along the straight gravel roads of the reservation, and he can be a warrior, which I'll grant he has to be, against a cow. It makes more sense than the psycho-peripheral sickness of Reno, or Elko. Or for that matter, Pocatello. Duck Valley is many miles from a large town or a main cross-country road. For the present at least, it is happily quarantined. Those men who find it necessary to drink themselves to oblivion had better do it in the safety of what isolation they can manage. The world they find surrounding them is not critically real anyway—the veterans at Duck Valley invariably referred to the military event of the early fifties as "the Korean Conflict." They had taken literally the politico-military subterfuge of the front page and faithfully retained the terminology. "The Korean Conflict" was for them real solely as *action,* it had been the one instance in their lives when they could

perform, under the benefaction of their conquerors, ritual battle. It would seem pointlessly arcane to imagine *any* sort of relevance between the present Shoshoneans and Koreans.

The steer-baiting was puerile. Most nascent ritual is. Fred W. Voget, speaking of some changes in the Wind River Shoshone Sun Dance, says:

A special subcomplex involving the American flag appears to be permanently incorporated in the ceremonial. The flag is raised every morning before the resumption of the dance following the sunrise ceremony and it is lowered in the late afternoon when the performance is again about to be interrupted. The subcomplex involves a pole (entirely stripped of bark to resemble the usual flagpole) erected at the entranceway, an American flag donated by a woman whose son was killed in action, special flag song, standing of all participants and nonparticipants with head uncovered and facing the flag, drumming and singing solely by a Shoshone group led by the inventor of the song, prayer by the sponsor, and veteran personnel to handle the flag. The incorporation of the above during the war *(ca.* 1945) emphasizes the sensitivity of Shoshone worship to current problems and the re-emergence of the predominant aboriginal function of the ceremonial in relation to war.[12]

IX

Shoshoneans in general are extremely reticent about divulging ethnographic information, and in the case of the Northern Ute this sentiment is intensified by a feeling of hostility against whites generally.

Lowie, 1924.[13]

The myths of the garden and of the empire [the American prairie and plains] had both affirmed a doctrine of progress, of gigantic economic development, even though the myth of the garden at the same time implied a distrust of the outcome of progress in urbanization and industrialization. Neither American man nor the American continent contained, under this interpretation, any radical defect or principle of evil. But other men and other continents, having no share in the conditions of American virtue and happiness, were by implication unfortunate or wicked. This suggestion was strengthened by the tendency to account for any evil which threatened the garden empire by ascribing it to alien intrusion. Since evil could not conceivably originate within the walls of the garden, it must by logical necessity come from without, and the normal strategy of defense was to build the walls higher and stop the cracks in them.

These inferences from the myth of the garden will be recognized as the core of what we call isolationism. The attitude toward the past and toward the outside world which the doctrine implies, its foreign policy, is related through the myth of the garden to a domestic policy. The society which is imagined as growing up in the protected West is in

theory (although hardly in fact) based on a minutely specified type of agriculture—the cultivation of family-sized farms by virtuous yeomen. The society is therefore homogeneous. There are no class divisions, no employers or employees, and the manners and tastes of each of the inhabitants resemble those of all the others.

Henry Nash Smith.[14]

Congratulations out there to all you Shoshoni-Bannocks for a job well-done, and all you Shoshoni-Bannocks participating out there at Fort Hall, Ross Fork an' Tyhee. . . . We can all be proud of the War Dancers.

KSSN Radio, Pocatello, during Indian dances on Fort Hall Reservation, August, 1965.

THE DRIVE to Pocatello from Owyhee took the best part of an afternoon. The road north from Duck Valley is an unmercifully pounding stretch of hard gravel for fifty miles or more. Most of that distance is through one vast ranch and the only stop is the general ranch store. The car needed some oil but I bought gas too, in those stretches it becomes a habit, a token to safety—always keep the tank full. We had an Orange Crush. There were a few young and solemn Indians hanging around inside the store, drinking soft drinks. Tight jeans and black hats on. Wide brown eyes deeply still behind dark glasses. Subject matter nearly always becomes familiar and it always has with it its famous companion. I had prepared myself for this in the several weeks that lay behind us, so it was not contempt I felt, but, always ill-prepared, I was impatient. Why were they here? Why not anywhere else? What had the ill-spirited and overweight boy who filled the tank to tell them? What, on the nature of things could the pioneer woman with the pinched mouth tell them? Of course it is beside the point. They were waiting . . . waiting in some dull afternoon's time, in the dry brilliant West—time is very much marked by the arc of the sun. Once in a while there is a celebration no one notices—a thousand years have transpired. Once in a larger while, a hundred thousand years are marked.

And on finally to the good straight-surfaced roads through the cultivated country along the Snake, more than two hundred miles west of Fort Hall. Lucas thinks aloud, as naturally he might, that if the Indians were to really get with it, prosper on a *big* scale, they needed land like this, or water, or what is it anyway. It is suddenly rich and lush. Suddenly the country reflects a neatness and vigor, it is all a well-kept entity, all the arrows point, at least externally, to the good and wholesome. Yeah, Leroy, this is some of the best land around here, you'll have to go a thousand miles in any direction in order to arrive at anything like it. And then he says, Well this is the part they should have kept. This is hip land, Jack.

Of course. But we all know it didn't work out quite that way. The following is from a mimeographed sheet entitled *Information about Fort Hall Indian Reservation* (no date or source):

At present there are over 53 million acres of land still held in trust for the various tribes and individuals. Arizona, New Mexico, Oklahoma, the Dakotas and Montana have the bulk of this Indian land. Executive Order of 1867 indicated that a reservation of 1,800,000 acres was authorized for the Indians of the Fort Hall Reservation. When the reservation was originally established in 1868, 1,336,000 acres was set aside. Shortly thereafter this was diminished by ceding back to the Government of 750,000 acres of land south of the reservation. The reservation was further diminished in 1924 by the sale of 26,000 acres for the American Falls Reservoir. These withdrawals and cessions, together with the sale of some allotted land has diminished the reservation to its present 524,000 acres, which is 76% of all Indian land in Idaho. There are smaller reservations in North Idaho known as the Kootenai, Coeur d'Alene and Nez Perce, also a portion of the Duck Valley Reservation extends into Southern Idaho along the Nevada border.

The next paragraph of the same information sheet from Fort Hall Agency is a paradigm of naïveté no young man educated by Saturday afternoon TV would fail, in some perverse way, to appreciate: "Indians who are now principally on the reservation were the aboriginal owners of the entire United States. Placing them on reservations was an act to protect the white settlers from acts of depredation, which became more common as the Indians were pushed further back out of their original holdings."

Acts of depredation . . . as the early settler moved up the river

valleys of the interior, occupying as an afterthought, the plains and then the terrible intermontane regions, he sought the scarce but jewellike river valleys. On April 1, 1878, when John Wesley Powell, in his *Report on the Lands of the Arid Region* to Carl Schurz, the Secretary of the Interior, urged that the homestead unit, on the basis of the climatic evidence, should be 2560 acres or more (as against the standard 160) on the high plains and in the Basin-Plateau, it was the western lobby itself that most resisted all such reform of the Homestead Act—the illegalities of land speculation had become the most stable industry of the West. And one must keep in mind that the great isolationist, Senator Borah, an Idaho man, was in no sense a terminal phenomenon. With the possible exception of certain congressmen of the West Coast municipalities, the western congressmen are singularly local (non-national) minded—even if this means, as it does presently, that silver continue to be mined against the wishes of the Federal Administration. Such a division over a "strategic war material" could only come to light in the context of old issues which have come into the present intact. Any move the Indians conceive of today will likewise be met along old, predetermined lines. No one has said it yet, but all real American citizens know that Manifest Destiny includes the moon. The Russians may, probably will, get there first. But they are foreigners. (Remember, the Indian is now a foreigner in America.) The Monroe Doctrine will be sufficient cause for a "just war" to safeguard that territory ceded to us by the Divine Will. It is perhaps a joke no longer that the division of the New World between Spain and Portugal, post 1492, was the first instance of corporate capitalism (divinely inspired). Mercantilism as a definition of that expansion is unfortunately nearsighted. The point is made if one simply posits for that time a Pope with a nuclear device.

And so, the Sun Dance. The Sun Dance is a technique for living. For the participant it is a form of worship. And it is a curative ceremony. "It is not conceived in terms of the moral regeneration of the individual . . . not a technique for salvation." [15] Although the dance is generally reckoned to be perfunctory in character now, and much less powerful than in aboriginal days, it is still too long and arduous for any but very serious persons to perform.

Leroy Lucas was very shortly to go into the Indian world in the only way possible—directly. Willie George put it to him: If you want to take

pictures of the Sun Dance you have to dance. Lucas agreed to do it; of course he would. During those weeks in Pocatello he had walked up and down the reservation—he had as persistently as his own great patience would allow lived with the Indian. He was never quite allowed to do that—live inside the house, be a part of the domestic business. To catch the waking blink as well as the wide-awake curiosity, see how the children dressed themselves. There is always that compromising point beyond which you aren't allowed to go and beyond which there would lie the fullest explanation of a people who have been so wholly maligned by crimes of omission. And he thought of it that way too. If you are an artist you have to live with your art, which is on every level total. The Indian knows this but it is naturally difficult for him to welcome the man who comes from the outside into his world. The Indian has, after several millennia, become used to thinking of his world as ceremonially special and strict.

The photographer had a great admiration for the culturalist Willie George. Lucas's open readiness to enter the games and ceremonies of the Shoshoni-Bannocks (at one of the lodges he entered a foot race and came in third) as perfectly as he could apparently met the stoic approval of Willie George. Willie George is a severe Indian. He wears braids under a high-crowned, gaunt black hat. His face is real. It is lean and lined with the grand quality pictorialists would like to capture and never can. Thin as a line, he seems to cast no shadow—there is an implication in him that he is in himself complete. The Shoshonean syllables emanate from him with such particularity that his speech is felt almost more than heard. I remember in a lodge one night in between dances and drums he made an announcement. The content, for all I knew, was simply routine. There was the sustained clutter of noise as he began, and it continued well into his speech—children, young adults buzzing—but at the last third of what he said, a stillness came across the hall and left it finally silent, down to the children—absolute silence. The smallest crying babies stared. The rolled, selective particles of language dropped into all their mouths. The pitch of his voice had been constant from the beginning and only a man who was not Shoshoni could have been amazed at the silence of the end. He sat down as he had got up, eyes straight ahead, then crossed his legs, and continued to stare as implacably into the future as ever. The whole event possessed

such a sense of active present there seemed a continual refreshment of the future—their attention came to him, not rushing out of itself into a past but as a materialization. Not time as a residue but as a dynamic fact. Part of what he had to say was that after the dance watermelon and saltines would be served. But that's beside the point.

Lucas helped build the Sun Dance Lodge. There is a form to be followed in its construction, less strictly observed in the modern dance and less adhered to in some places than in others. Most often variations are introduced at the discretion of the Sun Dance leader. The post holes are dug, the rafters are raised with special care for the cardinal points, west, east, south, and north. The center pole is very special—aboriginally a fresh buffalo head was hung from the top of it, or buffalo tongue in the tongue ceremony. Nowadays the head is stuffed and mounted. And once coup was struck on the center pole preliminary to felling.* Sometimes the pole is undecorated. Shimkin records an interesting prayer at Wind River, 1937:

. . . the dancer steps forward, and the old man faces him, holding up his right arm, and prays . . .

nu:′ma	ȝaŋkʷ	mi′agwai	ë:′ine	ȝaŋkʷ
May-he here /	well (be) /	going-indefinitely /	protractedly /	well /

mi′agwai	dïkapa	ȝa:ŋkʷ	di′kamiagwai
going indefinitely /	food (obj.) /	good /	eating-going-indefinitely /

pa:′ⁱ	yi′wikai	us	ma	ȝaŋk′
water (obj.) /	drinking-indefinitely //	That is /	he here /	good /

në′wikandë′	ᵑë′ine	miagaʷaɸuindë′	ȝa:ŋkʷ
feeling-will /	protractedly /	going-indefinitely-keep on will /	well /

na′nišundheŋgɛn	si′βa	so′goβa	ȝaŋkʷ
(I am) praying //	This on /	Earth (obj.) /	well /

manë′widuiɸuindoⁱ	na′nišundheŋgɛn	us	suwaix
his-feeling-will-keep on-will /	(I) am praying /	That is /	all

Freely, this says: "May this one here go well, protractedly go well, eating food go well, drinking go well! That he here will protractedly be feeling

* "Coup ('blow,' 'stroke'). The French-Canadian term adopted to designate the formal token or signal of victory in battle, as used among the Plains tribes. Coups are usually 'counted,' as it was termed—that is, credit of victory was taken, for three brave deeds, viz, killing an enemy, scalping an enemy, or being first to strike an enemy either alive or dead. Each one of these entitled a man to rank as a warrior and to recount the exploit in public." (from Hodge's *Handbook of American Indians*)

well, indefinitely keep on going well, I pray. That on this Earth he will keep on feeling well, I pray. That is all." [16]

When the long days and nights of dancing are over the dancers are given watermelon and saltines, the watermelon restores the liquid to their bodies. The days are hot and the nights are intensely cold on the plateau even in summer. I was away at the time of the dances, late July, and when I returned to Pocatello, Leroy had just been through it. He seemed at first the same as ever—large clear brown eyes, disarmingly easy manner—straight out in front of me, who had returned with the Troubles of the Great World in a bag. But he had, I gradually saw, changed. There was a subtle clarity and calm permeated his being.

X

WHENEVER any non-Indian citizen presumes to speak to or about Indians, there is in his mouth a rather heavy inheritance of qualifying history: past, recent and—particularly—present. Of course it is all one intersection, practical and theoretical. If a sensitive and informed man finds himself a part of the dual subject of "contact" (and that is what it is still with the Red man, contact, in this strange land, no matter what either party "feels") the stock of his informed emotion will include the 1890 massacre of Wounded Knee and he will see the sight no one cares to look on: the baby trying to suck the breast of its murdered, but still warm mother. The hidden children called out with the promise of impunity then to be cut to pieces by the Hotchkiss guns. The woman with the infant in her arms, cut down just before she could touch the flag of truce. They were three hundred Cheyennes, Algonquians, under Chief Big Foot, according to James Mooney.* But that hardly matters any more than that it was a Paiute, Wovoka, who had the visitation from his god who instructed him to begin the Ghost Dance, prepare for the coming of the Messiah, the restoration of game, the extinction of the whites. The massacre came with the suppression of the Ghost Dance at Pine Ridge Reservation, South Dakota, to which it had spread, changed from Wovoka's pagan-Christian vision of peace and return to an original condition, to the Plains traditional sense of guerrilla re-

* Robert Lowie says 128 Dakota were killed.

sistance. Sitting Bull was murdered in the same clutch of events by the constabulary of the U.S. Government. The important thing is that it is all a factor of the real. Some people, one day in 1890, in a particular locale, felt the burning powder of death. And they died, however we might have to strain to imagine the distinction of each of their deaths.

The attempt to align with the death of another being is one of the vaultings of the human spirit. It is the one thing we have in common. We can't do it. Some people, that same day, hacked men and women and children to pieces. They, the killers, agents of a national lust, died too. The death the killers died was not psychological and we should be careful not to imagine it was theoretical. December 29, 1890, at Wounded Knee, South Dakota—the massacre marked the end of the Ghost Dance. It also registered another small installment in the spiritual death of America. The Ghost Dance was a preparatory celebration for the coming of the Messiah, or deliverer. It had to be put down at *all* costs. The cavalry was chosen then to carry it out and the parallels of that situation are familiar enough.

One can seem to live after the deep insult of murder-lust. But only by virtue of biology, hardly more than automatic breathing. The point of resurrection is that you regain the *wholeness* of the body, and this is the function of the living only. Those who died are presumably once again a part of the residue of creation. The modern method of the unregenerate living dead is, apparently, to shut the eyes. For instance if you are a non-Indian citizen and do not know of the baby sucking the breast of the dead mother, or an Indian, and there must be Indians who are ignorant of that image, again it can hardly matter, the factors of existence neither require acknowledgment nor are they affected by it. It is in ourselves we feel the weight and leverages of reality without ever knowing what or how those levers move. The white man who doesn't know who an Indian *is* may not be any more "guilty" thereby: he may be pretending to be alive, though. And why are some Negroes brown? Wasn't some white man there, or are we dreaming? Haven't we all been somewhere? Isn't all reality familiar, somehow? Haven't we all had something to do with one another?

It makes little difference . . . where one opens the record of the history of the Indians: every page and every year has its dark stain. The story of one

tribe is the story of all, varied only by differences of time and place; but neither time nor place makes any difference in the main facts. Colorado is as greedy and unjust in 1880 as was Georgia in 1830, and Ohio in 1795; and the United States Government breaks promises now as deftly as then, and with an added ingenuity from long practice.[17]

And in 1966 what are the banalized, superstitious designations used to identify Indians? The following is from the excellent article, "Who and What is an American Indian?" by Frell M. Owl, who is a member of the Eastern Band of the Cherokee Indians of North Carolina and was at the time of his retirement from the Bureau of Indian Affairs, in 1961, Superintendent of the Fort Hall Indian Reservation:

A tribal member is an "enrolled Indian." An Indian who is not a tribal member is a "non-enrolled Indian." A "non-Indian" is a person who does not possess Indian blood. "Full-blood" means pure Indian. One who is part Indian and part non-Indian is a "mixed-blood" or "breed." An Indian is generally regarded as a "ward" of the United States. An Indian who can manage personal affairs without help of Government workers is a "competent Indian." One who needs help in managing personal affairs is "incompetent." "Reservation Indian" may indicate residence on a reservation or it may indicate the degree of acculturation attained by an Indian. A reliable, honest, industrious person is a "good Indian." One who is unreliable and constantly in trouble with the law is a "bad Indian." A person who has been converted to Christianity is a "Christian Indian." One who adheres to native religious ceremonies is a "pagan" or "heathen" Indian. Prior to 1924, a "citizen Indian" was a member of a special group of Indians. The President of the United States is "Great White Father." A "White Indian" is a person whose degree of Indian blood is small. An acculturated Indian may also be called a "White Indian." [18]

There is little need to speak of the pictures of these people you see in the book. The camera is at least as subjective as the word and inevitably has its own latitude. The Indian is no isolated subject and never was. Perhaps a Pequot of Mystic River sold into slavery to the West Indies after the colonial war of 1637, and those of his brethren left behind "forbidden" to call themselves Pequots, never met a Kalapooian. But that is an extreme case. On the other hand the two languages, Algonquian and Kalapooian are separated by only seven or eight hundred miles, say, from Helena to Eugene. This is a continent. I am

Sun Dance

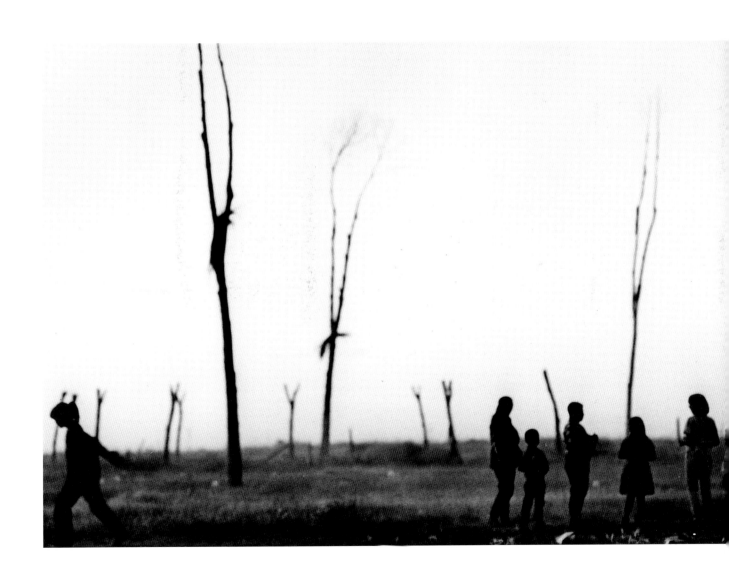

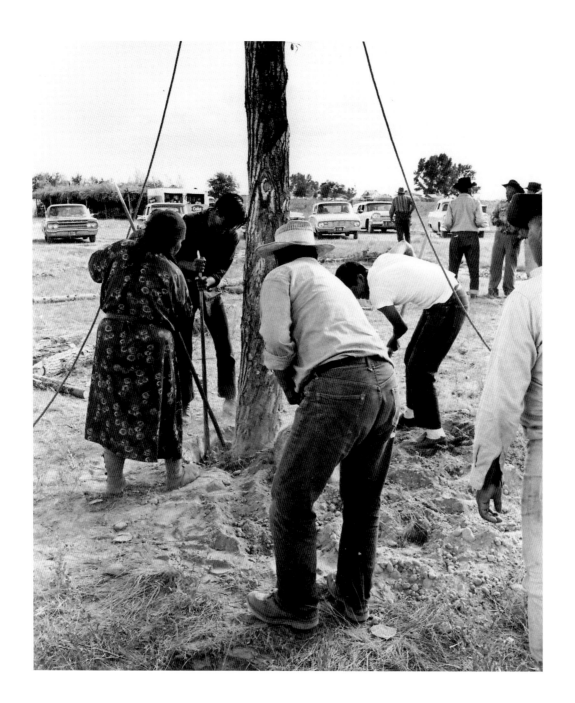

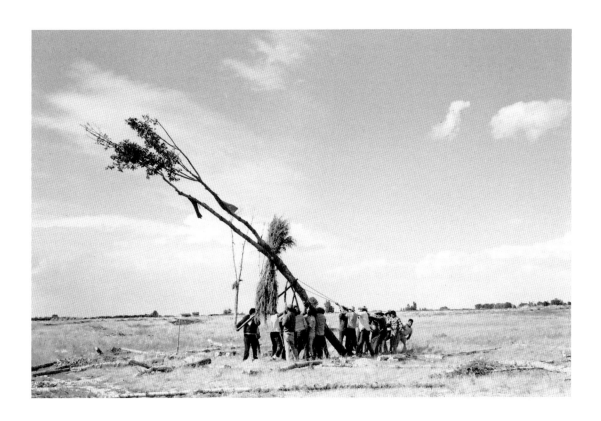

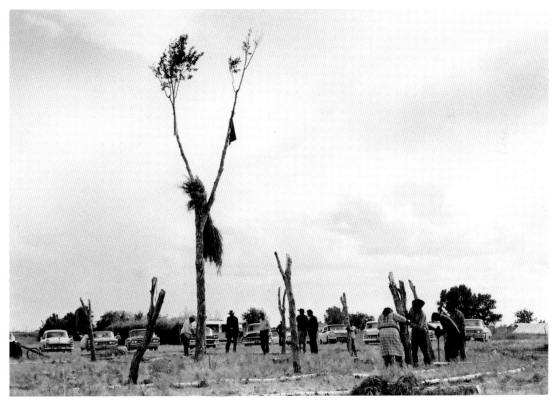

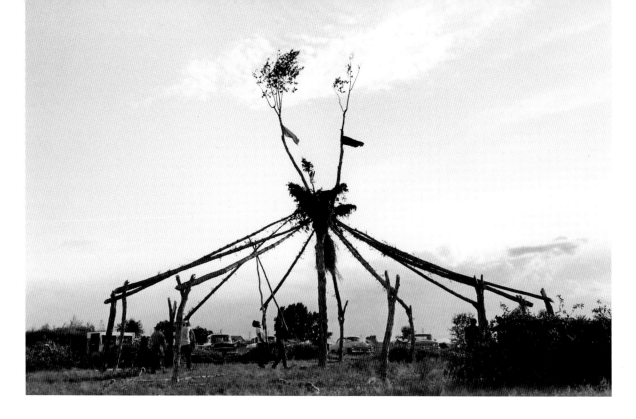

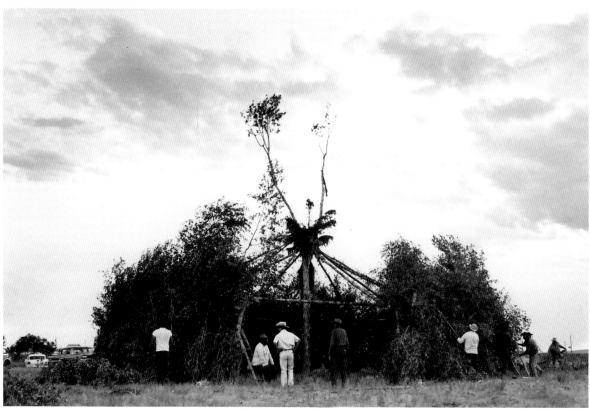

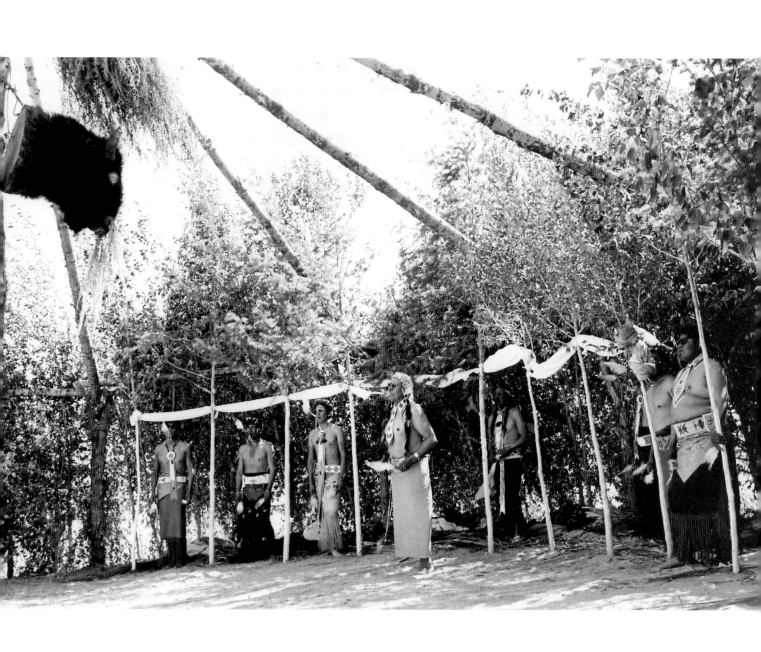

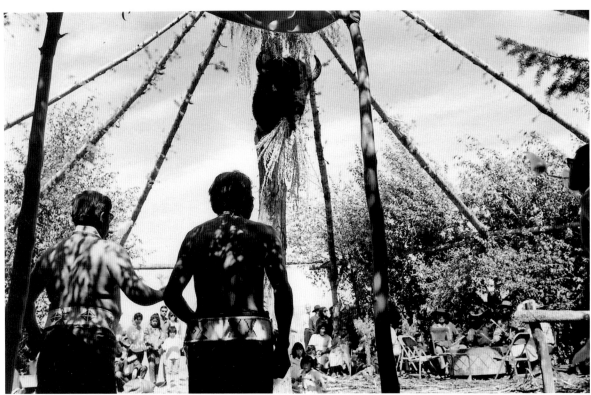

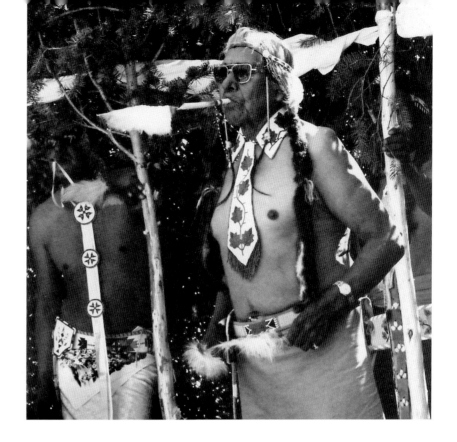

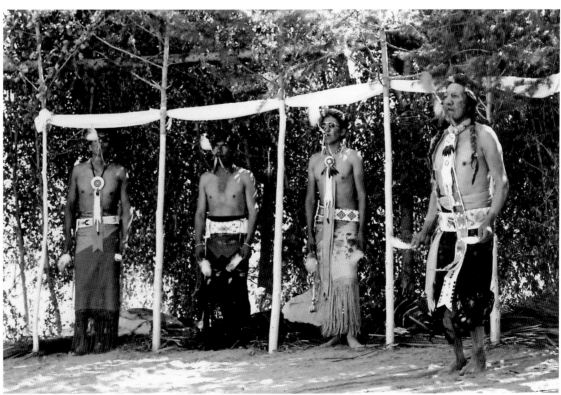

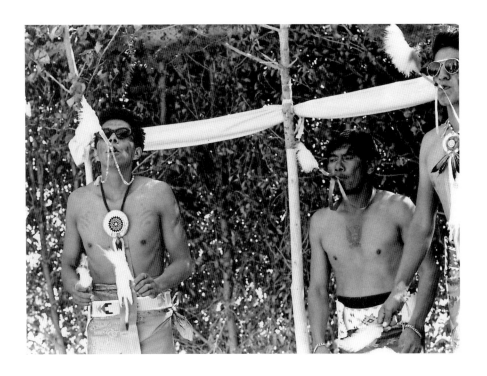

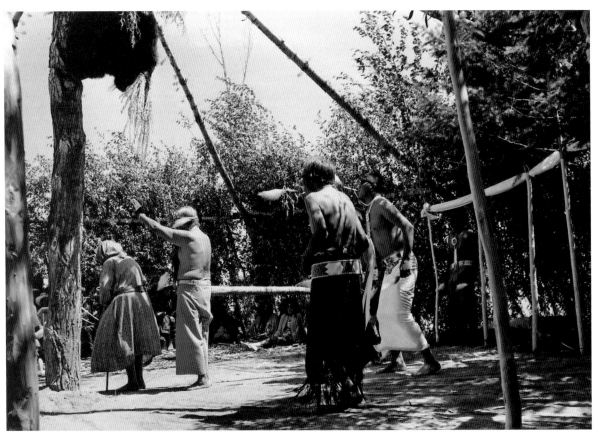

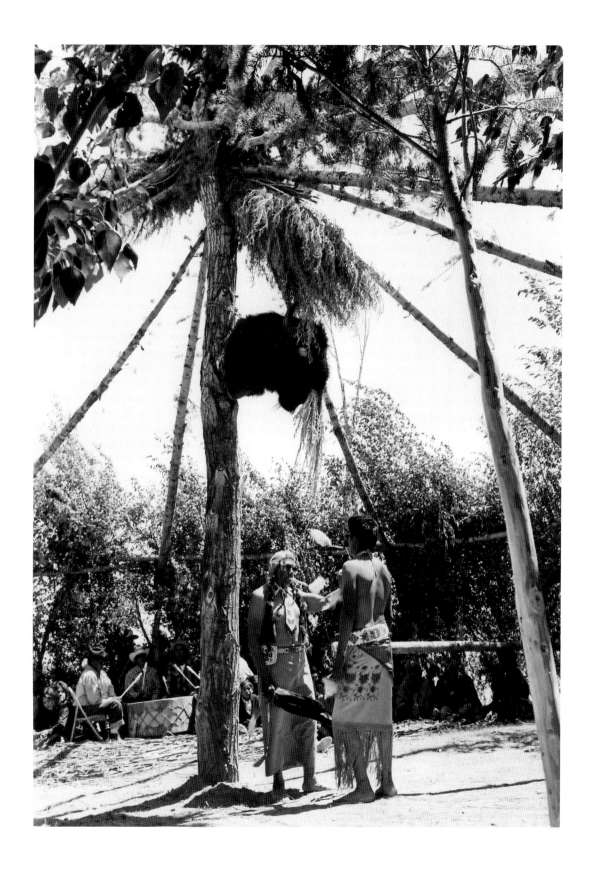

War Dance

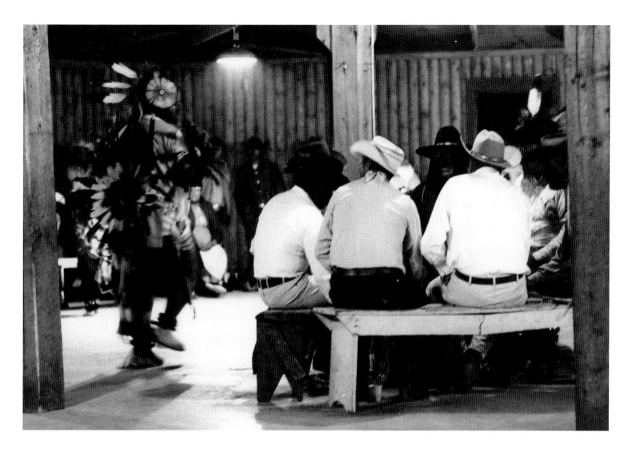

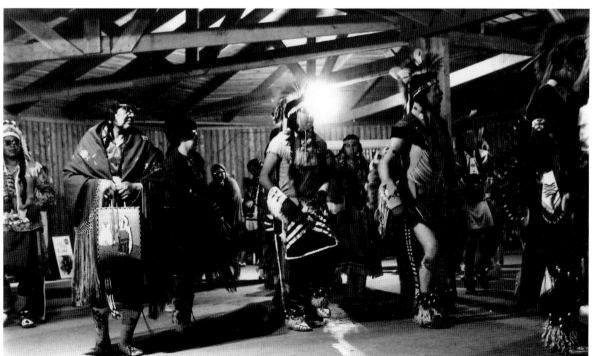

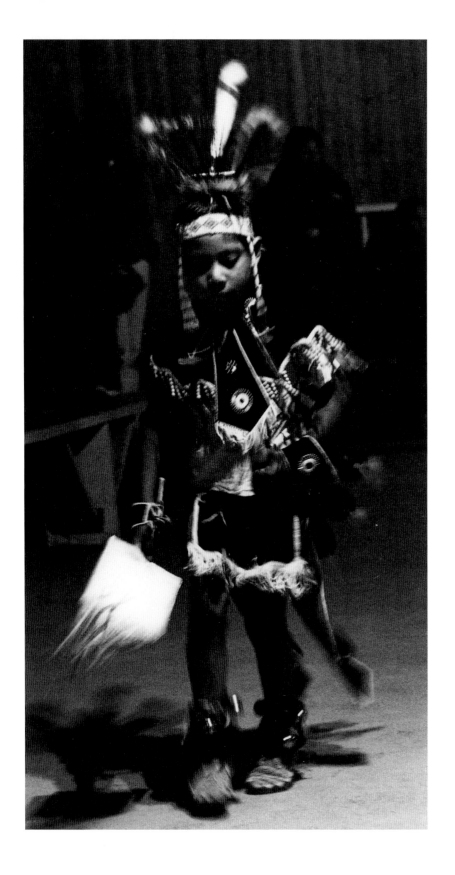

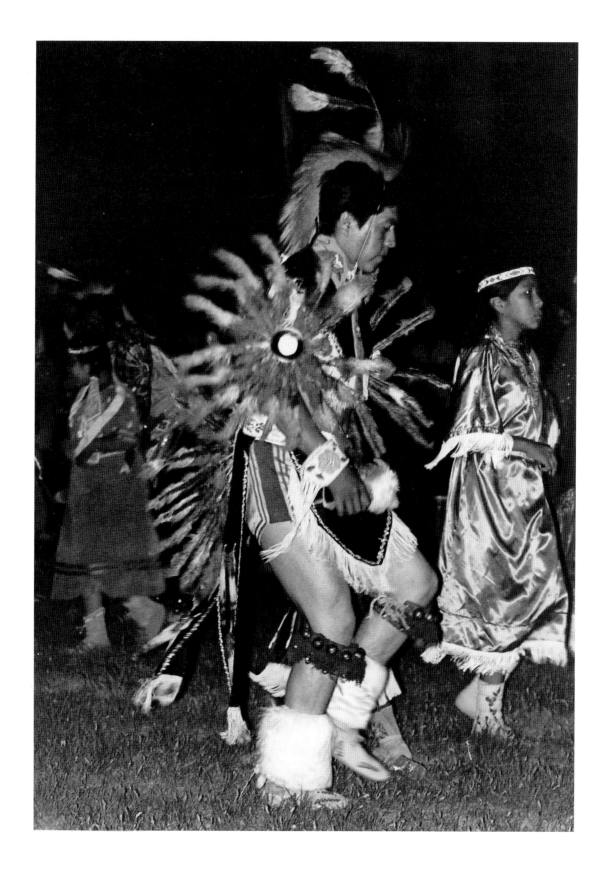

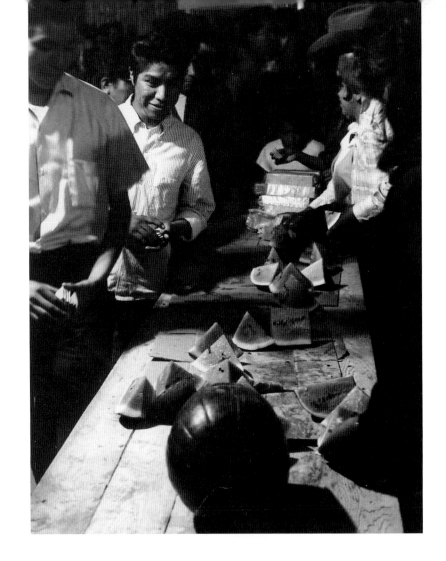

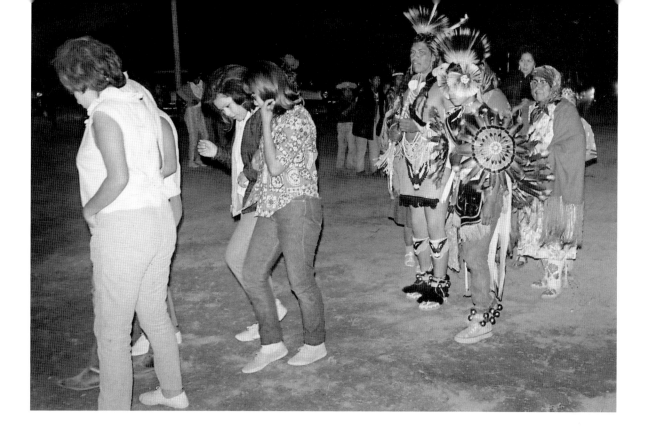

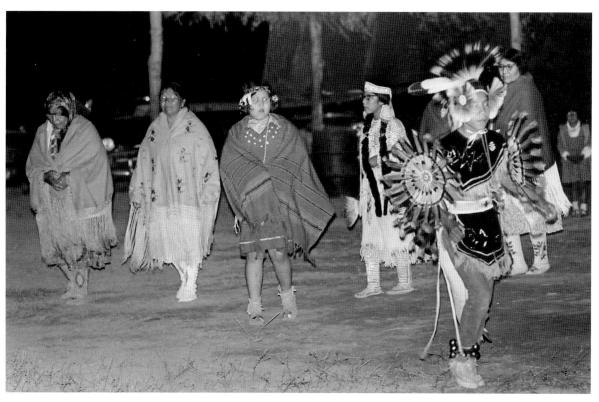

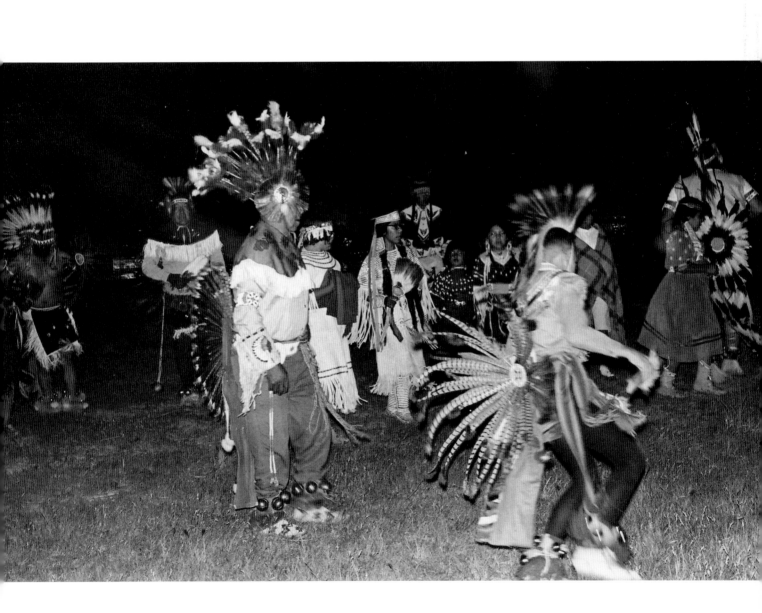

not trying to be simple beyond that. Certainly the language difference must be as difficult as the traverse of difficult country, Helena to Eugene, across the plateau between the mountains, nearly as difficult a trip as across the Basin. And why should you go anyway, if you don't have to? Impromptu travel is largely a late phenomenon for both white and Indian. The time has come now to recognize we have all been everywhere quite manifestly.

Questions of sympathy, outlook, ethic, point of view, attitude or whatever seem to me wholly beside the point. So what if one "feels" for the Indian? So what if one doesn't? The real ameliorative effect of civilized on uncivilized has thus far not shown itself to be much. The history of relationships has demonstrated that the "best" men were wrong, that the disposition of evil was finally never vivid enough to be remembered seriously except as a mark of our redolent capabilities. Indian and white hearts were broken, white lusts satisfied, but that did not make anyone more Indian or more white. What it comes to in our day is this: Who are the most usefully habitual people? Who are the most vivid members of any given people? It is all back in the street. Even in small towns. There the distinction is clear in the East as well as the West. An Indian family crossing the intersection of some dusty main street in a 1952 Ford. Or a Negro just released from a Utah prison trying for the life of him to find out, with all the dangerous sense of nuance a delicately experienced man has, how to get from this corner to the restaurant in the next block without becoming too precise in the eyes and noses of the indigenous loafer—whether he be businessman or town bully or cop, and the prisoner never has to sort the differences. Or a white bum wondering if, as he passes through Pocatello, he can get a job in Cheyenne as a dishwasher. If he gets to Cheyenne. Of course he can't. They can't. Nobody should have to. If one thing is clear today it is that the prevailing structure of supply is dead and has been dead from the beginning of the Industrial Revolution. All that gain was an unavoidable but nonetheless wholly mistaken activity. The grain grown on the appropriated hills of Idaho is used to buy off the Indian still— now it is shipped to India to secure the subcontinent against the ambitions of a China. Any stranger, passing along the ghostly sidewalks of our towns and cities, instinctively knows that he lives in "a permissive asylum."

But it may have become impossible to listen. The August 8, 1965, edition of the *New York Times* has in its pages a vacation article which points out the best areas to see "Indians in their natural environment." Real, live Indians. Take the kids, they'll enjoy it, and besides it is so educational. But it had better be good—Junior may not know much about Indians but he knows how to yap if the performance isn't up to snuff. The camping facilities are better in some places than in others, of course, and that ought to be taken into consideration. Some "ceremonies" are more "colorful" than others. A very few reservations have been "hostile" to tourists in the past and still do not "welcome" them. Avoid these. In the Bureau of Indian Affairs booklet, *Vacationing with Indians—A Guide to Campgrounds and Tourist Attractions on Indian Reservations,* Fort Hall is not listed. Neither is any other reservation in Idaho listed. This probably means that the Chamber of Commerce has failed to do its job. A piece of luck for local Indians.

Only in the instance of exchange can you find sense. It is strictly a matter of testing the process, living in it. Leroy Lucas entered the foot races at Gibson Lodge. Anyone might run a race, but the question is, will he have that sense of it? He danced. Three days' dancing in the burning sun without food. Only small sips of water mixed with clay. There are reasonably enough few Indians who will themselves take on that ardor. One can voluntarily or involuntarily take on another man's politics, his economic or social terms, and fairly well understand the risks or rewards. But you don't fool around with his ritual. There is nothing to demonstrate, nothing to prove, because you have moved into the matrix then, not into what he merely seems via your impressions. Both the Shoshoni world and the Afro-American world of Leroy Lucas were honored. And the honor did not derive from some stupefacient gimmick like race. He was there prepared to do more than look, was very much an emissary of himself. It is not so much that the tourist is incapable of the necessary singularity, even if he and the Indians were disposed toward an exchange. Rather his presence is compromised, he is not free to enter. He is a subject of a state wholly secular whose ceremony is now vestigial. The ill-fitting chasuble he wears has been stitched not in Sodom as he could be made to believe, but in the far less interesting personal sweatshop of his own systematic carelessness:

he is cheated by his very eagerness to believe that to look, tongue lolling, and then stumble on is to be alive.

Finally, these are pictures of a people who are still very potential in this hemisphere. Not Indians, certainly. That's the famous mistake Columbus made. They aren't Indians and they aren't, equally, *Americans,* another Italian assumption. It is up to them to say who and what they are. Saying and being can hardly be divided. All "American Indians" have *their own* names for themselves, naturally enough. And their names are not Shoshoni, Cheyenne, Apache, Sioux, Seminole, Caddo and what not. Those names were given to them by the various people who thought they were Indians.

I have tried to speak not of given Shoshoneans because they must be left men, women and children, in a stricter sense than it is the habit of government, agency and citizen to remember. No first names, please. No conniving familiarity. Willie Dorsey is so intensely Shoshoni he is now a part of the world and earth, the form of his death is organic. In him we are honored to witness the total exclusion of the private. If we happen to find ourselves in the frame of a human integrity of that order, we can go openly toward it. Heaven, or nothing less. There is an apprenticeship of the spirit as well as of carpentry. All religions know that, even if the more democratic ones hide it from their novitiates. Hard work is not the answer. Of all things, diligence is hateful to the spirit. And one's senses are so in debt, an open mind is a boast too idle to do more than laugh at. But it has to be better than that. What the European found here was a collection of cosmologies he thought was a continent. He saw Indians and many tribes of those. The nuances of language articulate each spirit differently but he never knew the languages beyond the few jargon mutations needed for bargaining. Just as he never knew when he crossed the Basin-Plateau those people were anything but "poor" or, if he were eloquent, "wretched." And it is still his yardstick of Indianness—the poor Indian is more Indian, to him. The American hegemony was always economic and pseudo-real. The "successful" Indian is less Indian. And less likely to land in trouble.*

* The police in Pocatello have a reputation for extreme brutality toward Indians who are picked up on the street and thrown into the "drunk tank" at the city jail. I can't say for certain how much the reputation is earned. But hardly a week goes past without report of an Indian subjected to beating, always severely, sometimes fatally. The local newspaper is evidence enough that, in Traffic Court, Indians are consistently given higher fines and longer jail terms than whites for the same offenses.

Although the spiritual manners of the Indian and Negro are demonstrably and happily quite dissimilar, it seems as true to me that the statement about acculturation LeRoi Jones made in a speech in Buffalo to his own people is true for the Indians—that any people are told to destroy, or get rid of, what is most essentially themselves before admittance into the homogeny. Since there is no spiritual life worth entering, they are asked, as initiation, to subscribe to the cheap and dishonorable mentalism of the "American Dream." Simply, "Let's think alike," the correlative to that famous Spirit of Independence. A reasonable guarantee must be given that you will kill the *right* people when told to, follow instructions, for God's sake don't kill the wrong people, last week's newspaper was full of that.

The atrocities committed by the American Indian in defense of his territory during the invasion/expansion were as terrible as those committed by the whites, it is often said. But the difference is an important and initial qualification: A technologically primitive people defended their world against the force of the organ of Western Destiny—and some unfortunate northern European settlers were the extended bit of that tool, merely a part of the instrument we call the Western World. I cannot see that there is any comparison between the two sufferings at all, except the obvious juxtaposition. Separate fates were at work upon a joined ground, and still are at work. That the Western World won the continent merely by occupation seems as equivocal as that it won the Western Hemisphere by the destruction of Tenochtitlan or the declaration of the Monroe Doctrine. And any of the Indian habits (horse stealing, any pertinent appropriation of white property with the concomitant "hostility") are as valid as the continuing ambivalences of whites, viz., disrespect for Indian religious practices, the sly legal pressure to appropriate Indian land, the constant pressure from sportsmen to curtail or abridge Indian hunting privileges and the general harassment of Indian peoples in Justice of the Peace courts. This has little to do with right and wrong. When those disheveled relatives of the Shoshoni, the Gosiutes, stole horses from the California emigrants without a thought to ride them (and thus "better their condition" since mobility somehow gives the mover the automatic right to acquire something not in his immediate vicinity) I find it as normal as the disgust felt by the emigrants.

The last thing a rich man wants to see a hungry man get is something to eat. The sight of that bothers him. He'll give you all you want to drink, more than you want, but not food. There are trickier and therefore better uses for horses. The Gosiute was suspiciously thin from the scarcity of the edge of the desert. He must have seen that noble flesh as several hundred pounds of live meat. Or however much it was according to his sense of measure. A week's substance for a half dozen families perhaps. In other words, it was *simply* real to him. And there is the difference. To the Reeds and the Donners the horses weren't real that way at all. They were useful. They were the instrumentation to move the richly laden wagons from nice Sangamon, Illinois, farms to the more glamorous possibilities of California, and that they were silly enough, so late in the season, to attempt a crossing of the Wasatch and then Salt Lake Desert is as much a measure of their psycho-materialist disregard of the meat of those animals as it is an assessment of the diggerism of the Gosiutes. Those Indians, by the luck of theft, occasionally filled their bellies. The Donner party failed just short of the pass in the early snow of the Sierras and some of them ended by eating their fellow beings, an act, it is said, terrible for a Christian man to contemplate. And the drab thing about them is, they must have thought of the Gosiutes, if they had such phrases, as welfare cases or unwed mothers. There is such a social clutter in the minds of the strong. Diggers indeed.

Little more than a hundred years have passed since then. They're still at it, only the names have changed, and in the Basin-Plateau scarcely anyone eats horses now. In the "88¢ Store" in Pocatello I saw two Indian boys approach the checkout stand. There was a cryptic exchange between them and the girl in charge. All very negative. They went out suddenly, dissatisfied, vaguely embarrassed looks on their faces. The girl turned to me with an overwhelming shouldn't-something-be-done-about-those-people shrug. I asked her what had happened. Oh, they wanted glue, she said, We have to keep the airplane glue under the counter or else they steal it, and we're not supposed to sell it to them anyway. Emphatic moral period when she stopped talking. And whom *do* you sell it to my dear? I thought. Surely no one builds model airplanes any more. The new myths of the American Indian deal with what? The fearsome realities closest to them, of course, as always. Small

tales which begin by locating dangerous ground, the signs of it, what to do, what not to do in a specific case:

"My Grandfather told me and my friends that if you go on fighting you will be killed. He said that if you are drunk and get into a fight you will be killed. He said that when you are in places that you do not know, you are bound to be in danger. He told us about how a man was killed by sucking glue. He said that if you suck glue, the glue might stop your heart. When his friend got drunk he threw his friend into the waters in Idaho Falls. He said that he was found in the water by a man." [19]

"What a people *does* in relation to its gods must always be one clue, and perhaps the safest, to what it *thinks*." [20] The tale the little boy told is interesting and instructive: it is one way a people have come to think of a social environment which has put the finger on its gods. The glue itself is not important, it is simply the current substance, the "88¢ Store" the current place, the salesgirl the current "hag in the dark wood." The Indian boys who seek to acquire the glue are undergoing, in some sense, the altered terms of their initiation rite. The rite will not be abandoned because one of the ritual objects proves difficult to obtain. The working out of the new theology, or mythology if you prefer, one will expect to be in the hands of those for whom it is most crucial to possess a lattice for their lives. The surrounding, non-Indian community will continue to see the merits of an Indian simply in the progress he has made away from the dishevelment of ambiguous gods, away from cheap wine and disreputable automobiles. The non-Indian community will never relax its hatred toward some practices of native Indian life—peyotism, the inhalation of airplane glue, the various burial methods, questions of sanitation, legitimacy and marriage, the lingering resistance Indian men have to domestication and routine work. All religious and civil facts are one great indiscriminate label—The Indian Problem. Meanwhile, those Indians who are apparently the most unable or "incompetent" and still "hostile," who go about marked by their sojourn through the bitter space of the past century, those are precisely the creatures whom with some pride we can call human, and who need no one to tell them what that means.

I have no need or intention to deny the speciality of my own view of Indian people and affairs. I am therefore pleased to give an American

Indian the last word in this essay. The following is an article, "Poverty, Community, and Power," written by Clyde Warrior (a leader of the Indian youth movement in the Southwest), which includes the speech he was prevented from giving to a conference of the "War on Poverty" program.[21]

Poverty, Community, and Power

In the midst of American society in nearly every state there exist cohesive groups of tribal people which are referred to as American Indians. These presently number over 500,000.

Within the last ten years the federal government has felt that to improve their lot, to insure "progress," American Indians should be moved to areas where American progress was a living Thing—twenty-four hours a day. Therefore the federal government by means of its instrument known as the Bureau of Indian Affairs embarked upon such a program in almost every American Indian community. There are approximately 100,000 American Indians who have recently been relocated by the Bureau or who have, on their own, moved to urban centers. Superficially this is well and good. On paper it appears that American Indians are "progressing" because they have moved to urban areas and are becoming like "US," but the 100,000 Indians who have moved to cities still maintain their home ties.

Today there are about 400,000 American Indians who still live in distinct communities in rural sections. Of this number sixty per cent live on Indian reservations. These lands are held in trust by the federal government. They are usually owned communally or tribally and are nonsalable and non-taxable. Indian lands are administered by the Bureau of Indian Affairs in much the same way that an imperialist government administers a colony. Instead of having a governor from the imperial government, a superintendent is in charge of the "colony." The "governor" or superintendent, because of the magnanimous nature of the benevolent colossus, administers for these areas. The government provides for these facets of Indian life—trusteeship for the land, social services, and programs designed by non-Indians for the betterment of Indians. These programs have been designed by well-trained technicians who have little understanding of the people involved. This is comparable to McNamara's designing of a military program for South Vietnam. The fact is nobody knows what the hell is going on.

Today American Indian tribes hold to a fiction which was "sold to them," by the federal government in the 1930's—the fiction of self-government.

This is well and good, but if these sovereign entities have self-government, why are their acts subject to approval by the Secretary of the Interior?

Forty per cent of American Indians today live in rural communities much like other citizens not on Indian reservations, although in many cases these were reservations at one time. In most of these regions the individually-owned Indian land is held in trust by the federal government, and the federal government recognizes some limited tribal organization and government. The Bureau of Indian Affairs also provides a few benevolent social services. The Ponca tribe of Oklahoma is such a community.

American Indians exist today in a variety of social and economic circumstances—one might say from sheepherders to steel workers. However, the majority of Indians are presently on relief. In the past they had no one particular thing in common. Today thanks to Western civilization, they have finally found the common denominator—poverty. Along with other minorities in this great society American Indians have come to share concerns about such things as civil rights, but American Indians are not as concerned about civil rights as they are about going to bed with an empty stomach. Many people wonder why this is so. American Indians come out of a very definite, defined historical tradition which stressed the preservation of the family, the people, and the community.

Today I see my people yet speaking many different tongues and living their lives in many different ways. We are the descendants of many small but independent nationalities with many distinct cultures. Recently our land was invaded and today we are temporarily submerged by a technologically stronger European culture.

The groups referred to as American Indians are the United States' fastest growing minority. Within the last fifty years they have tripled their population. To the gratification of many American citizens, individual "American Indians" have achieved prominence in the general society. But by and large the American public disregards and ignores the basic fact that American Indians, like most other ethnic groups, want very much to maintain their heritage and their culture. To state it briefly, they are like most other human beings who want to maintain the world they live in.

Historically speaking, the federal government has committed itself to "better the Indian." The way this is to be accomplished has never been clarified by the federal government.

It is typical of bureaucratic societies that when one takes upon himself to improve a situation, one immediately, unknowingly falls into a structure of

90

thinking—in order to improve any situation you take the existing avenues of so-called improvement and reinforce the existing condition, thereby reinforcing and strengthening the ills that are implicit in the very structure of that society.

The American Indian situation is a condensed and distilled version of the state of the union. The problems of American Indians are the result of bureaucratic behavior, of dehumanized interaction, of "intellectuals" defining the System.

In January of this year the National Indian Youth Council submitted a statement to the National Conference on Poverty in the Southwest. This fell on deaf ears because it was essentially a protest against the very conditions outlined above.

We are on the threshold of creating the Great Society. What was once thought a fantasy could become a reality. But if you don't speak, no one will listen—

The cancelled speech:

A friend of mine has a sign which hangs on the wall behind his desk. The sign says, "Are you contributing to the solution or to the problem?"

My name is Clyde Warrior and I'm a full blood Ponca Indian from Oklahoma. I appear here before you to try, as much as I can, to present to you the views of Indian youth. If I start my presentation with a slightly cynical quote it is because American Indians generally and Indian youth particularly are more than a little cynical about programs devised for our betterment. Over the years the federal government has devised programs and "wheeled them" into Indian communities in the name of economic rehabilitation or the like. These programs have, by and large, resulted in bitter divisions and strife in our communities, further impoverishment and the placing of our parents in a more and more powerless position.

I am a young man, but I'm old enough to have seen this process accelerate in my lifetime. This has been the experience of Indian youth—to see our leaders become impotent and less experienced in handling the modern world. Those among our generation who have an understanding of modern life have had to come to that understanding by experiences outside our home communities. The indignity of Indian life, and I would presume the indignity of life among the poor generally in these United States, is the powerlessness of those who are "out of it," but who yet are coerced and manipulated by the very system which excludes them.

I must say I smiled at the suggestion that this conference would draw together articulate spokesmen for the poor. There may indeed be articulate

spokesmen *for* the poor but there are no articulate spokesmen *of* the poor. If my relatives were articulate they would not be poor. If they could appear before gentlemen such as yourself and make a good case for their aspirations, they would of course not need a War on Poverty. They would not be "out of it." They might not be the warm human beings they are but they would be verbal, aggressive, and not so poor. They would have been included in on the act of America.

When I talk to Peace Corps volunteers who have returned from overseas, they tell me, along with many modern historians and economists, that the very structure of the relation between the rich and poor keeps the poor poor; that the powerful do not want change and that it is the very system itself that causes poverty; and that it is futile to work within this framework. I am not an economist and I cannot evaluate these ideas. I hope that men of good will even among the powerful are willing to have their "boat rocked" a little in order to accomplish the task our country has set itself.

As I say I am not sure of the causes of poverty, but one of its correlates at least is this powerlessness, lack of experience, and lack of articulateness.

Now we have a new crusade in America—our "War on Poverty"—which purports to begin with a revolutionary new concept—working with the local community. Indian youth could not be more pleased with these kinds of statements, and we hope that for the first time since we were disposed of as a military threat our parents will have something to say about their own destiny and not be ignored as is usually the case. If I am once again a little cynical let me outline the reasons for our fears. I do not doubt that all of you are men of good will and that you do intend to work with the local community. My only fear is what you think the local community is.

It has been my experience that many Americans think of a community in terms of a physical area or a legal unit, not in terms of a social unit—a unit where people have close personal ties one to another. Let me give you an example of what I mean. The Ponca tribe of which I am a member lives in Kay County, Oklahoma. You could call Kay County a community, it is a legally designated unit, but if it is a community my relatives are not part of it. In fact, I would imagine Kay County, Oklahoma to be a number of communities, as I use the term—several white communities and an Indian community. One white community, the business class of our county seat, owns the riches in the institutional structure and makes decisions for the other communities in Kay County. There is probably some overlap between the various white communities in our county, but certainly our Indian community, as far as being part of Kay County, might as well be on Mars. I

would guess that this is the dilemma of the poor, be they Indian, Anglo, Mexican-American or Negro. Our communities have no representatives in the legally designated units of which we are a part.

With the Indians this is even more complicated because, as many of you know, we do have a legal structure which articulates us with the central government even though we have no articulation with the county and state government. On the face of it, Indians seem to be in a better position than most other poor people. However, these institutions called tribal governments have very limited functions from the viewpoint of the Indians who live in our communities. In most places they serve as a buffer against the outsider. And in fact other people of prestige and influence among us thus go unnoticed and unbothered by the white man, so that much of our important leadership is hidden from the eyes of outsiders. Many times our tribal governments, which have very little legal power, have been forced into the position of going along with programs they did not like and which in the long run were harmful. They had no choice. They were powerless to do otherwise.

Modern Americans have developed a habit in recent years of naming something and then assigning attributes to whatever they have named which are part of the name itself. There is no Kay County, Oklahoma, community in a social sense. We are not part of it except in the most tangential legal sense. We only live there. There is no Ponca tribal government. It is only named that. We are among the poor, the powerless, the inexperienced and the inarticulate.

I do not know how to solve the problem of poverty and I'm not even sure that poverty is what we must solve—perhaps it is only a symptom. In a rich country, like the United States, if poverty is the lack of money and resources that seems to me to be a very small problem indeed. So I cannot say whether poverty is a symptom or a cause or how one would go about solving it in pure economic terms. But of this I am certain, when a people are powerless and their destiny is controlled by the powerful, whether they be rich or poor, they live in ignorance and frustration because they have been deprived of experience and responsibility as individuals and as communities. In the modern world there is no substitute for this kind of experience. One must have it to make rational choices, to live in a world you feel competent to deal with and not be frustrated by. No one can gain this experience without the power to make these decisions himself with his fellows in his local community. No amount of formal education or money can take the place of these basic life experiences for the human being. If the Indian does not understand the modern economy it is because he has never been involved

in it. Someone has made those decisions for him. "Hand outs" do not erode character. The lack of power over one's own destiny erodes character. And I might add, self-esteem is an important part of character. No one can have competence unless he has both the experience to become competent and make decisions which display competence.

In the old days the Ponca people lived on the buffalo and we went out and hunted it. We believe that God gave the buffalo as a gift to us. That alone did not erode our character, but no one went out and found the buffalo for us and no one organized our hunts for us, nor told us how to divide our meats, nor told us how to direct our prayers. We did that ourselves. And we felt ourselves to be a competent, worthy people. In those days we were not "out of the system." We were the system, and we dealt competently with our environment because we had the power to do so. White businessmen and bureaucrats did not make the Ponca decisions, the Poncas made those decisions and carried them out. If we were rich one year, it was our doing and if we were poor the next, we felt competent to deal with that condition. Democracy is just not good in the abstract, it is necessary for the human condition; and the epitome of democracy is responsibility as individuals and as communities of people. There can not be responsibility unless people can make decisions and stand by them or fall by them.

I might also add it is only when a community has real freedom that outside help will be effective. The lessons of new nations have certainly taught us that. It was only when colonies in Africa and Asia had their freedom that economic help from France and England became productive. We can apply that lesson here in America to the local community itself.

I congratulate you gentlemen on the great crusade you have undertaken. I wish you luck, not for your sake, but for the sake of my relatives; and I beseech you to *in fact* deal with the local community, not just a physical or legal area, but a community of people. Give our communities respect, the power to make choices about our own destiny, and with a little help we will be able to join the United States and live a decent fulfilling life.

Clyde Warrior, 1965

ENDNOTES

1. *Handbook of American Indians North of Mexico*, Frederick Webb Hodge, ed., Bureau of American Ethnology Bulletin, No. 30 (1912).

2. Theodora Kroeber, *Ishi in Two Worlds: A Life of the Last Wild Indian in North America* (Berkeley, University of California Press, 1961), p. 5.

3. Julian H. Steward, *Basin-Plateau Aboriginal Sociopolitical Groups*, Bureau of American Ethnology Bulletin, No. 120 (1938), pp. 10–14.

4. *Ibid.*, 235.

5. W. E. Woodward, *A New American History* (New York, The Literary Guild, 1937), p. 424.

6. J. A. Jones, *The Sun Dance of the Northern Ute*, Bureau of American Ethnology Anthropological Papers, No. 47 (1955), p. 220.

7. *Notes From Underground* and *The Grand Inquisitor*, trans. by Ralph E. Matlaw (New York, E. P. Dutton Everyman Paperbacks, 1960), p. 183.

8. Julian H. Steward, *op. cit.*, p. 5.

9. J. A. Jones, *op. cit.*, pp. 253–54.

10. Julian H. Steward, *op. cit.*, p. 86.

11. *Ibid.*, p. 158.

12. Fred W. Voget, *Current Trends in the Wind River Shoshone Sun Dance*, Bureau of American Ethnology Anthropological Papers, No. 42 (1953), p. 495.

13. J. A. Jones, *op. cit.*, p. 228.

14. Henry Nash Smith, *Virgin Land: The American West as Symbol and Myth* (New York, Vintage Books, 1957), p. 218.

15. Fred W. Voget, *op. cit.*, p. 496.

16. D. B. Shimkin, *The Wind River Shoshone Sun Dance*, Bureau of American Ethnology Anthropological Papers, No. 41 (1953), p. 450

17. Helen Hunt Jackson, *A Century of Dishonor: The Early Crusade for Indian Reform*, Andrew F. Rolle, ed. (New York, Harper Torchbooks, 1965), p. 337–38.

18. *Ethnohistory*, Vol. 9 (Summer, 1962), p. 265–66.

19. Cordell Buckskin, age eleven, told this story in a public "legend contest" at Fort Hall Community Center. It was passed on to me by one of his teachers, Mrs. Jeanette Serpa, of Pocatello.

20. J. E. Harrison, *Prolegomena to the Study of Greek Religion* (Cambridge, Cambridge University Press, 1903), p. a5.

21. Speech by Clyde Warrior, "Poverty, Community and Power," *New University Thought*, Vol. 4 (Summer, 1965), p. 5–10.

Appendix

Historical and Archival Materials, Introduced
and Annotated by Matthew Hofer

INTRODUCTION: "FEW/PEOPLE ARE LOST AS I AM":
ED DORN THROUGH THE GREAT BASIN-PLATEAU

Matthew Hofer

Ed Dorn's serious engagement with Native Americans and the western United States became a quest to discover something about place, time, and American identity that entailed, at first, a need to get lost. The kind of lostness that Dorn sought differs from the embarrassment of instrumental travel, the frustration of a teleology that is no more ambitious than a linking of point A to B. His journey did not follow such a conventional route, and this introduction to published and unpublished material relevant to that peregrination is meant to serve as a guide to his poetic and intellectual development during the crucial years that culminated in the publication of *The Shoshoneans.* As Dorn himself once expressed it, in retrospect, "its matter was, although at times linear, disconnected from reservation to reservation and from individual to individual. And, in fact, apparently, that could serve as a general description of how it is with the people of the basin-plateau too."*

 * I'd like to thank everyone who helped to shape this work and make it possible, especially Ammiel Alcalay, Stephen Fredman, Lindsey Freer, Alan Golding, Kaplan Harris, Scarlett Higgins, Aldon Nielsen, Kyle Waugh, and, of course, Jennifer Dunbar Dorn, Leroy Lucas, and John Byram of UNM Press.
 "The Poet, the People, the Spirit," 142. Editor's note: All supplemental material included in this appendix deviates from manuscripts, typescripts, or initial presentations only in the correction of spelling errors, and, very rarely, of style or usage in order to avoid the risk

Not unlike the travel done by James Agee and Walker Evans in the summer of 1936 for *Let Us Now Praise Famous Men*, their famous photo essay of Depression Era cotton tenantry, *The Shoshoneans* too employs both the "motionless camera" and the "printed word" in an "effort to recognize the stature of a portion of unimagined existence, and to contrive techniques proper to its recording, communication, analysis, and defense."* Yet the particular attachments to topography as well as morphology in the text of *The Shoshoneans* also bear resemblance to the radically lyrical and episodic desert theory Jean Baudrillard articulates to begin and end *America*, a postmodern journey that posits that the "form which dominates the American West, and doubtless all of American culture, is a seismic form [and] you have to follow its own rules to grasp how it works: seismic shifting, soft technologies."† Informed by a compatible desire to seek out and respond to the immanent qualities of the basin-plateau and its people, Dorn's travel is also motivated by an urge to resist the innate complicity of the citizen with national institutions and systems by assuming the role of the outsider, the stranger, maybe even the guerilla.

The condition of having no place, one Dorn frequently assumes, complicates the idea of being found just as it facilitates that of being lost. The value of travelling outward without nostalgia—without any prospect of *nostos*, or homecoming—resides in a hope of encountering something "initial," something "without cultural reference" (162). Dorn's special sense of being lost is clarified in part by "The 6th" (111–12), a previously uncollected poem that was published by LeRoi Jones in his journal *Yugen* (1960). In this poem the painter Ray Obermayr, Dorn's former teacher, leads him on an early spring tramp into the wilderness around Pocatello, the largest city in Idaho's Bannock county, ostensibly to pick out a site on which to build a cabin on

of confusion. Emendations were made silently when doing so did not affect content or tone. Unless otherwise indicated by square brackets, ellipses occur in the original document.

 * Preface to *Let Us Now Praise Famous Men*, in James Agee, ed. Michael Sragow (New York: Library of America, 2005), 8. In neither this volume nor *The Shoshoneans* are the photos merely "illustrative"; rather, they collaborate with the text, and each is meant to "be read continuously, as music is listened to or a film watched, with brief pauses only when they are self evident."

 † Jean Baudrillard, *America*, trans. Chris Turner (New York: Verso, 1988), 10.

Obermayr's land, though Dorn already realizes that he will never use it.* The occasion affords Dorn an opportunity to examine his own orientation as a western American transplant in relation to his affection for his friend and the land:

> That afternoon with our backs resting
> against the vertical rocks there were … well I had to follow
> him there, to know land and love it, is a great thing few
> people are lost as I am. And I love this man because he loves Idaho.

The extraordinary sense of being lost that is registered here—which is epitomized later in the poem by the phrase "Everywhere I am, I feel I am everywhere else"—conspicuously resists vision, the easy and too often transparent metaphor of "I see" for "I understand." By obscuring this with ellipses the poet denies the resolution of description in favor of his preference for a more profound understanding, one achieved not by settling in a "closed world" but by traveling as a stranger through an "open" one. For such travel, a once-important stop on the first railway through Idaho during the gold rush is an ideal point of departure. Apparently reduced to the status of a "miserable accidental town even the Union Pacific abandoned," Pocatello becomes a monument to an uncritical and materialistic drive from east to west, yet its ineffable beauty, emitted at night, is of another order, when "Pocatello wasn't Pocatello but a jewel / the red and the blue, something you could never narrow down / to gas in glass tubes." This irreducible quality of the place not only elucidates the love that his friend exemplifies but leads Dorn to consider seriously the otherness of the west and its indigenous peoples, especially the "very poor" ones, those "you've never heard of," those who welcome neither tourists nor anthropologists.

• • •

Dorn's most intensive training as a poet and intellectual took place between 1950–55, as a student of Charles Olson and Robert Creeley at Black Mountain College in North Carolina, though that fact alone explains less than some may hope or think. The Illinois native accepted his later inclusion in what came to be called the Black Mountain School of the New American

* Correspondence between the two about building materials, plans, and schedules may have given Obermayr reason, at least initially, to believe otherwise (see 116–17).

Poetry not because of any stylistic consistency asserted among its practitioners "but," as he insists, "because I was *there*."* This idea of "being there," of having somewhere to be, became as crucial for Dorn as it had always been for Olson: that is, for both poets, the idea of knowing your place was integral to developing your style. A demand for saturation is the insight that motivates Olson's closely packed yet ranging epistolary essay of 1955, "A Bibliography on America for Ed Dorn," written as a response to Dorn's comparatively modest request that Olson supply him with some suggestions for reading "about the West," with a particular focus on "Indians."†

Olson's key principle in the Bibliography is specified in the section that follows his list of books and authors, in a wind-up toward a conclusion that reveals a need to move beyond publications, a call for

> *PRIMARY DOCUMENTS.* And to hook on here is a lifetime of assiduity. Best thing to do is *to dig one thing or place or man* until you yourself know more abt that than is possible to any other man. It doesn't matter whether it's Barbed Wire or Pemmican or Paterson or Iowa. But *exhaust* it. Saturate it. Beat it.
>
> And then U KNOW everything else very fast: one saturation job (it might take 14 years). And you're in, forever.
>
> This one *principle* […] plus millennia […] does the trick.‡

Olson's two-part postscript further complicates the concept of history in favor of morphology and of geography in favor of topography. His point, in both instances, is to convince Dorn that the "locus" of making meaning is now "both place & time," since only the context of the present can give meaning to the facts of the past. He also argues in a pointed postscript against abstractions, admonishing,

> *Indians* is wicked. I think the thing is to settle on one of 'em, either literally one, Red Cloud, say; or the Utes (whose language is a family of Nahuatl, thus showing Aztecs passed down Rockies); or a "civilization"—

* Edward Dorn, "*The Sullen Art* Interview," in *Interviews*, ed. Donald Allen (Bolinas, CA: Four Seasons Foundation, 1980), 1.

† Editors' notes to Charles Olson, *Collected Prose*, ed. Donald Allen and Benjamin Friedlander (Berkeley: University of California Press, 1997), 435.

‡ Olson, "A Bibliography on America for Ed Dorn," in *Collected Prose*, 306–7; hereafter abbreviated "BA."

like Plains, or Maya, or Arawak; or even a tribe, Shawnee, say—and once one is dug, the rest ought to yield more easily. ("BA," 308)

Although Dorn valued Olson as a writer and a teacher, he was not a blatantly Olsonian poet. He held, in fact, that because Olson was a master, "there is no trafficking possible with his means, so tied to the source is he with his art," which explains why minor writers "whose mechanisms in a sense overlap" cannot expect to "learn anything of use from him" (131). But in their differences as well as their affinities, relations between Olson and Dorn are instructive. Whereas Olson was tied to Gloucester and wrote with the confidence that a connection to that place inspired, Dorn, without a specific *there* to inhabit, posited that to exist a poet "has to *be there* as much as possible" (157). Moreover, Dorn extrapolated from this insistently present and conscious position that

> [p]eople can be nearly poets when they do this. Not people. Yeah, people. Anybody. People can, are poets when they *are* there with all of themselves. And that's—yeah that is a condition again to my mind, it's a possible condition. Never quite reachable, I mean *exactly*. But only, only *by* that condition can you have the force of a poem then. (Ibid.)

Dorn associates this stateless and boundaryless *there* with the Fourth World, distinct from the merely underdeveloped Third World, and claims that he also occupies it. Its defining characteristic seems to be that it contains those without a place, yet "where else you might take them that would *not* be their place" (155). An ability to identify with places and to relate identities to those places mattered for New American poets; Creeley cites Dorn's own writing on place in Olson's *Maximus Poems* to elaborate on how the

> American condition has much to do with *place*, an active spatial term which differs in that way from what has been assumed its European equivalent. Space, as physical ground, not sky, I feel once again to be politically active as it has always been for the American from the outset.[*]

This claim derives from Dorn's appreciation of Olson's Gloucester, in which he acknowledges that while he "would be bored to sickness walking through

[*] "Introduction to *The New Writing in the U.S.A.*," in *The Collected Essays of Robert Creeley* (Berkeley: University of California Press, 1989), 94.

Gloucester, […] when the Place is brought forward fully in form conceived entirely by the activation of a man who is under its spell it is a resurrectionfor us and the investigation even is not extractable. And it is then the only *real* thing."* The Gloucester of *Maximus* is compelling because it is Olson. Few people were *found* as Olson was.

• • •

Dorn's essay "What I See in *The Maximus Poems*," which circulated widely (and still does) in *The Poetics of the New American Poetry*, can be understood as a response both to Olson's "Bibliography on America" and also to his unfolding epic. This is partially accurate. However, Dorn's essay, first published in 1960, began as a different reflection on emplacement, and its prior version helps to explain the journey in the summer of 1965 that became the photo-essay *The Shoshoneans*. Olson and Creeley's praise of "What I See" confirm its value as a piece of literary criticism as well as a general introduction to a notoriously difficult long poem (which it still possesses). Yet readers impressed by the density and nuance of Dorn's analysis in this essay may be surprised to find out that it was first commissioned by Gael Turnbull as a piece of "Readers Digest"–style writing. Turnbull also suggested the original title, "Ed Dorn in Santa Fe," which Dorn accepted "out of a vanity of my own, wishing thereby, to place myself easily" (127). As it became increasingly clear that "placing himself" was not going to be easy, the title became a hindrance—and Dorn complained in the only handwritten comment on the typescript, "This title creeps me out now!"

"Ed Dorn in Santa Fe" and "What I See" alike develop a sense of the American West as somehow alien, irreducible. As Creeley later put it in "My New Mexico," "Whatever the newcomer's disposition toward it all, the place is adamantly a condition in all that she or he can do. But it is as far, finally, from a simple regionalism—some accretion of human place and time—as is the literal moon, despite people have now walked on it."† Writing slightly before the accomplishment of people walking on the moon, Dorn employs similar rhetoric, explaining how place itself alters human senses to put one "really" in New Mexico: that is, "one really is 7,000 feet, the threading Rio

* Edward Dorn, "What I See in *The Maximus Poems*," in *The Poetics of the New American Poetry*, ed. Donald Allen and Warren Tallman (New York: Grove Press, 1973), 298.

† *Collected Essays of Robert Creeley*, 439.

Grande really is off to the right, though many miles, where the river perhaps doesn't change … But the sweep-out of the land one can see standing here, where it runs down all the way more and more barren, a moon-land, to Albuquerque and below" (128). The unfamiliar outpost is occupied by unfamiliar people, and this difference is concentrated in the figure of a

> man standing at the side of the street shouting in Navajo, at the police cars, shaking his fist, going back and forth in a frenzy across the plaza to stand there, shaking his fist, screaming in Navajo, at the passing cars.[*]

This passage occurs in both essays. However, the additional details about this unaccommodatable stranger in "Ed Dorn in Santa Fe" underscore the "problem" of native assimilation or integration: "He has," we discover, "an old hat jammed on his head. His precise dress shows he is used to the boxcar" (130). The point here is that he is not only accustomed to travel but always ready to depart, itinerant if not strictly indigent. This man, whom Dorn with no trace of condescension calls "my man," makes a second appearance several paragraphs later, accompanied by other "Indians … down in the plaza," some of whom "probably don't have a way home." A rare and telling emendation to the first section of the essay has him "screaming in his off-reservation world" (298) rather than, again, "screaming in abrupt Navajo" (131). This change underscores his "Fourth World" status: the native, Dorn suggests, may have only an uncertain place on the reservation, but he is unavoidably a stranger in the *off*-reservation world.

The second section of "Ed Dorn in Santa Fe" differs entirely from the second and third sections of "What I See," and here the concepts that spurred Dorn to collaborate with photographer Leroy Lucas on *The Shoshoneans* come fully into view.[†] The draft opens with an insistence that Dorn and his family live in Santa Fe only "temporarily"; that he will have to assume "that Santa Fe did not exist before I got here, not out of a vanity, but as the only way I know how to proceed, since no *artist* has bothered to mention it"; and finally that "Santa Fe didn't greet me at all and I wouldn't have liked it if it had, not dealing in dates, or any other raw material. If one is spiritual these days, and I am, it is a marked complication to be greeted, or even known, too

[*] "What I See in *The Maximus Poems*," 295; "Ed Dorn in Santa Fe," 130.

[†] Through 1965 Leroy Lucas was at least intermittently using the surname McLucas, though the initial publication of *The Shoshoneans* does present his name as Lucas.

widely" (127). A focus on indigenous difference gives weight and interest to the essay on Santa Fe, and does so in intriguingly unconventional ways; "[i]t is," he discovers, "a wild place," and "the confusion is fabulous" (135). The figure of the Indian haunts this particular "hinterland," and, as Dorn recognizes,

> We can't get off considering him. I am not shot on Indians myself. I don't mean any righteousness at all, like, "what they do is their affair." I don't feel sorry for what happened to them, I don't think anything was taken away from them any more than I think, know, anything was or is being given them. Of course when I hear a Zuni marching band in the street, it doesn't please me. It disturbs my sense of propriety knowing, just what you do, that it isn't their sound. I wouldn't like any people, nor would you, being made into monkeys. Good. (136)

The risk being articulated here is that of accepting U.S. monoculture in the wake of World War II as inevitable and of therefore performing sacred rites for profit rather than the sake of ritual. The incongruous band in Santa Fe—like the staged dances at the surrounding pueblos, but unlike the Sun Dance in *The Shoshoneans*—is said to be "all rote," "formerly remembered," and "a great difference" from any ritually significant expression (137).*

<p style="text-align:center">• • •</p>

* There are photographs of the Sun Dance in *The Shoshoneans* but no direct textual treatment of it, evidently because Lucas was accepted to perform the ritual whereas Dorn was not. The conclusion of J. H. Prynne's eulogy on Dorn helps to explain the critical consequence of this inevitable distinction between the black photographer and the white poet. As Prynne recalls, "it was a great source of humble amazement to [Dorn] that McLucas, at all these small native communities, was accepted immediately. When there was a Sun Dance, then Lucas would be accepted to do it; and Ed would not be accepted to do it! He simply was not the person who could be accepted to do it. And there was a kind of separation. And so, far from pretending that this separation didn't exist, or erecting some kind of self-righteous writerly insight that would carry him across this divide, he addressed himself very very deeply to this sense of exclusion, and to the level at which by spirit power you could get to the point where you could not cross the barrier, but see over it, and see down into the space which was not the white man's domicile, which he understood could not be the white man's domicile at all, but where by the power of imagination, he could elevate himself above the division, to look down on and to see into, with intense and humble clarity, and I thought that this was a true gift of the spirit." See afterword by J. H. Prynne in *Edward Dorn: Collected Poems*, ed. Jennifer Dunbar Dorn et al. (Manchester, UK: Carcanet, 2012), 941.

Dorn perceived that dire consequences would result from the growing uniformity of U.S. monoculture. Without the ancient laws of hospitality, an aspect of the culture we failed to inherit from the Greeks, strangers are neither welcome nor safe because "everyone in the community is a cop, everyone is a policeman, every woman driving a pickup truck is a policeman. [...] They watch you. You're a stranger. Why are you there? What right do you have to be in Nevada?" (156). The best available solution seems to rest with the Native traditionalists, those who actively resist assimilation and integration, those who are still able to "represent themselves," which is possible because "[t]he Basin-Plateau is self isolating" (148). Dorn confesses, "I feel very much like an Indian in a way. Because I remember when I was a young man there was no place to be either," but the difference persists in that the social and cultural forms have always been available to incorporate "even the most depraved of white Protestant American" into the national fabric, allowing him to "do that," to "be there" (157).* This makes being a stranger a matter of choice rather than necessity. For natives, however, Dorn does not find the same choice, and in this distinction is something that may be worth studying, perhaps preserving, at least trying to listen to. What effectively drives him out of Pocatello and into the great basin-plateau is a realization that "[a]nytime someone comes through Pocatello who looks like a criminal, or a fugitive, a bum, somebody weird looking—and it doesn't take much to be weird looking in Pocatello—I immediately recognize them as the people that I want to walk beside, to be near, to talk to, to be with" (159).

His response to that realization, which took the form of a researched

* In the years before native studies became "fashionable" it was neither surprising nor particularly clichéd to desire to associate (even identify) the figures of the "poet" and the "Indian" (141). Such positioning of uncompromised "authenticity" over and against institutional "authority"—a hallmark of the countercultural impulse of the American 1960s—still demands to be recognized within its specific historical context. Almost fifty years ago, when "pan-Indian" seemed a viable term and a prevalent rhetoric of exoticism received little of the critical scrutiny it is clearly due, a move that will strike contemporary readers as naïve— that is, Dorn attending the Berkeley conference as "the Indian"—suggested other possibilities to a socially sensitive artist. Indeed, Dorn's impulses to particularize and to historicize may be found to pose an early challenge to the problematic generalizations of his era. Those who find that his perspective risks an intensification of a dated sense of transcultural utopianism or an (intermittent) expression of presumptive identity politics should also consider that admiration, not acquisitiveness, underwrote his qualified act of appropriation.

book-length photo-essay, was, though a decade in coming, arguably quick at that rate (Olson predicted in the bibliography that it might take fourteen years of saturation). *The Shoshoneans*, in combination with Dorn's prose, poems, and letters from 1955–65, documents "the ONE JOB ... where one's nose is whittled," in Olson's terms, and points up its significance in making him, Dorn, the New American poet of the west ("BA," 307). He signed his contract in May 1965 to deliver the manuscript on the first of September, which not only spared him the need to join "that damn summer dig w/all those college students," but also made it possible "to get down to S.F. for the big scene," the Berkeley Poetry Conference from 12–24 July (120). In an introductory note to the published transcription of the lecture he gave at Berkeley, "The Poet, the People, the Spirit," Dorn reflects that he attended "as a substitute forced on the organizers of the conference by LeRoi Jones, who had begun to withdraw from such contact. And that's how I went along as the Indian" (142). To Creeley, on 10 June, Dorn explained,

> This book on the Shoshone is a good shot for me because it allows the clearing away of all that accumulated shit from the past semester, a drastically removed material. I'm spending my days now reading back into it and won't start any writing until I talk to McLucas and see what kind of photos etc. he's interested in taking. I want it to be as present and modern a take as possible, the mythology of sucking airplane glue, migrations in cars, families across the intersection etc. Luckily there is a linguist who is well disposed toward me here and since he speaks Shoshoni that will make it easier, but they are naturally hostile and suspicious people and have suffered a lot from local white hands—none of that slick professional Indian assurance and sense of presence one finds in the S'west. Diggers they were and mostly are yet. (121)

This research proved integral to the process and Dorn was reading intensively as he waited for the project to begin. To Tom Raworth, eight days later, he added,

> The book I contracted for, and indeed signed a contract for, and accepted a 500 dollar advance for to get thru the summer, is not even started. I finally got very bugged that LeRoy McLucas, the photographer, had not shown up so I called NY and he hadn't even left! but says he'll be here

next week.* I've in the meantime been reading every day about the Shoshone. […] I can see I'm going to be finally pressed right against that Sept 1st deadline. Oh well, and fuckit. I've been reading lately on the Wind River (wyo) Sundance. The eastern Shoshone. The sundance was a curing ritual and still is but the thing has got to be something else…. (122)

While Dorn's feelings about *The Shoshoneans* oscillated (his term) during the course of researching and writing it, the final text represents the wild wandering of a white poet and black photographer in Civil Rights era— also Vietnam War era—America through a part of the indigenous west that had resisted prior incursions. His reports from the field are sometimes ecstatic, sometimes deeply critical. Yet his overall satisfaction with the experience seems clear enough in an August letter to Olson: "Am now well into Shoshoni book—it looks good…." (124). At the Berkeley conference Dorn had more to say about the process, thinking specifically of strangers and American identity, observing,

They don't want anything to do with any national thinking. They don't think of this as a country. After all that's our word: America. You say, "Well, you're American too. You're the first Americans." Nix. They're not the first Americans. They never were Americans. That's *your* word. […] They've got a word for what they are but you don't know that. Because you've never of course taken the trouble to find out what it is. And you couldn't pronounce it anyway. (145)

Dorn privileges those differences that are not merely superficial, and insists that

[t]he man who doesn't belong in a community is probably the man to pay attention to. The old idea of the stranger is very strong. That's definitely a Greek idea. We may not honor him anymore. We don't…. [W]e didn't inherit that part of the culture unfortunately. But we certainly know who he is and the stranger's fearsome. He's the man to talk to. He's the man who knows where he's come from. (159)

* In a letter dated 26 April, Lucas again stated (twice) that he would arrive in Pocatello on 9 June.

This makes possible the idea of living without boundaries, which is the condition to which Dorn aspires and the one that Indians have made available to his understanding. Those who can achieve it "are precisely the people who for one reason or another have compromised their allegiance to the thing that might destroy us all, including them" (ibid.). Dorn asserts that such a rejection of nationalism, a conscious jettisoning of complicity, moves beyond revolution, for "it has to be far more radical and far more subversive than that. I think the people just have to stop paying attention to that bullshit and turn their backs on it. They have to start looking at each other." As that happens, he predicts, "[t]he state will become less and less important ... and it won't even know it" (ibid.).

• • •

The day after Dorn's reading at the Berkeley conference he and Olson had a revealing conversation about the enabling process of getting lost, prompted by a question about how they found one another, or how their "two lives came together." After some initial joking, Dorn earnestly tells Olson, "I thought of you when I was going through Nevada ... and trying to get out of that fix, you know, that local fix which I'm so hung up on anyways...." He continues to elaborate on this topic of superseding the local, explaining,

> This chant I heard, the old man [Willie Dorsey] dying, a Shoshone, actually a Northern Paiute. It was at Pyramid—no, it wasn't at Pyramid; it was at Duck Valley. I finally understood how you can use things that are, say, not available to you. [...] Well, this chant meant a kind of spiritual affirmation in me very much, and was not cultural; it was simply something I heard. [...] And I heard it literally; I mean, understanding is really beside the point. And I heard it as a death chant. It was piercing, I mean, you know, the thing just went through your body. It was a really beautiful song. [...] I had never had that experience before, feeling an immediate response from something outside myself. And then, you know, the possibility of its being initial, without cultural reference. (162)

The quest to get back to origins entails a possibility of moving outside or beyond cultural reference to something affirming and initial. In this process, place names are vitally important, and their importance is accentuated by the fact that when Dorn forgets this one in conversation he feels a need

to stop and correct his error.* The opening sentence to *The Shoshoneans*—a book that pays special attention to the artificiality and danger of borders—confirms as much: "I begin where it was highest pitched for me, at Duck Valley, on the Nevada-Idaho border," and Dorn then elaborates on this key notion by explaining that "[i]t is [Dorsey's] quickness that remains in me and why I choose to begin this essay on the Shoshoni with him, the highest circumstance I have ever encountered" (9, 14). Olson confirms the revelatory power of Dorn's experience of Dorsey's chant, and this manifestation of power, a quiddity of song, is for Dorn spiritual *and* material in a non-metaphysical sense. Here absolute difference as a thing can be conveyed and comprehended through song without any further cultural context, without borders or barriers, and thus without the burden of complicity that implies.

Dorn completed the manuscript of *The Shoshoneans* on shipboard as he traveled to England at the invitation of poet-critic Donald Davie to join the faculty as a Fulbright scholar in Davie's newly founded interdisciplinary literature program at the University of Essex. As Dorn relayed to Creeley in April 1965, Davie

> wanted me for several reasons. First because, as he put it, my reputation
> had been established outside the accepted reputation making circles
> (first time I've had that pointed out as a virtue, and […] I have to dig
> that rectitude) and second because he likes my writing, in his way of
> course, and third because he has an interest in the west and takes my
> sense of the west to be a metaphysic which will square his sense of the
> separation between Pound and Olson. The last reason is a mistake of
> course but I figure I can help him with that. (119–20)

Arrived in Colchester, Dorn completed the volume of poems *Idaho Out*, the next yield of his Olson-inspired saturation job, and, as Olson had assured

* The preface to *Idaho Out* revisits a concept delineated in the "Bibliography on America" of a "TRANSFER TO LOCAL" that is exemplified by "THE ODYSSEY AS A REWRITE OF A SEMITIC (PROBABLY PHOENICIAN) ORIGIAL SAILING DIRECTION," the evidence for which Olson took from Victor Berard's insight that "the Incidents in the Odyssey result from the Place-Names, in other words not fiction in any humanistic sense but that the process of the imagination is from 1) a place person thing or event—to—2) the naming of it—to—3) the reenactment or representation of it" ("BA," 301, 304).

him, "it's crazy, how, *one* yields," since afterward "[y]ou can go anywhere—right into some old maid's front parlor, Craigie Circle, Brooklyn or Monterey, Cal."—or even, apparently, England's first Roman city and reputedly the oldest town in Britain ("BA," 307–8). In this preface, written in that unlikely place, Dorn declares, "History has always seemed to me lying right on the table, forgetful of age, or not present at all. And geography is not what's under your foot, that's simply the ground" (164). Or, as he puts it in an unpublished poem dedicated to the poet J. H. Prynne,

> I have no place to be
> I am separated
> and I have no claim.
> good!
> I shall make no claim. (115)

<div align="right">Albuquerque, NM</div>

The 6th [For Ray]

I know a man, in the west too
in Idaho, oh, there are Indians there
but you've never heard of them, they're Bannoks
and very poor, always were.
Well, riches are obvious things and then it depends
on what routes they were subsequently on.
But this man, not the man I shall tell
you about later but another; a man named Swen,
who came from Sweden to study
the language
and they asked him repeatedly—
why he stayed so long (ten years).

Two months ago, in February, would you believe it
that far north the weather was so mild we could
walk about the hills, slight snow on the ground
and be very comfortable but maybe it was the fire
in our hearts because we were tramping for a house
site, one I knew I would never use, but the weather
I tell you was so perfect and the warmth of my friend
was like the weather, all in February. Very far below
was Pocatello, a miserable accidental town even the
Union Pacific abandoned in the forties. But the hills
and the moon at night on the snow all around that bowl
and at night too Pocatello wasn't Pocatello but a jewel
the red and the blue, something you could never narrow down
to gas in glass tubes. That afternoon with our backs resting
against the vertical rocks there were … well I had to follow
him there, to know land and love it, is a great thing few
people are lost as I am. And I love this man because he loves Idaho.
He wanted me to build a house somewhere near and I wanted to
but he you see, lives in a closed world but is very damn kind,
he is very great I like him more than it is easy to say

and it wasn't easy to disappoint him, but I think he knew,
he went on anyway describing the possibilities, that's love
in the mists of indifference. But I just can't build houses.
At all. Although I dig the juniper and think the hills swing,
you know how very much my world is not closed but open, open.
Everywhere I am, I feel I am everywhere else. But that man in the sun
last February, with the western hat, and whom I shall not see for many
years to come, the Idaho and the snow there and the huge
purple bitter juniper berries.

[first presentation: *Yugen* 6 (1960)]

The Mountains
 (for the painter, Raymond Obermayr)

Like a distant rumble of undeclared war
the wind shakes all things on our ears
and it's like the water treatment
or a willful cat how the nerves
don't anymore fend for themselves.

The base of the mountains
are blue and flecks of moving brown
are there like a lingering image.
But above that base
comes the magenta higher mountains,
steps to green, a rise the eye
can only take, where again lingers yellow
and all runs to a high atmospheric orange
but cut
the deep black blue of
full day.

I know men have perished here
there and all around.

Thus in a cut of all of it
there is the inferno we forget,
descends to the only red of fire.
To go down there is the whole
tension of its mystery.

All lingers. All passes in those hills.

One tempts the perfect
with suggested birds and men
suggested toil, one is reckless
enough to say they are there and forget.
And enough to leave all growth aside.
There is no frame for blue
but blue, but this is a late time
after blue was made.

And the earth herself
lets no such recessions loose.
You can move in the shadows, in that
wild blue, small towns
like specks flourish and go out
there is no coming back from the space
you make.

[first presentation: *Yale Literary Magazine* CXXXI.3–4 (1963)]

[Pocatello is black]

Pocatello is black
in a case of frost tonight
left as the elements flew.

There is a quick and brutal
and false carioca of iron
covering all I can see
of this forgotten town,
gaiety in this whole place
is a daytime restriction.
She is gone, already several days.
There is a small town not far distant
across the Michaud flats. All I can hear
is the tone, low and born
of a single horn that blew before
and blows still
 its location is a thing
beyond determination, just when
it sounds nearer the loneliness
increases,
 just when it grows distant
hope forms more. Everything is backward.

November ends today.

Nearer and farther
along the tracks of the union pacific
the screams of the wheels mark
mark
this foolish and this unwise atmosphere.

[first presentation: *Wild Dog* 1.8 (1964)]

114

a Poem entitled Bullshit
 for J. H. P. [Jeremy Halvard Prynne]

in the heat of undoing
the latch called
 our lives
there can be none.
Fact, you know
as well as I
is just another distracting
preliminary equation
to be got down
 because, among
other acts
we also promise ourselves
that one.
 in the end tho
 we know
 or we don't
 and isn't that nice

[unpublished, 27 July 1966]

my wandering
has cost me everything.

I have no place to be
I am separated
and I have no claim.
 good!
 I shall make no claim.

[unpublished, 19 August 1966]

n.d. [July (?) 1960 or 1961]: Ray Obermayr (Pocatello, Idaho) to Ed Dorn

Dear Ed and Helene:

The building questions:* About wood—it is possible to buy
lodge pole pine on a cut them yourself basis at Island Park (about
150 miles away) for 8 cents per 7 foot length. The problem there is
a truck to haul them in and it takes some time to cut them. I would
think however that the stone or the wood or a combination of the 2
would be the cheapest. A 30 x 40 building would cost however about
2,000 $ even doing all the work yourself. The quickest to put up would
be cement block. I don't think in any case that you could get more
work done in a week than just a bare start. I would take a week to haul
the rock and perhaps more than that to cut and haul poles. So don't
plan on doing more than hauling materials. I don't think it would
be wise to leave unfinished stone walls exposed to weather. Freezing,
thawing, snow, etc would probably ruin them quickly. But we could
haul materials and level a site. The site choice incidentally is up to
you. When you get here you can look the place over and choose any
area that suits you. If anything happens to make us leave here I'll
deed the site to you. However if we stay here that's a useless formality.
We have no plans to move but as I am on the shit list at school it is
always a possibility.

* Obermayr elaborated on this in an e-mail to the editor of 16 March 2013: "During
a visit to Santa Fe we talked about the possibility [of the Dorns] moving to Pocatello. Ed
was desperate to have time and a place to write full time. I don't remember if the letter was
written in 1960 and they came the same year, or if I wrote in 1961 and they came then. I
am fairly sure though that they arrived in 1961. I had just finished building an addition to
our old 3 room ranch house by myself in just one summer. In those days I felt that I could
do anything. The ranch had out buildings in good shape, two barns and an open front
machine shed. I closed the front of that building with glass and plastic, put in electricity,
running water, a floor of fire brick scrounged from the local fertilizer plant, a heating stove,
and a beautiful old Garland cook stove. It was about 30' x 15' and served me well as a studio.
The University had just provided me with studio space on campus, so I thought it would be
OK for Dorns to use the ranch studio until something permanent could be arranged."

I don't know what is going on in the English dep't. When you get here you can talk to Kegel and find out exactly what the possibilities of working here are. I find it impossible to figure out what in the hell academic people mean when they say something.

Don't expect Pocatello to be more than Santa Fe. But any change is good because it takes 3 or four years for a new place to become intolerable. Of course should you decide to stay here in Aug or come back in the fall for good you are welcome to stay with us until we can get your house livable. In the fall we also would be able to help with money on your house.

Well I hope this has been some little help.

See you in Aug

Love
Ray

26 February 1964: Tom Clark (Cambridge, England) to Ed Dorn

I am, as of a few weeks ago, editing poetry for *The Paris Review.* I am not responsible for the poetry appearing in the magazine lately, nor do I like it much. I want to print other poets, hopefully another kind of poetry, in the future. I very much like the work of yours that I've seen (the poems in Allen's anthology—especially "The Rick in the Green Wood" [*sic*], and *The Newly Fallen*, especially "A Country Song"—e.g., "through the window" p. 25—and "The Common Lot"; that one most of all), and I hope you will contribute some things to *The Paris Review.* I am also writing to Charles Olson and Robert Creeley.

9 January 1965: Tom Clark (Cambridge) to Ed Dorn

I've been in to see Jeremy Prynne: it turns out that the poems he showed me last year, and of which I made copies at the time, were ones you cut out of *The Newly Fallen.* So some of these may have been used by now. Of the group, I like best "A Vague Love" (begins "The Bannocks stand by the box..."), "In the Shadow," and "Nature Their

Passing Bell." Also "Another Vague Love," but that's now been in *Prospect*. Then, comparing a copy I have of your typescript of *Hands Up!*, I find a poem left out of *there*, "For Ray," which I've liked. So there are all these more or less old poems, which by now may have printed, revised, etc. So I'd like to hear from you about that. Certainly I'd like to use a large block of your work in *Paris Review*, so I'd also like to see those poems you now have on hand. Then, juggling that work with these older pieces, a group could be made up for printing. Ok?

[A handwritten comment in the right margin of this letter reads "These two are the ones I'd favor"—it refers to the marks next to "A Vague Love" and "For Ray."]

23 February 1965: Donald Davie (Grinnell, Iowa) to Ed Dorn

Thankyou for the enclosures you sent me. I am baffled by "The Advantage of Literacy…" from *Coyote's Journal*, but the bibliographical poem "as of Bozeman" appeals to me, and sets me to think quite furiously. You must not suppose that my mind is firmly made up as to Olson, and closed against him. You are right to surmise that I find myself irritated by his Poundian-hortatory style, but I know from working on Pound how this affectation does not preclude sincerity and perception. What this piece of Olson's sets me to wondering about is whether, in poems of my own, the impulse has not been the simple and ancient and honourable motive of raising in language as it were a memorial plaque to persons whose memory should be kept green. If so, and this is equally Olson's feeling about Red Cloud, then (I ask myself with dismay) isn't Olson's bibliography a more honest cleaving to that simple intention than some of the poems I have written, in which this straightforward act of piety is overlaid and disguised by the appearance of drawing morals about how history goes, or where history went wrong…. It is this last operation, the putting of history right, or the pointing out where history "went wrong," which nowadays seems to me presumptuous for poetry, and off-centre from poetry's true concerns. As usual with me, my feeling is not one of irritation with Pound (or Olson), but a revulsion from earlier preoccupations and presumptions *of my own*.

[…] Thankyou for your note on Hodges' *Handbook of American Indians,* which I will add to a list I am making of books to be purchased for the Essex library.

n.d. [after 21 February 1965]: LeRoi Jones (New York) to Ed Dorn

Do you want to go to California in my place? I don't really feel like making that, so if you want to, and feel like substituting and that bullshit, &c., then you're definitely welcome. Let me know and I will write to Dick Andrews. Thankyou for that poem, it was deep, and I appreciate it, and to know that feeling exists.

12–13 April 1965: Ed Dorn (Pocatello) to Robert Creeley

Olson mentioned in a letter your being there, with Graves, McLuhan, etc. How was he. I know those books, the Galaxy and that other Mass Communication I think. I think they are interesting, the lay-out of Gut. Gal. [*The Gutenberg Galaxy* (1962)] That sort of generation of ideas I mean. I can't say how valuable finally. And it must have been crazy anyway. I do remember thinking last summer, ie, as of the McLuhan there was a wiseacre correlation between current events and some huge explanation for all our actions. Very hung up on the problem of which comes first. Pop science perhaps.

[…] Otherwise I see from your last letter you ask how the Essex thing came about and what possibilities for yourself etc. First, I was offered a job teaching at the New University of Essex by Davie, thru Prynne. The Fulbright bit came up later as a choice of my own and mostly because if I want to teach somewhere else and for more money etc I figured it wld be more possible if I had that adventure, so official a thing, tacked to my non-degree. So I was anxious to take that chance. It was suggested by Davie, but I assume he had other means to get me there because he was surprised that I'd gotten the thing, for, as he said, it is unusual for one of the new universities to get Fulbright lecturers. And especially for Essex because it is the newest, Sussex is older. This will be Essex's second year. He said he wanted me for several reasons. First because, as he put it, my reputation had been

established outside the accepted reputation making circles (first time I've had that pointed out as a virtue, and no matter how stodgy Davie sounds, I have to dig that rectitude) and second because he likes my writing, in his way of course, and third because he has an interest in the west and takes my sense of the west to be a metaphysic which will square his sense of the separation between Pound and Olson. The last reason is a mistake of course but I figure I can help him with that. It wldn't seem too *vast* a problem, more one [of] straightening his logistics. For instance he figures Pound to have exhausted the Historical possibilities of poetic material, hence I'm METAphysical, and off again. Offhand I'd say he mistakes the insistent emotion-ism I have for the physical. That's why he thinks it's gotta be meta.

18 May 1965: Ed Dorn (Pocatello) to Robert Creeley

I had thot earlier, since we're always short of money, to go on one of those "digs" and then got desperate thinking of "spending" the summer w/all those same college people, and just like that this contract comes from Wm. Morrow and Co. to do a book on the Shoshone Indians w/the photographer Leroy McLucas. So I signed that right away and now I got 500 dollars and 500 more when the thing is completed, Sept. 1st. The point is that leaves the summer up to me and the way I want to work. So I'll definitely be able to get down to S.F. for the big scene [Berkeley Poetry Conference, 12–24 July 1965].

18 May 1965: Ed Dorn (Pocatello) to Tom Raworth

I lucked out of that damn summer dig w/all those college students by signing a contract (27 signatures in all) to do the text of a picture book on the Shoshone Indians this summer w/Leroy McLucas, a very good young photographer. $1,000 for 25,000 words. I'll have to use some of the words twice! Love—Later—and stay *there!* We're comin'—Ed

120

10 June 1965: Ed Dorn (Pocatello) to Robert Creeley

As for myself, I suddenly rush in at last wanting all of it and turn around to find I'm not doing anything all that different—i.e., as the form and the vision get expanded one sees beyond that there hasn't been the increase there seemed. I'm thinking of 2 mos. ago when Stuart Montgomery (a zoology student at University College, London) wrote asking if he could do a book for me, *Hands Up!* He thot small and printed rather stingy. I sd. yes and got excited by that chance, wrote most of it on the spot except for *Idaho Out* which I kept for the book Kelly never did do. But now it could be said all over again because a lot of it was my sense of the present and since that tends to be continuous when do you know you've got it? That might be my egocentric frame. Anyway I titled it *Geography* and he'll have it out he says early September. He's a speedy man it seems. Is now finishing some new book of Basil Bunting's poems. But it wasn't the energy or the delight w/ doing it that didn't finally satisfy me, it was more that the frustration of the passage of those events I tried to work and feel I didn't, now remains. Not altogether bad. [….] I wish to get to an integration of my own in that way—where the work is what I am more than what I can or do *do*.*

[…]

This book on the Shoshone is a good shot for me because it allows the clearing away of all that accumulated shit from the past semester, a drastically removed material. I'm spending my days now reading back into it and won't start any writing until I talk to McLucas and see what kind of photos etc he's interested in taking. I want it to be as present and modern a take as possible, the mythology of sucking airplane glue, migrations in cars, families across the intersection etc. Luckily there is a linguist who is well disposed toward me here and since he speaks Shoshoni that will make it easier, but they are naturally hostile and suspicious people and have suffered a lot from local white hands—none of that slick professional Indian assurance and sense of presence one finds in the S'west. Diggers they were and mostly are yet.

* By the phrase "in that way" Dorn is referring to the way he associates with Robert Duncan's "Multiversity."

The book I contracted for, and indeed signed a contract for, and accepted a 500 dollar advance for to get thru the summer, is not even started. I finally got very bugged that LeRoy McLucas, the photographer, had not shown up so I called NY and he hadn't even left! but says he'll be here next week. I've in the meantime been reading every day about the Shoshone. But it will be a modern book, ie, the text, it is hard to say what the pictures will be like but I think McLucas is a good, wild man. I can see I'm going to be finally pressed right against that Sept 1st deadline. Oh well, and fuckit. I've been reading lately on the Wind River (wyo) Sundance. The eastern Shoshone. The Sundance was a curing ritual and still is but the thing has got to be something else, i.e., there are few full-bloods left and it came via Comanche (southern split-off of Shoshones, mid eighteenth cent.) from Kiowa. Probably. Some claim direct from Cheyenne and/or Arapaho. Below is where we'll try to take pictures of Shoshone, at least the reservations, the streets yield them too, the drunk tanks etc, as you'd guess:

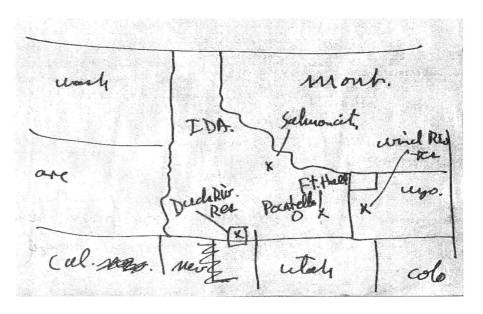

July 1965 [envelope stamped "Take Out / Jul 23 / Elko, Nevada"]: Ed Dorn (Battle Mountain, Nevada) to Helene Dorn

Dear H—this is quick—we've come from Pyramid today, a long gig. Lovelock is *too* much—a deadly little town like *love* was locked out from the founding day on. Winnafuckinmucka is no better. Battle Mtn. is strange but somehow straight—oh fuck Nevada!!!

I'm going to call you right now but wanted to write this before I called because I knew I wouldn't if I waited if I waited [*sic*]. There is a small enclave at the edge of town—looks interesting. We got here too late so decided to wait till morning to catch it especially since we're making good time first room we've had—chance to get clean. I swam yesterday in Pyramid [Lake] and it was very groovy and refreshing but the water is salty, dig, and left a scum on me. But it was the freshest thing I've ever done—especially it felt so after the bullshit of Reno.

The room, for both of us cost $7.00—very cheap—*huge* bowl of chili (Texas) for .50 but battle mtn. one street gets that shit. A Col. [crossout: general] Bourgoine was fucked up by sd. injuns here years ago. 187*—they had his ass but they been paying for that obviously, ever since—now you wouldn't believe this shit—

The H.E.W. Dept. [Health, Education, and Welfare Department] actually has the gall to put a sign outside this ghetto saying it is a pilot proj. plumbing water supply etc—and right then before your eyes are the same shacks and outdoor johns—the Paiutes are too much tho— groovy people—I dig 'em—

Love—Ed
P.S. I dig you too

* This date lacks its final digit. However, it may be related to the 1870 Ghost Dance Dorn addresses in chapter III. In 1870 the Central Pacific Railroad also relocated its Argenta station to Battle Mountain, where it established an unincorporated townsite to serve the Battle Mountain copper- and gold-mining district (according to local legend, the name Battle Mountain derives from conflicts between settlers and natives in the 1850s and 1860s). However, if this "here" is understood as the region rather than the town, it may refer to the Nez Perce War of 1877. See Elliott West, *The Last Indian War: The Nez Perce Story* (New York: Oxford University Press, 2009). Colonel Bourgoine remains unidentified, and the name might be misspelled.

The injuns in these small collections of hovels are shyer than on the res. Naturally, I suppose—they've had it—

Roy is now in room developing all the film so far—

On way out of Reno Sunday afternoon he dropped $15 more & then said, "gambling ain't my stick Jack, you know, I never was a fucking thing gambling. I'm gonna quit, *forever.*" Oh wow.

3 August 1965: Ed Dorn (Pocatello) to Charles Olson

Dear Charles:

I wrote to Blackwells to have them send you a copy of Lawrence's *Movements in European History* (Oxford 1921 w/pseudonym—Lawrence L. Davidson, but later 1924 or 25 regular moniker) ie —had it sent to Sunyab [State University of New York at Buffalo]— actually don't even know you are still at Berkeley—I hope all goes along and won't even ask that you drop post card, you must be *involved* in any case.

Am now well into Shoshoni book—it looks good—i.e., that whole intermontane thing is a sink Humbol[d]t sink, playas etc.* even the people scratching w/their fingers etc.—Juxta Comstock lode & 1st white jaw†—ok man & love always—Ed

* The Humboldt Sink of northwestern Nevada is an intermittent dry lake bed approximately eleven miles long and four miles wide. Playa lakes are smaller round hollows that occur throughout the southern high plains of the United States. Since the presence of water in them is, again, ephemeral, they confused early explorers, some of whom described the region as a collection of countless small lakes, others as a desert.

† The Comstock Lode, made public in 1859, was the first major discovery of silver ore in the United States, under what is now Virginia City, Nevada; it resulted in rapid growth and the development of major fortunes in the area (Nevada is known as the silver state after this discovery). The first white jaw refers to the Piltdown hoax of 1912, in which the lower jawbone of a Sarawak orangutan was expertly combined with the skull of a fully formed medieval human and chimpanzee fossil teeth, then "discovered" in a gravel pit at Piltdown, East Sussex, England. This very prominent paleoanthropological forgery, which was supposed to have identified the missing link between apes and humans, was introduced as evidence by Clarence Darrow in the Scopes Monkey trial. It was not debunked until November 1953.

28 October 1965: Ed Dorn (Colchester, England) to Charles Olson

The bad mood I spoke of right off was more than a mood—when I got to New York the photographer, LeRoy McLucas tells me the negatives and contact prints of every picture he took this summer in the Basin has [*sic*] been confiscated along with his gear by the landlord in NY for back rent. So there were no pictures. And then Morrow (the publishers) were coming on to me this last month and a half where is McLucas, and I can't say anything to them because I know what's happening and hope he gets it all back, and then they are going to sue, and then they say he is dead and christ knows what all. Finally it did get straightened and they have their flicks. And I'll have the Ms to them in a week. That was another thing, I'd thot to finish it before we left Pocatello and I nearly did except for the last chapter and getting the references and footnotes straight etc, but I had to bring it with me finally and it all hung like that.

28 October 1965: Ed Dorn (Colchester) to Robert Creeley

I got into one of those damn binds of confusion & inertia there were plenty of times I could have written etc. In the first place this book has been finally a pain in the ass, there turned out to be not *quite* enough time to finish it up before leaving Pocatello. So with it nearly done except for the last chptr and checking some references, getting the footnotes etc, that busywork, I packed it together and brought. When we got to New York I find the editor hasn't heard hide nor hair of McLucas since he'd returned late July, so I finally got in touch with him and his hesitation it turns out has a real base, ie, the landlord had confiscated all the negatives and contact prints for back rent. And he was in bad shape generally. He's really a lovely attractive man in all ways, but sort of incompetent, like to walk down the street etc, and perhaps I told you he nearly broke us in Reno gambling, 150.00 one night til I said nix! and got him out of the casino. OH wow. So then the way I oscillate, I started thinking what the goddamn hell am I some nursemaid. And I thought maybe the spooks aren't really ready for self government after all. At any rate I was suddenly between my man and the publishers who were saying that crap won't go etc. They

were coming on like investors dig. They wouldn't know an Indian if they saw one. Now, with some luck I get the thing off my back next week. The photos are back and in the publisher's hands everything pieced together again.

I thank you very much for putting my name in the pot, the Guggenheim pot, and they say in their note your application is assured of a reading if you're suggested. I sent it back in time and listed you as one of the referents hoping that would be OK too, since you'd given my name. They acknowledged receiving it and didn't raise any questions. Actually it would be nice to "receive" such a thing. I told them in the proposal I wanted to finish up some stories on de [*sic*] western scene and that I'd like to write a novel with same material in mind, but I don't really have anything real in mind there. It was half true half false, a good percentage. I did mention one thing tho, I wld like to get next to the Utes, sou'eastern Utah, which interest came out of this potboiler of a picture book, but that is highly speculative like they say and the Utes haven't gone for it with anybody else yet including the celebrated Robert Lowie, but maybe that's why, anyway it seems to me they are the injuns of the U.S. 1875 onward. Otherwise I guess I sit and wait. Again thanks, and thanks again.

Ed Dorn in Santa Fe

Gael Turnbull asked me to write something very personal about Santa Fe, where I now live, temporarily, and this is what I am going to do. He said "Readers Digest" sort of thing. Of course he is relatively English so that I imagine it is very much easier for him to set a thing in that context, and think it interesting in a wry sense, than it is for me, predominantly an American, and for whom place is one of the eminent concerns, walking, sitting, out in the open or in an enclosure, driving or sleeping; altho I of course assume the matter of *wry sense*. Anyway the title is taken from him, out of a vanity of my own, wishing thereby, to place myself easily.

Another assumption I will have to make is that Santa Fe did not exist before I got here, *not* out of a vanity, but as the only way I know to proceed, since no *artist* has bothered to mention it. It has nothing to do with an *attitude* toward history. I am quite aware of the bark surrounding the trunk of "where I am." Santa Fe as we are being told is about to celebrate its 300 or 350th anniversary. But that is as far, anniversary and date, as I care to carry Readers Digest. This does not hold my interest and I hope it doesn't hold the interest of anyone else other than those who are making a direct living off the fact. Any *interest*, and I think that is a valuable condition, will come out of the greeting I gave to the place. The greeting it gave to me was restricted to a "gift book" containing coupons, of price reduction or outright gift. For instance I got my pants cleaned free. And my wife could have gotten a set of stainless steel kitchen utensils. The children are still harping on the ½ gallon of ice cream we could get from a supermarket. But you or anyone could come and receive the same. The point I make is that Santa Fe didn't greet me at all and I wouldn't have liked it if it had, not dealing in dates, or any other raw material. If one is spiritual these days, and I am, it is a marked complication to be greeted, or even known, too widely.

There are a handful of places in America today where artists gather, some of them, New York, San Francisco, and I have heard New Orleans (altho I

* The only substantive handwritten note on this typescript, which is housed in the Department of Special Collections at Stanford University, reads, "[T]his title gives me the creeps now! In a way it all does. For not being clearer."

instinctively doubt New Orleans) are large cities, with all the commitments to that size, i.e., streets that are busy over a long span of the day, buildings with more people in them. Suburbs where it is said the really important people like computers live, and so on. Others, Santa Fe, Aspen, perhaps a place or two in Missouri, and the ones in New England, are much smaller, the buildings, streets, parties, private libraries and public, don't come on so fabulously. It is dangerous to imply the artists are either numerous or plentiful, no matter how true it is they are widespread. This doesn't at all depend on what one's *taste* is.

Right now, this evening there are some very nice bells coming from Christo Rey. Across the Santa Fe River. Whole distance perhaps a half mile. There are departures like this that belie all the other grossnesses of this city, and for a brief period the sense is changed, and one really *is* in New Mexico, one really is 7,000 feet, the threading Rio Grande really is off to the right, though many miles, where the river perhaps doesn't change (I don't know, I haven't seen it at a point below Española). But the sweep-out of the land one can see standing here, where it runs down all the way more and more barren, a moon-land, to Albuquerque and below. And then at this time, once in a while, I walk up on the ridge back of the house and can see the most standing thing on any of the horizons hereabouts: the great bulwark of the Sandias which is opposite Albuquerque. 60 miles south. For all the clearness, and the visibility, the sky itself is variable. Usually there are darknesses. More than one shape of cloud in the sky at a time.

I bring up artists and skies, the range of the Sandias, and will later, the Indians and a few other things. This is perhaps a harsh way to talk, throwing the components of this place together, human and non-human, all together in the same bag. I certainly don't do this because I am impelled overly toward abstract forms, or impelled toward that basis from a wish to be modern and cold, "dehumanized." Not at all. In those terms, I know what I am doing. The reason is: it is not in my hands to do otherwise. As everyone knows, places vary widely. In spite of the fact the earth is reputed to be a ball, the uniformity of form stops there. And that man is of one species and can interbreed, endlessly, is not the same thing. Man makes his true hybrids manifest in the acts of men. Ultimately, the general mass of men even act the same way, but as you come up, there is a smaller way of looking at it, for instance Kemerer is not the same place as Biloxi which is not the same as Santa Fe.

128

But all men *try* to act the same, there is the generality. "Nature is less indulgent. After the mule comes nothing," said Gauguin.

So that place has to shift for itself, largely. I mean it is all *there*, certainly, but that isn't enough. Man, who is separate from nature, will attempt almost anything. This has unfortunately a limited interest, for the rest of us, because, tho the direction, even stated intent, may differ, even be a nuance, that's possible. The place he comes back to, to show the rest of us, the spot as a motivation, his very maligning reason, does not change, it officially is always the same. So that when he takes off from the green and grey earth, from wherever, Kemerer or Santa Fe, he returns with the news, not surprising, that the planets are inhabited by the same creatures we are, with the same propensities for the half-cocked, the same deception in their well-stated motives. Finds, and brings back specimens we are already familiar with, alas. But the trip was ostentatious. That we are familiar with too.

No. Where the depth, the stratas are, that we as human beings require it, to be satisfied with the revelation of it, the recurring nouns that pronounce our lives, these are wilder places, are not cast indefinitely upon the earth any more than gold is. So you have to take the veins as they come. Invention is not the point. That the Indians and artists and mountains are the same here as the merchants and artists and the mountains, and all lying in the strata of promotion I would never argue with. Because, having a flagging patience, I won't bring forth something which balks at coming. Not that it depends on me and my ability. It is that I refuse to be perverse.

To bring this whole theme together briefly and then on to the literal hustle of Santa Fe—Places, the geographic and oceanic tidal surgings which have been common ground for man since time, are built, not rebuilt (that refers to ruins, for which there is no hope) or they are birthed again. There is no loss implied altho I can't seem to shake a term that implies *second* or *following*.... Anyway a beautiful thing is occurring in America, today. By the way I don't use the term Place as a mannerism, as an indiscriminate word, covering the "doings of man," at all. Not in any of the senses of the usability of anything, there is no functionalism meant, we mustn't have anything to do with arrangements put into people's hands, with reports or accounts, at the same time not discounting it is a Place, where the din, of everything that happened there, and is, comes to the ear, and eye, the building front, the woman's smile influenced by the school she attended etc., but that man

standing at the side of the street shouting in Navajo, at the police cars, shaking his fist, going back and forth in a frenzy across the plaza to stand there, shaking his fist, screaming in Navajo, at the passing cars. He has an old hat jammed on his head. His precise dress in fact shows he is used to the boxcar.

But the beautiful thing is the writing now of *The Maximus Poems*. This is all that I am saying Santa Fe would only hypocritically yield. I.e., one could force it out, carry it farther than Vestal would, but it would be a trick, and interesting as that might be, it wouldn't at all serve to spring immensities of reality, of art, because they were never here. Men came into this area governed on the one hand by what they distinctly found—Indians & raw space in front of them, and carrying, a principle—Spanish Christianity, which produced at most some interesting carved doors and Santos. That's about it. That isn't good enough to support a structure of place. Indeed it propagates a condition for the effete, not the human art; the latter is dreadfully more deep and wide than the first. That is precisely why you found that the archaeologist, the anthropologist and the sociologist, take them all as one, flocked here. There was from the start a superabundance of the effete condition, surface, large thin space, and a principle just dead enough and known enough to make a likeable and easy complication in what they found. Which was *things*, which are effete. This is not a generality. It is awfully particular, it takes a very exacting registration, such as *Maximus* is capable of, to make *things* not effete, effects. The same thing, superficiality, probably explains too why opera is so popular here. And at the same time a predicament. Everyone wants an Art. But they want it too easily and casually, and they subscribe to very spurious people to get it sometimes. There is a series of letters in the local newspaper disputing the quality of reviews of the Opera. Naturally, when the local newspaper proceeded on its own account, for the first two or three performances it handled the thing as a social occasion. Which I comply with, opera has no possibility of art, it *is* a social occasion. But the ringer came when cultured people recognized this as a poor reflection on the *Place*, hence themselves, since they make up a disproportional number. They wanted critical reviews, saying in effect, that this or that was or was not so etc., treating the thing seriously, analyzing, cribbing the procedures of art. Of course it is indisputable that these people are art lovers. But what is that? This is the point. You don't have a place just because you barge in on it as a literal physical reality. You had better go see the Grand Canyon, that's what it was made for. Place, you have to have a man bring it to you. You are *casual*. This is a really serious

130

business, and *not* to be tampered with. You might just as well live in Buenos Aires of Newfoundland, it doesn't make a damn bit of difference. But being casual, you have to be brought up.

Now, once we have got our place, or hope for it, the fine relieving quality and discrimination, Gloucester, the thing is then art, and you can never go to it, by any other route, is then the complex instrument I at least never cease to carry with me and be kept alive by, live under, and feel myself very damn glad to be on this lovely earth, having been given this gift. This is probably the only sense in which I am a child. It seems to me the way Homer must have worked. Not to be underneath the writing, not to have to pay attention to that. Olson is a master in the normal sense, i.e., there is no trafficking possible with his means, so tied to the source is he with his art. Nor can we learn anything of use from him. When other poets, those who exchange terms, whose mechanisms in a sense overlap, or make sense in a functional procedural way to one another, address him "for Charles Olson" it isn't necessarily improper, who is to say that, but it is beautifully useless. As a man he is in Gloucester, that is definitely something else. One takes uses from minor writers. This is their availability and to some extent their value, they are not deeply tied and the display of their talent is thinly spread, covered with bubbles, temporarily available to the eyes. They come to realizations late, and as an afterthought to their art. Wilde is an example. They never resurrect, theirs is a technology of the senses. It isn't that Olson doesn't manifest the same recognizable properties that mark writing. It is that the terms are not extractable from the whole art: there are no terms, but there is the term of the form. It isn't just a piece of logic to say that in order for the total art of Place to exist there has to be this coherent form, the range of implication isn't even calculatable. I know *master* is a largish word. I don't mean my master. I mean Dostoevsky, Euripedes. The power. It is a removal from the effete and at the same time the aesthetic. There was a certain fascism (not the political term) that existed in american writing for the last 35 years more or less, in which the zeal for material effect was the cardinal quality, material effect being something that impresses itself by virtue of itself, per se, in which the springing is neither inward nor outward, but merely within. Images suffer. Techné is brought in.

Well, that is ended now, even tho it is still practiced. Here in Santa Fe. The Indians are down in the plaza some of them probably don't have a way home, but there seem to be many pick-up trucks. My man is probably there too, screaming in abrupt Navajo. There happens to be a hell of a wind coming

against the house. It doesn't slow down once it gets a good start off the sloping walls of the Jemez. Haniel Long has been dead three years. Somewhere out there, I don't know where the cemetery is, the wind is blowing over his grave, blowing the grass and weeds, I must find out where he is buried.

Long was the only man concerned himself with art, here in this Place, concerned with Place. He never had one. He is a minor writer. A great minor writer, in America, and he had the radical mind it takes for that kind of art. He was involved with aesthetics, like minor art is, because the components themselves, the members that come together to make their art are always on the outside, as tho the building were reversed in its construction, showing its structure first, enclosing its content, interiorly. The elements he brings forward would normally be those given elements that gracefully go together in an accordance which one could retain the mystery of and thus have the timelessness of the effect, which is what is lingering, and know no tenses, the now, the then, the will be. Cabeza de Vaca. And, his wandering Christ figure, who traversed the southwest barefoot from Denver to the border, and cured, cast lovely spells, who had long hair, was a man full of grace and humility, a violent kind, who talked much, walked, was lonely, and had meaning and cognizance, was followed, there was an awe. Would normally have been his figures, had, as I say, there been a concordance of Place for him to work. It would have just happened, as it is he did what he could. I love Long's writing for this abstraction of fulfillment. It couldn't be. It was no loss to him probably. I don't know. It *was* a loss to us. *Piñon Country* is the specimen of a radical mind with no home, no anchorage; as artist this is the one factor outside our control.

But when the Place is brought forward fully or partially in form conceived entirely by the activation of a man who is under its spell it is a resurrection for us and the investigation even is not extractable. And it is then the only *real* thing. I am certain, without ever having been there, I would be bored to sickness walking Gloucester. Buildings as such are not important. The wash of the sea is not interesting in itself, that is luxuria, a degrading thing, people as they stand, must be created, it doesn't matter at all if they have reflexes of their own, they are casual, they do more than you could hope to know, it is useful, it is part of industry. It has an arrogance of intention. This is the significance of Olson's distrust of Thucydides and his care for Herodotus. It is the significance of Blake's "the practice of art is anti-christ." Which further means that if you are not capable of the same act God indulged in,

132

the non-functional striking of a World, you are not practicing art. Description, letting things lay, was reserved for not necessarily the doubtful, but the slothful, or the merely busy.

> The landscape (the landscape!) again: Gloucester,
> The shore one of me is (duplicates), and from which
> (from offshore, I, Maximus) am removed, observe.

> In this night I moved on the territory with combinations
> (new mixtures) of old and known personages: the leader,
> my father, in an old guise, here selling books and manuscripts.

. .

> The places still
> half-dark, mud,
> coal-dust.

> There is no light
> east
> of the bridge

> Only on the headland
> toward the harbor
> from Cressy's

> have I seen it (once
> when my daughter ran
> out on a spit of sand

> isn't even there.) Where
> in Bristow? when does I-A
> get me home? I am caught

> in Gloucester. (What's buried
> behind Lufkin's
> Diner? Who is

> Frank Moore?

This is toward the most acute measurement. All the arrogance of intention that pervades Place is left out of "The Librarian" poem. The beginning of the poem, right down through the first two stanzas, is the key to this code to location, as of now. We can come home. From the Pacific or out west. And the ending fragment beginning, "The places still…," is my great reunion with the huge nouns and questionings of my life, it makes me weep, there is no loss suffered, I am very much excited, what next, who is Frank Moore? When does 1-A get me home?

The singular problem is difficult to come at. There is no contention that things, in the sense that one holds them, material things, but that is rather limiting, because utensils aren't only meant, or santos, or carved doors, or the "I" and all its predicament, its environment, inclement and happy, and in general the ranges upon ranges of materially disposed things that contain the mines of our lives, there is no contention that these things are really permanently deadening to us, they *are* grotesque in their deathly confrontation. I am perhaps a little suspicious about their strength, but that's all right. The important thing is that the only quarantine we have from them now is this new discovery of a total disposition of them in the human inherited sense. Coming all at once, and large, it is a morphology that up to now has been lacking. There is no aesthetic to bring us back into a social world of intention, delaying by way of modern functionalism our grasp, shortening our vision, putting us back outside again, where we spend so much time traveling the hall of distraction and apportionment, not ever coming to rest in cognizance and lingering mystery. But there is no mystery, outside.

● ● ●

"My stock of provisions had so long been consumed that I had forgotten the flavor of pulse and maize and pumpkins and purple and sweet potatoes. For Nuflo's cultivated patch had been destroyed by the savages—not a stem, not a root had they left: and I, like the sorrowful man that broods on his sorrow and the artist who thinks only of his art, had been improvident and had consumed the seed without putting a portion in the ground."*

* This epigraph, which begins the untitled second part of "Ed Dorn in Santa Fe," is taken from chapter XXI of W. H. Hudson's *Green Mansions: A Romance of the Tropical Forest* (1904). While the first part of the unpublished typescript is substantively similar to Part I of "What I see in *The Maxiums Poems*," what follows differs entirely from Parts II and III of that

Well, here we are. It is a common day in Santa Fe. Looking out the window, if I cared to I could probably see a shoddy old lesbian going to the Palace Grocery for a pack of cigarettes. Brooding on what? The kids are one place or another. We live very much in the midst of Natives, that's what one tactfully must call the people of vague Spanish-Mexican descent. On the one hand, they can't be referred to as Mexicans because that is taken as degrading, and the other, Spanish as an appellation sounds a little untrue. There is very little exchange because they don't *really* speak English. Oh they have all the phrases, but there is that mist that always separates them from an understanding. They are apt to suddenly say "carboard" for "cupboard," and look at you strangely, in doubt. These people are said to be bilingual, but that again is for a purpose, the enhancement of the place. When one goes out alone leaving all that behind, the causes that they try to infect us with, it is another thing, then one's eyes and ears harbor no presuppositions and it is good to be here. Because it is a wild place. The people are all immigrants so that there is a certain uneasiness in that respect, and the Indians don't escape either, having been infected with it. Made to produce blankets as such, jewelry, as I pointed out somewhere else, the circle is complete, now they use it as a lure, to con the white, from Iowa. A jumpiness about how long you have been here, dates arrivals, departure? And the confusion is fabulous, for instance, in the plaza there is an obelisk to commemorate the whites that died at the bloodthirsty hands of the savages. In fact I think it says just that. At any rate that's what it is.

Coming in from the north from Taos, there is a sharp rise at Tesuque just short of the city and then onto a high flat grade that runs toward the city for a half mile, at the end of that macadamized stretch zipping along so to speak, like everyone does, here we suddenly have Santa Fe, very remarkably, and immense, distorted, lying in undulations on the foothills, where to the left are two prominent soft hills like dark green breasts. Beyond immeasurably, is a great amphitheatre of space with nipply mountains, dead volcano-like groups immediately, but vastly, ahead. Back of that, a mere shade, is the fabulous hump of the Sandias, as I said. 60 miles or so. Over in a giant's swing to the right, to the west are the Jemez much in form like the Olympics, if you

essay, which was initially published as a Migrant Pamphlet (1960) and was made widely available in *The Poetics of the New American Poetry*, ed. Donald Allen and Warren Tallman (New York: Grove Press, 1973), 293–307.

have seen those, and no snow, in July. In the depression down between, only imagined, but surely there, is the Rio Grande running running toward Matamoros. Running down to Brownsville. The thin ribbon runs, too, the road to Albuquerque, thru the moon-land, south. On that road, driving along out by the penitentiary and the airport turn the neck and see the dribbling off of the Sangre de Cristos into a dinosaur back, the spiked plates of the mountains digressing into a tail, off toward Pecos. Very large prominence. It is a crazy hunk, let's not go to Venus.

But quietly, now, coming up from Albuquerque, thru the silent moon-land, rimmed in by the ranges, one goes along, sitting, the sound of the ceaseless motor, the gazing out at the declivities and arroyos. And it is coming up thru a land of uplands more and more, and shelves. So that what greets the eye is stages, never looking back, the rise is gradual except in one place. And then, coming around a specific curve, you see Santa Fe. Dimly and far away, resting against the mountains. Dimly and far away, like any registration on our Earth, it isn't discernible for many minutes. Very lovely, the whole thing. Earth, Earth. But this isn't Santa Fe, it is only the sight of Santa Fe, and Santa Fe takes part in the grandness that any other spot on earth does. Distance is the beauty, given. When you get to the city, that's something else.

Well, in the meantime there are the Indians off over in the hinterland, and of course by the road, in the plaza, in trucks, maybe on the mountain, god knows. We can't get off considering him. I am not shot on Indians myself. I don't mean any righteousness at all, like, "what they do is their affair." I don't feel sorry for what happened to them, I don't think anything was taken away from them any more than I think, know, anything was or is being, given, them. Of course when I hear a Zuni marching band in the street, it doesn't please me. It disturbs my sense of propriety, knowing, just what you do, that it isn't their sound. I wouldn't at all like any people, nor would you, being made into monkeys. Good.

But nothing happened. Nothing changed. The Pterodactyl is not the ancestor of the bat. The Indian is still there underneath it all. I am momentarily discounting all fascination with the grotesque, the aesthetic, the thrill quality of the voyeur. When the band marches by it is of course a gas. But there is no dark revenging consciousness lurking here ready to strike my white guilt down. Not at all. Contrariwise, when I look sharply at them they avert their eyes, perhaps out of sheer guilt, but I hope, remembering what

136

they were, recognizing what I am. Commissioners come and go, some, formerly at least, wanted to restore a hopelessly artificial Indian that had been, others, to reform, make modern worker productive Indians of use, of uniformity, of design. Neither got or will get what they wanted.

Of course it seems otherwise. You could seem to correct me by going to the Indian dance. And seeing the old men and the young shuffling about in their dances, the colors are still gay enough, but you can thank J. C. Penney for that, there is a log or a drum about and it is being beaten. But there isn't any war. There are no people left. It is all rote. It was formerly remembered. A great difference. The Greeks were apparently not the only ones who knew that difference.

And where I meet them now is downtown. And meet them in the way I would meet anybody I respect, i.e., with a right-honoring look. Brushing against them in the dime-store, I honor their long hair tied tightly in a cylindrical knot at the back the rest, long, and bobbed in a line around their great heads. And the handkerchiefs they have otherwise, jeans, or khakis, crazy old shoes sticking out, sport coats.

They very much do gaze out at the world. So do I. Their women are usually great fat hulks, and I don't mind this in them, they are genuinely like the rocks and mounds of their country. All this fabulous waddling intensely immovable woman is wrapped in what are the best of attires, the quick wrapping around of cheap cloth got right off the bolt, great tropical flowers, from the jungles of production, they would have never made that exotic trip if it hadn't been made possible by....

And then, too, I can hardly wait for the trips down to the Safeway to get groceries. There is always the same big Indian woman there, she shops apparently when we do. Or the reverse. Anyway I love this woman greatly for what she does. When she shops, going down the aisle taking things off the shelves at random, she throws them with all her might into the cart. Vinegar, flour, hopeless boxed breakfast cereal, everything gets the same mighty throw, and she smirks, frowns, spits, kicks things out of her way, boxes that happen to be on the floor in front of her, and yells; is a demon, is a troll. Wow I love her. The single person in my life who I really think knows what the hell she is doing, exactly. She makes me feel very wonderful. All over. Watching closely as the takes loaf after loaf of soft sticky bread from the counter and whips it, what an arm! into the cart 10 feet away, and cuffs her kid with the same swing.

And then, on a day, one opens up the newspaper and sees what they mean by real deep Indian, retainer of tradition, the lengthless time meandering nirvana that stretches back so far even Wernher von Braun could never hope to go in his shiny rocket. And you see her standing there in the picture. She has the hair cut of a Canyon-Road Artist and wouldn't you know she's dressed in woven, not printed, material. And Helene K. Wurlitzer or somebody is interested in her, she gets the highest for her blankets which are most unusual.* The blouse of course could have been bought anywhere. But it is "well-made." She is standing by a curator probably handing him a pot or a blanket or an "artifact" only she knew the existence of and waited for a generation to bring to light. Later it will be exhibited in the lobby of Fred Harvey (who is said to be the first benevolent man to see to it the Indians didn't get screwed by just anybody, when they sold their goods) or any of the myriad waiting merchants, you name them. And when I see them on the street, recognizing them I go up and whisper in their ears, "shame shame, promotion promotion, break it break it."

I have mentioned the opera.

There is one thing I honestly should say, to keep it straight. I was greeted in Santa Fe, yesterday. By a Native, properly speaking. That's what should be kept straight. I have lived in many of the houses of Santa Fe already and been kicked out for one reason or another. The first time was because my son made the mistake of using the homeowner's patio, which was outside our side door. This woman, by the way, thought I was brilliant. The second time the owner came and said he was selling the house. The third? Then I went to Taos to see about getting a house for no rent at all. By merely keeping it intact, so to speak. Nothing much happened in that line, although it was a lovely trip to Taos. Then we were driving around the town and happened to go over to the west side, which is the low side. It seemed unusually lush and green there, verdant, although everything was ready to fall down. It was like an intrigue. I stopped by a Native's house. He was out in front of it washing his pick-up truck. I asked him if there were houses he knew of in that neighborhood because we were looking for one, and, oddly enough, couldn't pay a high rent, were looking for a house in short to be able to live in it. For example, was that house across the street vacant, and was it for rent,

* Established in 1954 by Helene V. B. (not "K.") Wurlitzer (1874–1963), the Wurlitzer Foundation of Taos, NM, is one of the oldest artist residence programs in the United States.

did he know? There was a hesitation which I took to be a normal response to a gringo. We talked of other houses, the cost of rent etc. Suddenly he said. That house belongs to my father who lives in California. Has been empty for 7 years. Look at it. If you want to move in, and you will have to do some fixing, you can, you can live there for nothing. No rent. Because it will fall down otherwise, no?

In another sense, there is possible a generally well-disposed feeling toward the World when I sit outdoors early in the morning, greeting, and nodding to the people going down the hill on their way to work, or wherever they go.* And it isn't all the excellent bright climate. And it isn't at all whether they are Natives or not, or whether that is a correct appellation or not. It is just that they are people, and so am I, and not to romanticize that notion, it probably takes till long about 10 or 11 o'clock for everyone to get back into the rut of the previous day which can be pronounced like—"I hate you." Granting that the time lag is due to the fact that the pace here is relatively "human." And in the meantime one looks up and sees the forlorn children at the top of the hill against the deep blue sky which is the color of the sky over Houston, oddly, their cotton dresses blowing in what is, again, an excellent good breeze. A good time to have a cup of coffee, "the puritan's opium," and think it over. The children have their eyes fixed very often on the eastern part of town we can see up here. Over the trees and half hidden streets somewhere is the Plaza, and since it is early the lurid tourists will be emerging from Fred Harvey's hotel, who it was by the way that first saw to it the Indians didn't get screw[ed] (on their blankets) by just *anyone*. And oh yes! The crazy thing. At this time, or even before I am up, there starts a procession up and down the hill of the children to get popsicles. In groups of 2 or 3 to 6 or 7 they walk back at the pace of snails tearing the paper off. And they continue all day. They may also have a pack of cigarettes in their hand, or a loaf of bread, maybe some soap. But always the popsicles, they consume an incredible amount, every day. Then, before I go in, I wait to see the old women coming back from Mass, black mantillas blowing softly in the

* This unnumbered page consists of a single double-spaced paragraph (the rest of the typescript is single-spaced but was evidently composed on the same typewriter). Although this paragraph was clearly conceived as part of "Ed Dorn in Santa Fe," its relation to the rest of the material presented here is uncertain and was not necessarily meant to serve as a conclusion to it.

morning breeze. And their slow deliberate tread up the steep hill, talking in the softest Spanish tones imaginable, with their hands close together, jogging gently together as they walk, hardly a thing matters to them I imagine, except their venerableness, which they know nothing of and probably think that all that is significant about them is, life.

TRANSCRIBED LECTURE BY EDWARD DORN:
"THE POET, THE PEOPLE, THE SPIRIT"*

We frequently travelled without water, sometimes two days, over sandy deserts, where there was no sign of vegetation, and when we found some water, we most generally found some Indians who appeared the most miserable of the human race, having nothing to subsist on (nor any clothing), except grass seed, grasshoppers, etc.

—JEDIAH SMITH
July 17, 1827
Great Basin, Utah

Introduction

The contents of this speech and *The Shoshoneans*, the book it anticipates, were both the product of the summer of 1965, rather ahead of what was to become, and to a certain extent continues to be, a fashionable concern for the social and cultural appurtenances of Native american life. The political and economic actualities of course remain enshrouded in the unaltered patterns of avarice which stretch from the chambers of commerce local to the chambers of the federal bureau of investigation. Transactions were clearer, over the fiercer part of Native-white history, when affairs were subsumed under the Department of War. The bureau of Indian affairs is one of the early linguistic deceptions in a trend which has now become pervasive, and which is the medium of a raging disease of the national outlook. One is bombarded by the flak of indignation over cruelty to animals but not even a phrase of time for the starveling Sioux. It is the function of the "social worker" to rob "the case." Our shock at the public examples is meant to absorb the otherwise unincorporable bitterness of our knowledge.

The nature of the expression about to come under view, and to a certain extent its occasion, is marked by a variety of peculiarities, I noticed as I re-read it. In the first place, its awkwardness is extreme even for something which was not originally a verbally ordered text. The problem is not that I do not do this kind of thing well, but that the material was at that time merely

* The original transcription of the lecture Dorn gave at the Berkeley Poetry Conference on 21 July 1965, later edited by Bob Rose from an initial transcript by Derryll White, was published in 1976 by the Vancouver (Canada) publisher Talonbooks and reprinted in 1980 by the Four Seasons Foundation in the volume *Views*, ed. Donald Allen.

141

accumulated, and in any event there never was the configuration of a conventional story. Rather, the matter was, although at times linear, disconnected from reservation to reservation and from individual to individual. And, in fact, apparently, that could serve as a general description of how it is with the people of the basin plateau too.

From our experience, we know this predicament to be not universal. The situation in the newest theatre of conflict, Alaska, is otherwise in many significant ways. Subsistence there has been marked by the richness of the marine life on the continental shelf and by the existence of a vast reservoir of large mammalia with all their by-products. There was famine at times, and disease, both alcoholic and viral, was certainly introduced. Nevertheless, labor and wit could always have application. And although dangerous, the northern winter, which season is much of the year, provided a stability of travel which was unknown in the basin. Dogs can't get much to pull across alkali and sand.

In both these instances one can see how the terms of prior existence came forward into the present. In Alaska the people, who were always enthusiastic and able traders, now fly as well as float and slide, the first and last modes very often over their own continuous ground. Now they appear to be in good shape as the latest and biggest invasion of honkers finally clomps in to save the environment. This is to speak in such wide and soft contrast as the Advantaged and the Disadvantaged, but the effect, which we call "recreation," is common to both locations, whether that be mountain climbing, moose killing, or crap shooting.

Another, and quite secondary peculiarity, was the circumstance in which I was "invited" to give this talk. I was not actually asked to attend the Berkeley Conference of the summer of 1965, but went as a substitute forced on the organizers of the conference by LeRoi Jones, who had begun to withdraw from such contact. And that's how I went along as the Indian.

As a further note, it is my pleasure to thank Bob Rose and Derryll White for transcribing the raw tape, cutting it back, restringing it, and thereby generally enhancing its sense.

<div style="text-align: right">

Edward Dorn
Jimtown
30 Sept. '76

</div>

[DROPS SOMETHING ON THE FLOOR, LAUGHTER.] That might be lucky. Gee, I had a slip of paper. The title of the lecture, "The Poet, the People, the Spirit," was sort of quick. And I didn't really have anything in mind: I assure you, it has no meaning. It simply was a kind of inclusiveness that I knew I could talk inside of, in the sense that I must at this point know something about all those things. At the time I decided to come down here, I had just come back from Nevada *with* Leroy McLucas, taking pictures of Indians, he was. I was tagging along making notes, looking. I was really looking at the kind of terrible awesomeness of the miscellanea of American upper landscape, what's superficially on it, the geography. What's resting on top of it.

[DRAWS ON BLACKBOARD.] Here's Nevada and Idaho, Wyoming, Utah. The Paiutes, the Northern Paiutes and the Northern Shoshonis stretching from Fort Washington in Wind River to Reno are laying claim to a land mass that's like this, approximately. That's a lot of territory to claim. What they're after is, not the land back, which is obviously impossible. All those white people are not going to move off easily once they've established farms and bought tractors, built dams. So what the Indians want is *money* payment for it, in some way. Well, it's hard to say what money is. It's very difficult to say what money is. It's difficult to say what money is to an Indian. Very often you—it's awfully hard to talk to Indians by the way, because they don't speak English, except, you know, in the most casual sense. And you don't speak Shoshoni, at all. So they want a dollar for their picture. Something like that. Well, that's not much. Leroy McLucas of course is used to being asked much more than that. So he thought they were pretty square in that sense. But they say "a dollar," you know, "I want a dollar." All right, well, here's a dollar, everybody's got a dollar. And it doesn't mean anything, except that occasionally you'll come across the Indian who is really depressed and wants fifty cents. And then that *really* makes you open your eyes and wonder about *that* person. What relationship does he have to this nation? What sense does he have of it? Where does he think he is? What does he think of us? Quite obviously such a strange pair as myself and Leroy McLucas, who is a Negro, approaching American Indians with the idea of photographing them is… well, might be a loaded proposition in every, every step of the way. And it was. So you don't go up and say "How!," although that might amuse them too because they're not humorless people. But you have to somehow get out

143

to someplace where you're just a man, there. And you…have to make them know that. Well, they don't know that, though. Because you are a man. And that's the precise thing they fear. They don't frankly trust American Negroes or even like them very much. And not at all on…it's not racial in any sense that I could feel. But very much cultural. Very much that…the American Negro is precisely wrong because he wants to enter the mainstream American life. That's *the* reason he's wrong. Racially, he's just another man to an Indian. And that was a relief along those…Route 40 for instance, where you get so much of the southern element all over the West. The red neck, the red of which has faded a little bit, but all of the kind of incipient hostility is there. Perhaps even more viciously because it is, you know, about to spring out, and not on the surface. We all know that, as many Negroes do *know*, that it's easier to meet the hostility directly than in some unpredictable way.

Okay. So there you are, right there with the first, with the natives, with the first people, the first human beings…on this continent. And you don't know what to say to them. You can't say, "Well, look, I'm a poet and if…so that means that even if I'm not, even a good poet, I don't have to be a good poet actually. But if I'm a true poet…you can trust me.…You can trust me to be sympathetic. You can trust me to know that you're Indian and that this man is a Negro. And we're not here to really…shame you or take *bad* pictures or *anything* like that." You know. But I mean you can't say that. They wouldn't understand that at all. Not at all. And I can see and I can understand their not understanding it. It seems to me that the national life creates a situation in which any person who goes out to do something is thwarted by the fact that he is stigmatized already if he comes from this nation. Right inside the nation. I'm not talking about the "Ugly American" or going to Europe and being loud-mouth and insisting on water when people don't have it or all the crudenesses that we know *do* exist. That's not it; that's another situation altogether. This is simply a matter of how trustworthy can you be if [you] come from this context. And I assure you, you can't be very trustworthy. Nobody trusts us. You *don't* have to talk about Vietnam. You don't have to talk about South America. You can talk about Nevada. That's much closer to home. That's right here. The only reason why those Indians aren't guerillas is because *they are not westerners*. I mean western civilization types. They don't have any sense of that. They just don't want any part of it at all. They're not trying to overthrow national life. They have no sense of organization, *like* that. They're simply trying to be Indians.

Now those people who are trying to remain Indians in the, I suppose, the truest sense that now exists, are the culturalists or the traditionalists; the old men who still wear their hair in braids, who still insist on speaking Shoshoni; who will refer to other Indians with derision as *thinking like white men*. In other words, the progressives. The ones who would like to assimilate to some extent at least. Those people … exist in an utterly negative sense. They don't want anything to do with any national thinking. They don't think of this as a country. After all that's our word: America. You say, "Well, you're American too. You're the first Americans." Nix. They're not the first Americans. They never were Americans. That's *your* word. You applied the word "American" to them. They don't know—that's some kind of Americanized Italian label. They're not even Indians, even more conspicuously. And they know that. They're not Indians. They're not Americans. They've got a word for what they are but you don't know that. Because you've never of course taken the trouble to find out what it is. And you couldn't pronounce it anyway. Shoshoni has a kind of "ah K^h K^h K^h K^h," an aspirate "ch" sound with everything. You can't really even hear it. So everything you bring to them is your notion of what they are. It's not theirs. And they, if you press them, of course they'll tell you it's not theirs, the hipper ones. But mostly they won't even bother to tell you. They'll just look at you. They'll just look right at you.

[PAUSE. BACK AT BLACKBOARD.] Okay. Now, here, this is … Pocatello and Fort Hall Reservation is here. Fort Hall is one of the main points on the Oregon Trail. The Oregon-California Trail came out here through South Pass and up here the Donner Party made the mistake, as you probably all know, of trying to go across the Wasatch and got lost.… Fort Hall was where people went over and went down into the Humboldt or they continued on to Oregon. These people, the Northern Shoshonean speakers, are all called Basin-Plateau people. Paiutes are Shoshonean speakers. Bannocks, who are at Fort Hall, are Northern Paiutes. An important thing to understand is that these Indians are not those … fabulously acculturated, tricky cute types that you can run onto in the Southwest who … have made themselves attractive from … lots of points of view. I mean, there's a spectrum … I mean a wholly competent professional Indian to the real cultured Indian that you will find. But whatever that spectrum is, this is not the kind of Indian that the Shoshoni is, at all. He did not come under the sway of the Spanish. He was not taught silv—they never worked in silver. They made a few baskets, mostly deerskin. Mostly leather clothes and moccasins, beads. Beads were

introduced by the trappers and Fort Hall was one of the main dissemination points for those. And so they learned a kind of bead craft. But they didn't throw any pots of any value. Again culturally…. They didn't do *much* actually. They finally acquired the horse … and that allowed the Eastern Shoshoni to then go out onto the plain and make for himself a different economy with the buffalo … and he was fierce too. The Shoshoni was a dreaded horse-man. For these other people down here, the horse never became really important. They got it, finally, as it came in, in the eighteenth century. But it … never moved them out onto the plains. This is the Eastern Shoshoni. The Western Shoshoni are at Duck Valley, which is right here. [POINTS TO BLACKBOARD.] It's a fairly big reservation, about 500,000 acres. But that's all they got. Before that they were called Diggers. And that's a term of a program in American anthropology. It just meant, I mean, they dug camas roots and … other roots. And they gathered, too. They were gatherers also. And then they were jack rabbit hunters, small game. Because without a horse— And there weren't too many buffalo in there anyway, in the intermontane region. So they're very much like people you would meet on the skid row. They were like skid row Indians. Not post-white but I mean pre-white…. In other words, they were poor Indians. Their economy was bad. Now Indians for the most part *were* rather limited to where they were and what they had available where they were. The Sioux successfully made the transition out onto the plains at a particularly opportune time for themselves. From the woodland to the plain, and everybody knows that. But … that's exceptional.

Even the Shoshoni religion, the most significant aspects had to come back from the plain. In the seventeenth century a group of Eastern Shoshoni split off and went to the Southwest, the Comanche. And they're Shoshonean speakers. And then about 1,800 Omahamagwaya or Yellow Hand came *back* and brought the Sun Dance, which had its big revival there in Wind River. And then spread across the mountains to—their relatives of those people at Wind River. It's a curing dance. So that became their most important thing. But never a rich culture in the sense that the eastern traveler who's after something to wear back home could come and respect what they were or what they did. Never that way.

And indeed, on the government maps for the reservation locations until just recently, about last … about last year I think, 1964, Fort Hall is the only reservation listed as "tourists not welcome." That means two things. They're not welcome because there's really nothing for them to do except to look at

Indians. And most tourists want to buy something actually. They don't want to just look at Indians. Especially if they're dirty poor Indians. And also the Fort Hall Shoshoni didn't particularly want anything to do with white people because the experience in Pocatello was very bad, had been for a long time. Pocatello is not a very sympathetic town to Indians. So the smarter ones, the traditionalists again, the culturalists, stay on the reservation, rarely go to Pocatello.

Now at Duck Valley, here [POINTS TO BLACKBOARD], that's Western Shoshoni. There are no, well, there are a few Paiutes there—I mean, who can tell the difference. There is no difference really. They've all mixed by now. You'll find that that place is richer. They have a lot of water. There's a place called—there's a dam, the Wild Horse Dam in Nevada right here, in the mountains. And the river flows all the way through the valley. And it's a long and wide lush valley—lots of irrigation—lots of Lombardy populars planted by the first settlers in there, who were Mormons, and later kicked out, the place being then restored to the Indians. So it has a beautiful aspect as you look out over it. These tall slender trees placed around on the farms. And they grow hay, almost exclusively. Some of the best hay I understand in Nevada. And a lot of it. So they're not so bad off. You find places where they have telephones in their house. And then of course they have tractors and bailers and windrowers: everything to make hay with. There are very few traditionalists at Duck Valley. There are many more at Fort Hall. They've been forced back to the reservation, in a very real way. The Duck Valley people can go off of it. They go to Boise and Elko. And they have money. So in the sense that—not that they tried—but they have assimilated. They have become part of America. Money will do that. Whether you like it or not. Whether you want it or not. I mean, the sheer power and force of money will make you more American than you are without it. I certainly would say that the most American Americans are—there must be some ratio between how much money they have. For instance, the man who is broke must be less American. He has to be. I don't want to suggest that it's slightly un-American not to have money, but...I think the implication is there.[*]

Well, alright, so the Indians came under that almost technical factor of how you are an American without even knowing it, or without even caring.

[*] To clarify tone, although the transcription does not indicate laughter here, the recording establishes that the audience did laugh at this remark.

After all, why should they care? They want—under these Lombardy pop-lars are the same shacks that you'll find in the ghettos at the edge of Elko and Lovelock, Winnemucca, Carlin, Carson City, Reno, Sparks. Same shacks. Same conditions—but they'll have a phone inside. Rarely a toilet. An Indian has to be really liberated in that part of the country to have a toilet because there is this notion that it's dirty and unseeming to go to the toilet in your house. *In* your house—you wouldn't, you don't do that. I mean the fact that it flushes doesn't really help, much. [LAUGHTER.] The point is it went on there. And that's gotta be bad.

Well, what I'm trying to say is that such an experience—say if, when it was proposed to me—I didn't have any particular interest in it. Any more than anything else. I'm interested in anything. Like I could walk out the door and go somewhere else. It doesn't really matter to me. I don't have any center in that sense. So if someone says, "Let's take pictures of Indians," I think, well, why not try it. And if it doesn't happen at least I'd like to talk to some Indians if possible. And if they don't talk that doesn't matter either. Just keep going and maybe you'll meet another one. But especially these Indians because they're not—they're off the road and … they—no matter how poorly they're doing it they do represent themselves at this stage. And this is rare. The Basin-Plateau is self isolating.

Now on the way up to Duck Valley, Leroy and I stopped at a place called Mountain City. And there we met an Indian. Who, one could recognize immediately. His manner would allow one to read a great deal about him before he told you, or you asked. He had a cowboy hat on, one of those black things. All those hats are always turning up, like that. And he had Levis and cowboy boots and had that western—he assumed that swagger. And was drunk. Not drunk but I mean Indian drunk. The way they sort of walk like that. And the way they—their faces are almost masked with some kind of tension. And they're looking at you. And this funny English they speak. So he comes toward you. And he's playing the jukebox. And the jukeboxes are, you know, they're very hip. They got the Supremes and so forth—Rolling Stones, in those little towns. There's not, oddly enough—not country and western much. So he's doing that. He comes over, sits down, and asks us if he can ride on to Duck Valley and we say "Sure." Be happy to have an Indian along. It's always safer to go in with an Indian. But again, right off he's suspect. Because these people are divided in many ways. And that's another reason why they're very unlike—say their problems are very unlike—

the problem of the American Negro. We knew right off that perhaps it's not like going in with just any Indian. But this is this particular Indian. For one thing he's a braggart, he's a firefighter, he's a rodeo performer who's really seen better days and now he's going to seed and it's dangerous for him—he gets busted up, his arm was messed up. And he's not going to be like the *best* recommendation to the authorities there, that we should be there to take pictures.

But anyway we took him and that night met his cousins. Who were all like him. Now they have a funny feeling of relationship to this country. For instance, they were, let's see, how old? Oh between thirty and thirty-five, I think. It's hard to say. They had been to the Korean *Conflict.* That was their big reference. And they referred to it as "conflict." They retained that propaganda device so effectively used at that time in the early fifties to avoid its being called a war. Right up to this time. That word. And you see, "Korean Conflict" is a very funny thing to hear coming from the lips of an Indian. I mean if somebody else said that to you you'd think, "Well, wow." [LAUGHTER.] But—an Indian. I mean you wouldn't per—you might not expect him to know better, but that's not it. But you wouldn't expect him to say that. He might … he'd surely say something else. And they all said "Korean Conflict." Which again indicates how far out of the current news they are too. Because the Korean Conflict, as the Vietnamese Conflict, is not being called a conflict anymore. Now it's a war. Everybody says, all the official organs refer to it as a war now. It's possible to change that last term after 1964, '63, because you can only have one conflict going at a time, obviously. There are many wars so then that, you know, got put in another bag. It's a war. Well, they wouldn't have any sense of that. They didn't.

They drank white port by the half gallon. And a great deal. I've never seen such capacity, I don't think. They're all over the place. I mean we're driving all over the reservation wildly. It isn't like—you know any conception anybody might have of the wild life. Right there on the reservation. Really the wild life. And they were obviously the rowdy crowd, the do-nothings. When we would go by—it was late afternoon—we'd go by a field where a man, an Indian, was, you know, putting up his hay. They'd say, "Heyeyey, look at that." [LAUGHTER.] Putting down his effort, you know. Anybody working they put—oh wow, really—doesn't know what he's doing. "Come on come on," everybody was going. Small tight-knit group: hard core. Real rebels but inside nothing of course, *inside nothing.* Just inside their own Indian-ness.

Never, never any relationship to what we might think of as a larger form of protest, involving some concept of the people as a whole. Never, never that. But very good. Actually I got very scared because they had guns and they were shooting them—[LAUGHTER.]—you know—[LAUGHTER.]—but I thought, "Take hold of yourself, Ed. You came here to see these Indians and now you've got to do it." The obligation became almost....

And then, well, where we went was over to another ranch. Again cousins. By the way, every time they move they have this phrase I noticed, "Down below, let's go down below." And they meant for everything, in every direction. Every radial you could possibly go in. Down below. "Well, let's go down below and ride ... you know ride this cow." Well, they were very drunk. And needless to say we, both Roy and I, pulled the cheapest of all white men's tricks and really faked the drinking. So, we weren't. We got there and they rode, they rode the cows. Which turned out to be Jersey milk cows. [LAUGHTER.] But very *tough* Jersey milk cows. [LAUGHTER.] And they could hardly get on. There was a beautiful girl, about eighteen, who smoked cigarettes constantly. But never took them out of her mouth ... a lovely girl. And she—she wasn't drunk either, but she went along with the whole thing. Now there was a little, a very little girl—Mary was her name—about five or six, who spoke very good English. Very *nice* particular language coming out of her all the time. She told me that her mother would be very angry if she knew that these particular cowboy Indians were there drinking. So there was that going on, too. The mother was away. These were real rowdies. Going around the univer—, the uh, university—[LAUGHTER.]—the reservation—[LAUGHTER.]—causing trouble. [APPLAUSE.]

Well, it was kind of dark by that time and it was hard to get pictures. But these were the Indians who wanted their pictures taken. Once they relaxed and once we got to know each other they wanted their pictures taken. Not because they—you know it wasn't specious but they liked it. You know, they had an appetite for it. And we could satisfy it and get two things done at once. They felt funny about it. Because one man said to another, you know, "What are these guys taking pictures for?" ... And this one Indian looked at him *very* seriously and closely and directly and said, "You want your picture taken. You wanted your picture taken." And that was very serious, I mean there was no—and so he was called. And he did want his picture taken. But he couldn't *quite* admit it. So there was their feeling that well, we're doing something dirty, on their part. And they were. They were doing something

150

dirty by letting us take their pictures. We were doing something dirty by wanting to. They were going along with it and so were we. Every—that's one of the oldest American habits there is. Everybody's always doing something dirty and knowing it. I'm not pointing that out. I mean that was one of Lawrence's major themes, at least. But one gets to think of it as some wildly literary fantasy of the mind that you know belongs in a book back somewhere. But it's right now and there. It's going on all the time. Always doing something dirty. And you call it understanding. Well, all right, let's understand these people better. You know, we'll get to know them through their images. And I believe that. It's true. I mean, some of those pictures are going to be beautiful. But back of it there's a national strain that keeps it from being wholly beautiful. And it's in us. We can't and they can't.

Finally they fell off the cows. And the pictures were, you know—some of them didn't turn out. But then the photographer being black, and me, the writer, being white, fell out at that point. We had an argument. And that's predictable, too. Because, well, Roy didn't want to look at it. You know, "For Christ's sake if these guys, you know they're going to kill themselves. If they want to do that let them go to Vietnam. You know—I don't want to see this. It's stupid." And he said, "What do you want to look at this for? What are...." And I said I want to look at it—it's not that but, I mean, this is ritual. And I see it right before my eyes and I want to look at it. This is the old—this is what—all they've got left, this is the vestige of that possibility of being a hero. OK, so it's riding a milk cow but they're taking a chance with their lives, which is very important to an Indian. And remains very important to an Indian. It's not important to us because we value our lives for some silly reason. We think death is some rather large event. We don't have the sense that death is simply another occurrence, like any other occurrence that might happen on this *string* we call our lives. But they very much have that feeling. And they very much want to test this all the time. When is it going to happen? How tight is the string? What's on this particular segment of it? And death is not any, it's not any *great* thing. It's either there or it's not. And if it's not there then you know it wasn't, so you test it again. These people very much know that. So they do all sorts of dangerous things. Edmund Wilson in the back of that book—this anthropologist who talked about the Mohawk's particular ability to swing high steel in New York City, and the sharpness of their eyes. The ability to gauge distance without any surrounding reference. That is up three or four hundred feet in the air, or higher. Whereas we

have to have the—like, you know, the glass is here so I can tell the corner's there. I don't think there's anything genetic about that. All of that idea that's pronounced in that book about how Indians do still want to test their own courage by very external means. That was what was happening to me. But on the other hand you can argue again … I, as it turned out, it wasn't—I stayed and watched it but—and I don't yet know what I think of it. But I'll think something about it, later.

Okay. Those were those people. Now I kept trying to tell myself: I have to be here. I have to be there with the Indians. I don't have a country any more than they do. I'm like part of the Fourth World too.* I, of necessity I have to be part of the Fourth World to retain any possible honor for myself. Which may be presumptuous, to want to honor *myself.* They're part of the Fourth World. One speaks of the Third World, the underdeveloped nations. They're certainly not part of that. Any Peace Corps endeavor in their direction is right off ludicrous. They're at least a Fourth World. There may be other worlds. They're not even, well—we met a bourgeois Indian. He was something else. He worked at the … at Duck Valley there's a hospital, in there. The doctors who were not really Army, I guess, but they wore Army uniforms and had those same major, captain, lieutenant insignias, worked for the Public Health Service at this hospital. They were all well-fed and rosy and innocent and honest and decent—suspicious. [LAUGHTER.] So their pictures were taken. And they told a little bit about the hospital, what they were trying to do and so forth. And the Indian who worked there … and had the use of a car, I noticed, but he had no rank, was very affable and co-operative, interested: not suspicious like the ordinary reservation Indian because he figured us as good publicity for the tribe. For the, he—in other words you can smell that way of thinking. Like, well this is going to bring our problems before the nation. It's going to create an advertisement for us. So … that's good. So we went home to lunch with him. He had a white wife, a French woman that he had met in France and brought back to the reservation. She seemed completely indifferent to where she was or what

* The term "Fourth World" describes a problem of modern sovereignty. Unlike the First, Second, and Third Worlds, the Fourth World is not spatially bounded and refers to dispossessed groups whose members cannot be reconciled to citizenship within an established nation-state. For more on this concept, see George Manuel and Michael Posluns, *The Fourth World: An Indian Reality* (New York: Free Press, 1974).

152

was happening…and the children were beautiful. The house was neat, a model of efficiency, cleanliness. It had the look of a worker's house more than a middle-class house, much more. And I thought of some kind of scale in which—and his income by the way must have been pretty good. Because I suppose he made three or four hundred dollars a month from the government and has three hundred acres in hay. Which is a good income there, again. So he had a new pickup truck. It wasn't—the worker quality of the house was simply what happens, it seemed to me, when the Indian gets out of the absolutely disheveled shack into something he conceives as approximate to a well-run American household. So that it didn't become middle class. It didn't have that pretension. It stopped lower on the scale from that. He had horses. He was very anxious to have his picture taken. And he—so he posed on his horse and so forth.

But then he told us of his great-grandfather who was still alive and a hundred and two years old. His wife was alive. He drew—and he thought that we very much should go over and visit with this man. A historian, a state historian had come down from Boise several years ago and done an article on the man. And it had been in the Boise paper. So he was sort of used to that sort of thing and was there as a figure of antiquity. So we said, "Sure, yeah. We'll go over there." So after lunch we went over there using the map and got there through three gates or so, which you have to open and close. They're barbed wire gates on posts with just wire to hold them. There were a collection of three shacks and it took us a while to find them. And I went around the back and to the screen door and the woman was there. And…I can't really express my shock at seeing her. She—I've never seen anyone older than a hundred years old. And she had a white, no blue, yeah it was a blue kerchief with white flowers around her head but down certainly across her eyelids like that. And so she looked up a little bit. And she didn't say anything except some Shoshoni [UNINTELLIGIBLE GUTTERAL SOUNDS] like that. And unlatched the screen and I went in. I mean I felt—I don't know. You know, I mean I don't know whether she said get in or drop dead or—I don't know. I mean but she didn't pay any attention to me just pointed into the next room where the man was. I went in and there he was. Certainly thinner than Gandhi at the end of one of his fasts or at least comparable to one of those pictures after the war in Poland or from one of those camps where people were—had their knees like that and their legs that way. He was sitting on the edge of the bed. Absolutely beautiful man with utterly sharp

piercing eyes. But the rest of him. Well, the wrinkles you can imagine. You've seen that approximately already. His hair was black *and* white. No gray but interspersed. Long hair. And he was dying. He said in—he had a little bit of English, although it was disconnected because he could hardly hear. And so he wasn't replying to what you'd ask him or anything like that. But he described that his troubles were in his chest here and around his back. And his feet were really dirty: the whole place was very, very dirty. Incredibly dirty. It was one of the dirtiest places I've ever seen. I thought, "Wow, I—I don't—I don't know where I am." But then I thought, well, again, "I'm here." So back to that. How do you get around being where you are? Even though you went to whatever you did to get there. You may question what you did to get there but you're there, alright. So I tried to talk to him and had to speak very close to his ear. Right up almost my mouth touching his ear almost screaming. And he could hear but then again he wouldn't reply to the question. So it became obvious that we weren't talking. But still I, you know, we tried. And every once in a while, he would break out in a *lovely* chant. In Shoshoni, which has a nice long line to it. [CHANTS.] Like that—haaa—but deeper, you know. I mean that's—I don't want that to be a parody or anything like that. I thought it was a death thing, you know, a death chant. Because the wife would go over—she wanted to *die* very badly—I mean she was *begging* to die. But she just, I guess, couldn't. She went over, she would go over all the time and lay on the edge of the bed and sort of curl up in a foetal position. And right on—the only corner that she could possibly lay on because it was piled high with rags and a lot of things. And then she would get up and go back: she was taking care of him. I mean she would then go over and speak in Shoshoni to him, once in a while. They were, I suppose, trying to get straight who we were, or what we were doing there. I mean 'cause there was no way to tell. I mean they must have been a little bit, oh, I don't know, scared, maybe scared. Although they didn't have the energy to display it—any kind of fear.

The question in my mind all along was: now why had this man, the Public Health Service employee, the grandson, the great-grandson, why had he sent us over there? He had been there—he must have known what the place looked like. He must have known what—how these people were. I mean what…and again the calculations started going on. Like how we always try to calculate, what reason do they have, you know, for doing something. We're always calculating that. And I was—my machines were

154

running. And he's either—he can't be—he's not a stupid man. Because I talked to him. And at lunch he had told me what real respect he has for the traditionalists. That they use the language in the old sense with authority. That—say there's a man at Fort Hall, a famous traditionalist—Willie George is his name—is a great Shoshonean speaker and when he gets up to speak he speaks in the old way. Which is to say that everything says something. The people of the last generation who have still been taught some Shoshoni in the household, according to this man, very often *don't* say much with it. They can speak it but it's hit and miss. They may say something or they may not. It's kind of, yeah, it's just hit—it's hit and miss. But these old men really—they speak all the time and they're saying something all the time. It has great weight and direction and authority and it's right there. Nothing—no slack at all. And he respected this. He was talking about it, in a very lovely way, I thought. How he, although he was a progressive and wanted the, you know, the Indians to be better off. He liked this and would think it a shame if it died out, but that it *was* dying out. And so forth. So I mean—I had respect for him, too, and the way he felt...I don't know, I thought perhaps, it might be the old man himself. Hundred two years old. And his wife. Maybe that after all was their place. And no matter where else you might take them that would *not* be their place. And they were dying. And they were going through the wait of dying. They were performing the act of dying. And finally it didn't really matter *where* that happened. It was really beside the point. I mean when I finally saw that— well, I knew anyway. I'm not scared by dirt in any sense. In fact I prefer it. I just can't stand other people who like it.*

Alright. Let me get off that. What I'm trying to get to is that no matter what—no matter how you find the Indian or no matter who you are, no matter what your interest is, the thing you come up against is the in—the inside of a nation: it has a life, inside. And if you go out with someone—to someone, to meet someone else, *that's* a relationship. And then all three of you, all three of those factors, have a relationship with the whole thing. And it's always there. It's always there. It's always there. You will find that everyone, every—everyone in the community is a cop, everyone is a policeman, every woman driving a pickup truck is a policeman. Every one of them. You can't ever make a mistake about it. They're all part of the constabulary. They

* This last sentence is not audible in the recording.

155

watch you. You're a stranger. Why are you there? What right do you have to be in Nevada? The sovereign state of Nevada. Or the sovereign local community of wherever it is. It can be the most Podunk worthless dry-faced town you could imagine. But they value that enough to make the whole citizenry a constabulary. It must be obvious that in our national life, say taking it in the last fifteen years, that this entire nation *is* one vast huge policeman. There are only a few people to be policed. Just a few. In fact there are so few people to be policed by this vast horde of policemen that you know them all. You know who they are. They are that few. They're recognizable. You know who they are.

Well, that leads to another thing then. On the reservation it's one thing, say…if you're there. Because that's their land and their nation. They deal with the government by themselves. They're independent national entities, the reservation people. You go to small enclaves along Route 40: this is the Paiutes now. And you'll find that those people form a pool at the edge of town for *use* by the local citizenry whenever they want it. They're kept depressed. There's usually one street, a collection of hovels, and maybe fifty to two hundred, three hundred Indians. Now those people, if you try to go in and talk to them, are going to be very, very different. They don't even want to see you. They just think you're coming down to do something. Of course you are. You very much are. So *they* don't form part of anything at all. They're *not* an independent nation. They're *not* American citizens. They *don't* exist on this continent. They have no existence at all, except in those hovels. And that's nothing. And believe me, I'm not trying to argue any kind of sociological concern. At all. None whatsoever. They've had that too. It's simply the fact of existence. Relative to a small town that thinks well of itself, to which they can be of occasional help, on land that they once occupied, which was theirs, in the Basin-Plateau country, between the mountains. Now they are the most *wretched* of the earth.* And without any possibility, foreseeable at least, of coming together in some organized way. They're split by language and dialect. All through that one small area actually—because they're not all Shoshonean

* In 1963 Grove Press published *The Wretched of the Earth*, Constance Farrington's English-language translation of psychoanalyst and cultural theorist Franz Fanon's influential study of occupied Algeria and the Algerian struggle for freedom. Fanon, who died in 1961, famously described the role of language in shaping the position of the "Native."

speakers in the intermountain west. They're split by what remains ritual differences. They're split by a hangover of wanting to fight each other too. Because what happens if you always went out—say if you used war as a dance, as a party, as entertainment, as a social form: war as a social form, with not too many people killed. Largely by accident. And that's missing then—but something else has come to replace it, namely drink. And in the case of Reno, dope. There are Indian junkies there. Which is a *pretty strange* thing to see. There are all sorts of other things that will be handed to you to substitute for this once more coherent way of conducting your life and relationship with your neighbors. War for them was a way of getting along, if it could be, if that can sound right. It kept things straight. And it allowed the young men to be some place. Now the young men can't be any place. It's a problem of the young men. I feel very much like an Indian in a way. Because I remember when I was a young man there was no place to be either. And again, I mean to pick up what Bob [Creeley] said about—the war is a large reference for my generation, I'm sure. The end of it, not the war itself, because I was slightly too young to have gone to World War II. But that end of it where there was no place to be, the stream of G.I.'s coming back. The whole disheveled nature of the United States at that point was—seemed to me—very parallel to the problem of young Indian boys, off the reservation especially. On the reservation, they can—there's some work to do. But otherwise, no. They're really without any form. Even the most depraved of white Protestant American has a form. We almost understand that—even the most grotesque athletic youth of eighteen has a hot rod or knows somebody in the country club. Or does something. He has something. And it's part of the national fabric. He can do that. He can be there. It may be nothing that will give him any kind of strength. But it's something to occupy his life on earth until he waits for this moment he must dread.

Okay. Well, those are some of the things I saw. Now I'd like—I want to ask myself if a poet exists except—except as he can *be* somewhere and *with* something. I really do think that … it's possible to have a poem. Yeah—a poem exists. We know that. But it's a much harder proposition as to whether a poet exists or not. Sometimes he does, sometimes he doesn't. He may or he may not. To my mind he has to *be there* as much as possible. In other words, he has to discharge himself into the—some arena of life at least to the extent that—or trying to approximate the extent to which a

poem can do that. And then he can be, I would say, maybe nearly a poet. People can be nearly poets when they do this. Not people. Yeah, people. Anybody. People can, are poets when they *are* there with all of themselves. And that's—yeah that is a condition again to my mind, it's a possible condition. Never quite reachable, I mean *exactly*. But only, only *by* that condition can you have the force of a poem then. And a poem is force, that kind of force. Now I don't—the other part of it—I believe in the gods. In the sense that I—not that I have any particularly. I've thought a couple of times I did and they've come and gone. And they're certainly welcome. But other people do and you might be able to see them. I thought a couple of times with the Indians that I was close to gods I could respect. And heard them really. I mean certainly when the old man was chanting I thought—god *power*, very much. And several other times. And also…I don't really want to talk about that because I think everybody knows what it is.

Now, let me finish it off by talking about one more thing. I've got a note: the world and the uselessness of national boundaries. With the provision that any kind of one world idea is usually a trick of misunderstanding of what to be a whole world is. One world is not necessarily a whole world. It can remain the same conglomerate that we've got. I have no love at all for the state or any kind of nation but, on the other hand, I listen to anti-state arguments that strike me as stupid also. So I don't really know what to think of that. Except that it might be possible to have a world very shortly in which the *people* will start ignoring that apparatus that intervenes with us constantly and constantly hangs over our head like that famous sword.* To ignore it, in other words. I don't think—as I think of it actively, I don't think that revolution except in rather particular places, namely, say, South America or Southeast Asia, has any point. It has to be far more radical and far more subversive than that. I think the people just have to stop paying attention to that bullshit and turn their backs on it. They have to start looking at each other. They're doing that already. The state will become less and less important

* Dorn could not have been thinking here of Louis Althusser's "Ideology and Ideological State Apparatuses," as that essay was first published in *La Pensée* in 1970 and translated into English in 1971, by Ben Brewster. The "famous sword" he evokes is the Sword of Damocles, a still-common trope that originated in late Greek culture to describe the omnipresent risk to the head of a powerful leader (i.e., the sword hangs precariously over such a head, suspended only by a single hair of a horse's tail).

and it will—it won't even know it. I'm sure that the—say, the government of the United States doesn't really realize yet that it's no longer a force in the world. And that it's no longer important to the American people. It really isn't. It's utterly beside the point. Now, the strength of its vast apparatus is another thing and that obviously continues to grip us and will. But for… even practical purposes it is not necessary to have it any more and I—everyone *must* know that. It's really just irrelevant. It's certainly irrelevant to anyone who doesn't—who isn't American. And I would again maintain that most of us are not Americans who think we have the possibility of living. Anytime someone comes through Pocatello who looks like a criminal, or a fugitive, a bum, somebody weird looking—and it doesn't take much to be weird looking in Pocatello—I immediately recognize them as the people that I want to walk beside, to be near, to talk to, to be with. Because they are precisely the people who, for one reason or another, have compromised their allegiance to the thing that might destroy us all, including them. And they've taken that risk. Maybe they haven't taken it voluntarily. I don't—that I don't care much about. But they maintain it. The man who doesn't belong in a community is probably the man to pay attention to. The old idea of the stranger is still very strong. That's definitely a Greek idea. We may not honor him anymore. We don't. Because we don't have—we didn't inherit that part of the culture, unfortunately. But we certainly know who he is and the stranger's fearsome. He's the man to talk to. He's the man who knows where he's come from. Thank you. [APPLAUSE.]

TRANSCRIBED CONVERSATION WITH EDWARD DORN AND CHARLES
OLSON: FROM "READING AT BERKELEY—THE DAY AFTER"*

RICHARD MOORE: You know something that would be mighty useful for
us, if convenient for you: that relationship here between the two of you, how
your two lives come together.

OLSON: Gee, it's an amazing story to tell, and it's a nice one, I think, don't
you? Go ahead, Ed, you pick it up.

DORN: No, I was simply thinking that it's biographical starting now, or at
the end point, and it's been biographical altogether.

OLSON: Yes, it has. Yes, it has.

DORN: You know, very recently, I…

OLSON: This very minute.

DORN: …I thought of you when I was going through Nevada, by the way,
and trying to get out of that fix, you know, that local fix which I'm so hung
up on anyways, and I suddenly realized I hadn't been on at this for a long
time, or into the world. And these people were, were there. I couldn't think
of them as Indians,† you know, in that sense; and, in fact, it's very funny that
the one place we went into where anthropologists had been was a complete
failure. I mean, all the people supposed that they knew what we wanted to
know from them. These people were from Stanford, Pittsburgh, University
of Nevada, you know, and they almost, like, they were—suddenly they had
been made volunteers of their own grudge.

OLSON: Right. That's something to me that you've got. I mean, you know,
I tell you, I was stuck. I'll add my piece to our autobiography because, you
know, what you…. Well, let me start with what's happened right here, and
did when you read, is to me—was to realize that you had filled out what you

* Dorn and Olson's transcribed conversation is given the title "Reading at Berkeley—
The Day After," in Charles Olson, *Muthologos: Lectures and Interviews* (rev. ed.), ed. Ralph
Maud (Vancouver, Canada: Talonbooks, 2010). The excerpt reproduced here begins on
page 196 of the revised edition.

† "Dorn is describing a recent experience which had been the subject of his talk at the
Berkeley Conference on 21 July 1965 (see pp. 141–59). See also Dorn's book, with photog-
rapher Leroy Lucas, *The Shoshoneans* (New York: William Morrow, 1966)." N.B., while note
numbers and bibliographic references from the Talonbooks edition have been adjusted to
correspond to this volume, the substance of Maud's three quoted notes, here and in the
following, is unchanged.

mean by that local fix, which is, for both of us, powerful, and could be something that anybody could trip us, oh boy, and fall us, and probably most people, well, I guess they still will. [LAUGHS] But I don't think that—my point is I think—and I feel it even for myself, and I feel it even happened like almost last night, literally—but that identity simply coming out of work has overcome any of the conditions that we both determined to stay with and to seek, not materials in, but stories, a story, actually. Because the thing is that, literally, as rider together, it was a story of Ed's, which was called "C.B. & Q,"* and it was a gandy-worker story, and it ran from, like, say, St.—not St. Paul…

DORN: Joe's…

OLSON: St. Joe's, where they set out. But the funny—it's a funny story, it's as—at least for me, I said it, and I haven't said it to you before: that what you have filled out at that reading the other night was in poem, poem after poem after poem, it ended all that word "West." I now know how to—somehow or other from that reading, I—that title's just never been—simply been a project title to me of those poems that I've… [GAP] … *Wild Dog* in Pocatello is the only place, except for the first one which LeRoi published, that "Bozeman Road" thing, has been there. But it's as though "West" is no longer a word due to how much you—that same enormous…. It was St. Joe in the North, but the end of the story is the gandy-worker's going the hell back to New Mexico, going down the track to New Mexico. And you know how much I felt that you had appropriated, not the transposed continent, but the unknown, which had presented itself again, and that a great unknown suddenly arose, I think, for us at least. I think that would be true, specifically for Ed and myself. Or, put the other way, for Ed and myself it had a geological term. I'm sure some unknown presents itself similarly to Robert Creeley, I know it does, and, say, to Duncan, others, and Hadley here, who, by the way, should get into this conversation at this point because—hey, Drum, are you listening?—because as of the very thing that, say, is both the subject and where I think it's all gone now, the dissolving of something like the word "West" or "Indian" or "White" or anything. So does that make sense?

DORN: Yeah. Does it have anything to do with this thing you're talking about, the literal and the numerical?

OLSON: I do. My god, I do. But how did we get there? No, as a matter of

* "The story, whose title is the abbreviation for the Chicago, Burlington, and Quincy Railroad, appeared first in *Black Mountain Review* 7 (Autumn 1957)."

fact, I know where your poetry just the other night—and that poem I wrote, which I wish I—the one I wrote, still, and is the last *Wild Dog* poem of the series, the one that mentions him and Diana,* that's still the only time I feel I got a little of that. I mean, I think that's what we was [*sic*] trying to find out was how to cock the literal so that it went off. And it is a language like mathematics used to be, or something. I don't know what that means, or saying where it leads to, but those poems—and that those are poems, that's what's so beautiful, you know. Those are stories and poems as one, those things of yours.

DORN: But it was the story that, yeah, you first helped me write. I mean, simply I did it, but you pointed out to me what it meant to me.

OLSON: Did I really? No kidding?

DORN: No, well, it's possible I wouldn't have known.

OLSON: Well, that's the—well, it's nice to run into somebody who recognizes, I think, sometimes, that's all. A man always does what he does; you can never talk somebody's influencing another person. I mean, the only thing you could—there isn't only love, and that's interesting, and you go to bed with that. But this other stuff is simply, well, it's friendship, that's all.

DORN: This chant I heard, the old man dying, a Shoshone, actually a Northern Paiute. It was at Pyramid—no, it wasn't at Pyramid; it was at Duck Valley. I finally understood how you can use things that are, say, not available to you. You were talking about obscure, you know, in trying to make a point that if, well, if it's obscure maybe you can make it unobscure, like shoveling the shit out for cows you can also learn a little Greek. Well, this chant meant a kind of spiritual affirmation in me very much, and was not cultural; it was simply something I heard.

OLSON: Yeah, I getcha.

DORN: And I heard it literally; I mean, understanding is really beside the point. And I heard it as a death chant. It was piercing, I mean, you know, the thing just went through your body. It was a really beautiful song. I never saw that before. I had never had that experience before, feeling an immediate response from something outside myself. And then, you know, the possibility of its being initial, without cultural reference.

OLSON: Right, I gotcha. Well, I consider that one—and it's the only thing

* "'West 6,' a poem that mentions Diana and Drummond Hadley by name, was first published in *Wild Dog* 10 (September 1964), 31–32 (see *Collected Poems*, p. 599)."

I've been saying is that the only lines that I can keep with at the moment is that place where—and I ended that reading last night—that reading happens to be the last two lines were [I.82]

> And he and I distinguish
> between chanting
> and letting the song lie
> in the thing itself.

And I think that he's saying that we have got to a point, or that Shoshone chant does that thing, which is that the song lying in the thing itself is the only real, what used to—it's too easily called magic, but of song—but what really song is, is something that goes right through everything, and that the literal, that attention, when I think you'd agree that that's where it was, autobiographically, that it was attention at the start, that it was so critical that we—and I find this still true, that the specific—that you have something very specific that will cause your attention to be, and that then you get the results, which are these, that the song does lie in the thing itself. And that's what they call—I mean, that's powerful, that's power, and that's what we, I guess, really, I think we—this last 122 hours is simply an evidence for that quite a few men have caught on to the secret of power. And it's been treated cheap a long time, somehow. I don't know even how it got treated cheap, and that one doesn't even know, except that one does know exactly how you have to live to have that come in to at least language, so that it does do what you're talking about that song did, anyhow that guy that time, huh?

Writing of the decade of 1820–30, Fredrick Jackson Turner says:

> West of the Mississippi lay a huge new world—an ocean of grassy prai-
> rie that rolled far to the west, till it reached the zone where insufficient
> rainfall transformed it into the arid plains, which stretched away to the
> foothills of the Rocky Mountains. Over this vast waste, equal in area to
> France, Germany, Spain, Portugal, Austria-Hungary, Italy, Denmark, and
> Belgium combined, a land where now wheat and corn fields and grazing
> herds produce much of the food supply for the larger part of America
> and for great areas of Europe, roamed the bison and the Indian hunter.
> Beyond this, the Rocky Mountains and the Sierra Nevadas, enclosing
> high plateaus, heaved up their vast bulk through nearly a thousand miles
> from east to west, concealing untouched treasures of silver and gold.
> The great valleys of the Pacific coast in Oregon and California held but
> a sparse population of Indian traders, a few Spanish missions, and scat-
> tered herdsmen.

Over this vast waste equal to…. It is still waste, although it isn't so vast any
more. A historian like Turner can only occur once, as of a given place,
then the next instant the real inspection begins. The girl dancing by the
juke-box in some wretched mountain town is no more assured of comfort
than the pioneer woman in the wagon. She is perhaps less liable to rape,
or if not, it will hardly be the same startling opera, a cast of cruel and gai-
ly costumed savages down in the river bottom. Some habits, like suicide,
seem specifically introduced by the conquering race. There would seem
to loom only facts: that boulder, this mountain, those store fronts, his
greed, her compassion, water, no water, prayer, arrogance, futility, loneli-
ness, a swindle, an even break, the dandy charmer, the slothful soilbound
fanatic, the dream and of course the inevitable dreamer. History has always
seemed to me lying right on the table, forgetful of age, or not present at
all. And geography is not what's under your foot, that's simply the ground.
Idaho and Montana are political assumptions surveyed from what was at one
time the apple of someone's eye. The name never was more than a sign of

* Dorn's unpaginated preface to *Idaho Out* (London, England: Fulcrum Press, 1965).

appropriation, and most people still do not know where it is or what it looks like. A poem about such a place is equally arbitrary and no more apt to confirm it... once the poem is thought it returns home to its own fire.

Edward Dorn
COLCHESTER
NOVEMBER 1965

CREDITS

Poems by Edward Dorn. Courtesy of
Carcanet Press. Copyright © The Estate of
Edward Dorn, by permission of the Estate.

Letter from Ray Obermayr to Edward Dorn,
n.d., Series 1, Box 2, Edward Dorn Papers
(M1514), Stanford University Department
of Special Collections & University Archives.
Courtesy of Stanford University Libraries.
Copyright © Ray Obermayr, by permission of
Mr. Obermayr.

Letters from Tom Clark to Edward Dorn, 26
February 1964 and 9 January 1965, Series
1, Box 1, Edward Dorn Papers (M1514),
Stanford University Department of Special
Collections & University Archives. Courtesy
of Stanford University Libraries. Copyright
© Tom Clark, by permission of Mr. Clark.

Letter from Donald Davie to Edward Dorn,
23 February 1965, Series 1, Box 1, Edward
Dorn Papers (M1514), Department of
Special Collections & University Archives.
Courtesy of Stanford University Libraries.
Copyright © The Estate of Donald Davie, by
permission of the Estate.

Letters from Edward Dorn to Robert
Creeley, 12–13 April 1965, 18 May 1965, 10
June 1965, and 28 October 1965, Series 1,
Box 39, Robert Creeley Papers (M0662),
Stanford University Department of Special
Collections & University Archives. Courtesy
of Stanford University Libraries. Copyright
© The Estate of Edward Dorn, by permission
of the Estate.

Letter from Edward Dorn to Tom Raworth,
18 May 1965, Box 8, Tom Raworth Papers,
Archives & Special Collections at the
Thomas J. Dodd Research Center, University
of Connecticut Libraries. Copyright © The
Estate of Edward Dorn, by permission of the
Estate.

Letter from Edward Dorn to Helene
Dorn, July 1965, Series1, Box 1, Edward
Dorn Papers (M1514), Stanford University
Department of Special Collections &
University Archives. Courtesy of Stanford
University Libraries. Copyright © The Estate
of Edward Dorn, by permission of the Estate.

Letters from Edward Dorn to Charles Olson,
3 August 1965 and 28 October 1965, Box 150,
Charles Olson Research Collections, Archives
& Special Collections at the Thomas J. Dodd
Research Center, University of Connecticut
Libraries. Copyright © The Estate of Edward
Dorn, by permission of the Estate.

Edward Dorn, "Ed Dorn in Santa Fe"
(unpublished typescript), Series 3, Box
20, Robert Creeley Papers (M0662),
Stanford University Department of Special
Collections & University Archives. Courtesy
of Stanford University Libraries. Copyright
© The Estate of Edward Dorn, by permission
of the Estate.

Edward Dorn, "The Poet, the People, the
Spirit." Courtesy of the Estate of Donald M.
Allen. Copyright © The Estate of Edward
Dorn, by permission of the Estate.

Charles Olson and Edward Dorn, "Reading
at Berkeley—The Day After" (excerpt).
Transcription by George Butterick with edits
by Ralph Maud. Courtesy of and copyright ©
The Estate of Charles Olson, by permission
of the Estate.

Edward Dorn, preface to Idaho Out. Courtesy
of Carcanet Press. Copyright © The Estate of
Edward Dorn, by permission of the Estate.

Mr. Lucas thanks Ms. Lauren Upchurch for
her assistance in locating, organizing, and
inspecting the original photo negatives for
purposes of reprinting and also Holland
Photo Imaging of Austin, TX, for making
the new prints.